South East Essex College
of Arts & Technology
Luker Road, Southend-on-Sea Essex SS1 1ND
Tel:(01702) 220400 Fax:(01702) 432320 Minicom: (01702) 220

30130504251617

50 PHOTOGRAPHERS
YOU SHOULD KNOW

Peter Stepan

Prestel
Munich · Berlin · London · New York

400287690010

Front cover from top to bottom:
Lewis Hine, Workmen eating lunch on the 69th floor of the GE Building during the construction of Rockefeller Center, 1932 © ullstein bild
David Goldblatt, Incomplete houses, part of a stalled municipal development of 1000 houses, Lady Grey, Eastern Cape, 5 August 2006
Eadweard Muybridge, Animal Locomotion, Animals and Movements, Horses, Gallop, thoroughbred by mare, Annie G, plate 626, 1887
Eugène Atget, Saint-Cloud, 7 p.m., 1921

Page 1: Wolfgang Tillmans, paper drop, 2001 © Wolfgang Tillmans, Courtesy Galerie Buchholz, Cologne
Frontispiece: Edward Sherrif Curtis, Bear's Belly, Arikara Indian half-length portrait, facing front, wearing bearskin, c. 1908
Page 6/7: Ara Güler, Massage in the Cağaloğlu Turkish bath, 1965 © Ara Güler, Istanbul

© Prestel Verlag, Munich · Berlin · London · New York 2008
© for the works reproduced is held by the photographers, their heirs or assigns, with the exception of: Diane Arbus © 1972 The Estate of Diane Arbus, LLP; Richard Avedon with The Richard Avedon Foundation, New York; Brassaï with Gilberte Brassaï, Paris; Walker Evans with The Library of Congress, Washington; Nan Goldin with © Nan Goldin, courtesy of the artist; Kaveh Golestan with Kaveh Golestan Estate, Teheran/London; David Goldblatt with David Goldblatt; Ara Güler with Ara Güler, Istanbul; André Kertész with the Association Française pour la Diffusion du Patrimoine Photographique, Paris; Dorothea Lange with Dorothea Lange Collection, The Oakland Museum of California; Jacques-Henri Lartigue with Donation Jacques-Henri Lartigue, Paris; Robert Mapplethorpe with Robert Mapplethorpe Foundation, Inc.; Helmut Newton with The Helmut Newton Estate, TDR; Edward Steichen by permission of Joanna T. Steichen; Paul Strand with Aperture Foundation, New York; Josef Sudek with Anna Fárová, Prag; Edward Weston with Center for Creative Photography, Tucson

René Burri, Robert Capa, Henri Cartier-Bresson, Bruce Davidson, William Klein, Josef Koudelka, Martin Parr, Sebastião Salgado with Agentur Focus, Hamburg

Hugo Erfurth, Alexander Rodchenko and Alfred Stieglitz with VG Bild-Kunst, Bonn 2008; Man Ray with Man Ray Trust, Paris/VG Bild-Kunst, Bonn 2008; August Sander with Photograph. Samml./SK Stiftung Kultur–A. Sander Archiv, Cologne/VG Bild-Kunst, Bonn 2008; Albert Renger-Patzsch with Albert Renger-Patzsch Archiv/Ann and Jürgen Wilde/VG Bild-Kunst, Bonn 2008; Andreas Gursky, Courtesy: Monika Sprüth/Philomene Magers/VG Bild-Kunst, Bonn 2008

Lee Friedlander, Garry Winogrand with Fraenkel Gallery, New York

Robert Doisneau, Willy Ronis with laif agentur für photos & reportagen gmbh, Cologne

Wolfgang Tillmans, Courtesy Galerie Buchholz, Cologne

Prestel Verlag
Königinstraße 9
80539 Munich
Tel. +49 (0)89 242 908-300
Fax +49 (0)89 242 908-335

Prestel Publishing Ltd.
4 Bloomsbury Place
London WC1A 2QA
Tel. +44 (0) 20 7323-5004
Fax +44 (0) 20 7636-8004

Prestel Publishing
900 Broadway. Suite 603
New York, N.Y. 10003
Tel. +1 (212) 995-2720
Fax +1 (212) 995-2733

www.prestel.com

The Library of Congress Control Number: 2008924898

British Library Cataloguing-in-Publication Data: a catalogue record for this book is available from the British Library. The Deutsche Bibliothek holds a record of this publication in the Deutsche Nationalbibliografie; detailed bibliographical data can be found under: http://dnb.ddb.de

Project management by Claudia Stäuble and Andrea Weißenbach
Translated from the German by John Gabriel, Worpswede
Copy-edited by Chris Murray, Crewe
Cover and design by LIQUID, Agentur für Gestaltung, Augsburg
Layout and production by zwischenschritt, Rainald Schwarz, Munich
Picture research by Peter Stepan, Andrea Weißenbach
Timeline by Andrea Weißenbach
Origination by ReproLine Mediateam
Printed and bound by Druckerei Uhl GmbH & Co. KG, Radolfzell

Printed in Germany on acid-free paper

ISBN 978-3-7913-4018-0

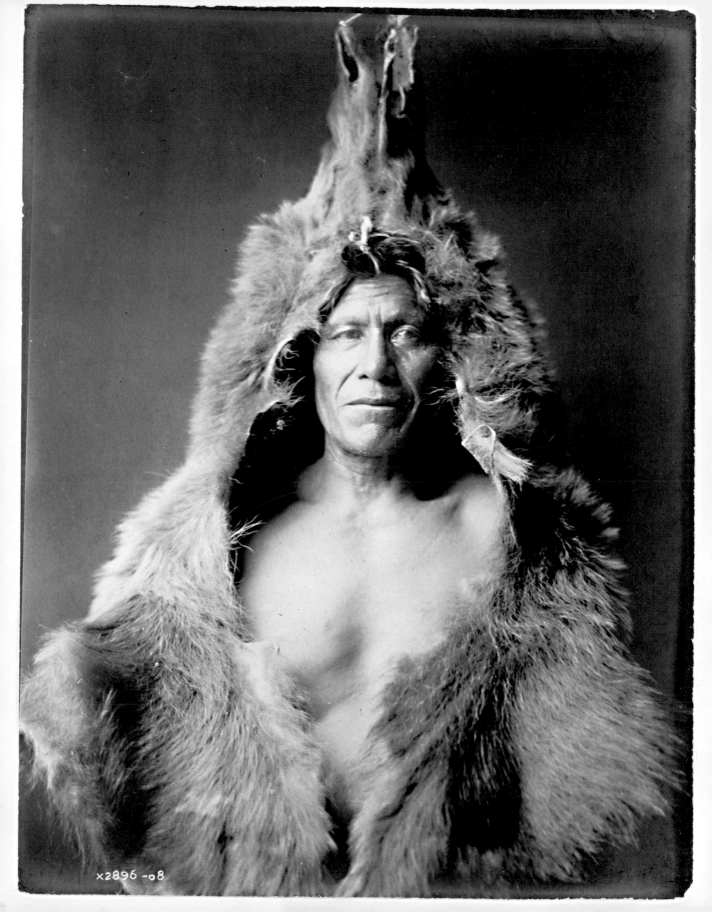

X2896-08

CONTENTS

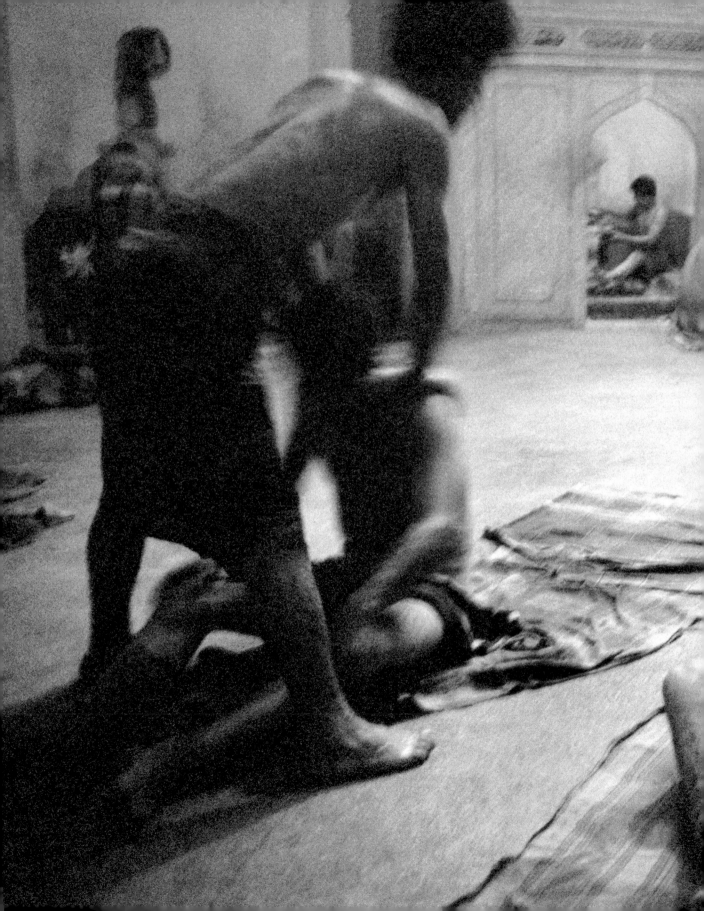

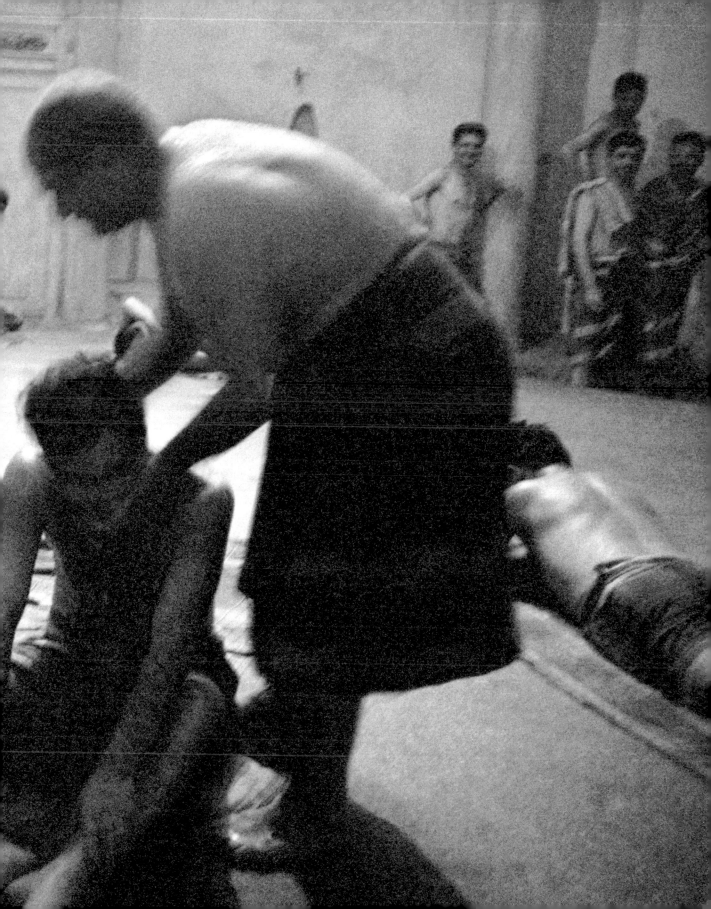

RENDERING THE VISIBLE TO MAKE IT VISIBLE

Photographers are magicians of time; their cameras are magical instruments, with which they arrest the flow of time. They outsmart Chronos, the devouring god, snatching away a fraction of a second and granting it permanence. If you want to take on the gods, you have to be armed with powerful technology: with subtle mechanisms (such as the camera shutter) and highly polished lenses. The photographer may be the master of sophisticated chemical processes, or may take a wooden box with a hole and a lens, and cover a glass plate with photosensitive emulsion. This was how the 19th-century pioneers worked, and some photography purists who are appalled by all this new technology still do so today.

The magician of light is richly rewarded, for a glimpse into a gap in time provides more than a mere fragmentary impression. It may seem paradoxical, but the best in their field succeed in making a greater statement about the subject of a portrait, about the world of objects, about an urban or rural landscape, than an in-depth and long-term study can. The data captured in a microsecond will suffice. But how many films have been used up by photographers in order to produce one or two outstanding images! Of the hundreds of thousands of exposures made in the whole long life of a photographer, only a few dozen photographic masterpieces often survive. Photography is a battle with materials, with an uncertain outcome: Chronos can have his revenge on the photographer.

To equate a photograph with "reality" is, as we know, naïve. And yet some photographs seem to come very close to what we might call reality. Does the boldly captured fraction of a second perhaps grant us a glimpse "behind the mirror," into the mechanics of the world? Can frozen movement provide unexpected insights? Do the mists disperse, the veils lift? Perhaps we can come closer to a truth, or encounter a "lie" that nevertheless opens our eyes for a moment to a truth.

Fleeting moments want to be courted and invited like divas; one must lie in wait for them, patiently awaiting the moment they grant their favors, their acts of graciousness. If we try to impose our own wills upon them, we can be sure that they will suddenly escape our grasp. All the great photographers have had their personal formulas for taking hold of the Achilles heel of their profession, that unaccountable, unknown moment of chance. As Willy Ronis said: "I don't arrange, I deal with chance." And Robert Doisneau: "I always keep my foot a little in the door, to let chance come in, pilfer something, or bring something I hadn't thought of." Henri Cartier-Bresson is considered the master of the accidental. Inspired by André Breton and the Surrealists, with whom he was on friendly terms, he thought exhaustively about the principle of the accidental. Photography could not be planned, he said, one must simply let it happen. Easier said than done...

Photography is a child of the industrial era. It was invented during an era when time was being codified in Europe as a linear concept. A temporality perceived in other cultures and eras as a continuum was now divided into a before, now, and after. The concept of past, present and future became a basic mental pattern, hardly to be questioned any more. At the same time, history was becoming enthroned as a science. From then on, one was reliant upon falling "out of time" if one wanted to evade this temporal construct. Many poets, composers and artists made this exhilarating discovery—and photographers too were among them.

It was in the 19th century too that the time clock was invented (according to Lewis Mumford, the time clock, and not the steam engine, was "the most important machine of the industrial age"). Time clock and camera—even though exposure times were at first still measured in hours and minutes—have one thing in common—they fix the moment: the one as a procedure for monitoring individuals, the other to stop the flow of time in visual terms. Beyond this, what both technologies have in common is not only the focus on the moment, but also the temptation to manipulate. In the service of political propaganda, photographs were being falsified long before Photoshop was invented. And officials and employees who were dismissed for manipulation of the time clock are legion. Precise measurement of time was also a precondition of worldwide navigation (as it is today of satellite navigation with the use of atomic timing devices), and thus the basis of colonialism and Western hegemony. To be in command of time is to have power.

Photography is the pleasure of making time come to a stop. The perpetuum mobile of our existence pauses for a brief moment. No face, even in repose, is totally motionless. Our cheeks swell in the up and down of the beat of our pulse and breath, our eyelids twitch, our facial expressions subtly alter … A face held motionless on silver gelatin paper radically confounds our perception and triumphs over time and ageing.

The portrait—apparently a simple matter to manage—is perhaps the most difficult of photographic genres. Although portraiture, like all areas of photography, is today a mass product, over 170 years of photographic history the number of outstanding portraits has remained limited. The masters of this genre include Nadar, August Sander, Gisèle Freund, Diane Arbus, Richard Avedon, and Bert Stern. Each of these found an individual way to approach his or her subjects. Good portraits have always been a question of the interaction between photographer and model. The charisma of the model reacts to the charisma of the photographer, and in the most favorable cases the effect has been reciprocal.

Much thought has been devoted to the nature of the portrait, and much has been written about it. Perhaps it was Diane Arbus who made the most perceptive comment, when she observed a fault line between intention and effect in the self-perception of the person portrayed: "Everybody has that thing where they need to look one way but they come out looking another way and that's what people observe." It is at this point of distortion in our self-image that her rigorous photographic gaze came into play. Arbus used the portrait as a window into the "examination of reality," so that what has long been visible should be perceived.

Not every photographer starts off with a desire to question our image of the world. The temptation to do homage to captivating surfaces in artistic images has made many famous. Photographers have celebrated the splendor of the landscape, the dignity and charm of human beings, the wonders of the animal and plant world. Their lenses have peered into unknown expanses of the microcosm, and telescopes that for a long time have not worked with visible light and celluloid have enabled us to discover ever more distant stars. As early as the 19th century, many photographers fed the image-hungry business of state, industry, and technology, serving as faithful helpers towards the "survey" of the world. But just as poets reflect the language, the sound and color of words, and fathom their associative and metaphorical components, the artists of photography were above all concerned with actual artistic techniques. They were self-confident masters of light and form, surfaces and masses, melody and rhythm. And this at a time when they were considered to be skilled craftspeople and placed no value on being respected as artists. Perhaps this was the real golden age of photography.

1808 b. Honoré Daumier, French printmaker,
caricaturist, painter, sculptor

1821 b. Charles-Pierre Baudelaire, French poet

1848 French Revolution

1853–1870 Hauss-
mann's renov
tion of Paris

1855 Expo in Pari

1770 1775 1780 1785 1790 1795 1800 1805 1810 1815 1820 1825 1830 1835 1840 1845 1850 1855

Pierrot Opening an Envelope
(Charles Debureau), 1884/55

1860 1865 1870 1875 1880 1885 1890 1895 1900 1905 1910 1915 1920 1925 1930 1935 1940 1945

FÉLIX NADAR

Nadar was a Leonardo of photography, capturing the world from above in his own tethered balloon, and the catacombs and sewers of Paris from below, as possessor of a patent for artificial-light photography. He was a well-known journalist, novelist, and caricaturist before his photographic studio brought him fame. An ardent republican, Nadar portrayed the greats of the era, and garnered gold medal after gold medal at the World's Fairs.

Nadar was one of the most creative, original and daring artists and entrepreneurs of the 19th century. When he was a young man, his socialist sympathies caused him to be placed under police surveillance. He fought duels when honor demanded, and was likely befriended with more writers and artists than anyone else at the time. Nadar nursed the dying Charles Baudelaire, who called him "the most astonishing expression of vitality," and hosted the Impressionists' first exhibition on his premises. Nadar supported the old and impoverished Honoré Daumier by helping to organize a show of his works. It was Daumier who made the famous caricature of the aviation pioneer in his balloon, "raising photography to the altitude of art" (1862). Nadar operated a private balloon called "Le Géant" (The Giant), and in face of the impending French defeat

by the Prussians in 1870 he and his friends established a "Company of Military Balloon Aviators" to conduct aerial reconnaissance.

After taking up photography in 1854, not a year passed before Nadar produced now legendary photographs: the experiments with electrophysiological facial distortions conducted by Dr. Duchenne de Boulogne (with Nadar's brother, Adrien Tournachon, as co-photographer), and portraits of the great mime Charles Debureau, who reinterpreted the Commedia dell'Arte role of Pierrot. Nadar had hired Debureau for a series of "expressive heads" to promote his new studio. These pictures by the brothers—collectively billed as "Nadar jeune"—won a First Class medal at the 1855 Paris World's Fair. Yet sadly a quarrel over rights ensued between Félix and Adrien that would occupy the courts for a long time.

The name Nadar stood above all for high quality portraiture. His *Panthéon Nadar* immortalized the intellectual greats of the day: artists such as Doré, Daumier, Delacroix, Millet, Daubigny, Courbet, Manet, Monet, and Rodin; authors such as George Sand, Marceline Desbordes-Valmore, Charles Baudelaire, Dumas, and Hugo; and composers such as Hector Berlioz, Rossini, Offenbach, and Verdi. Many of these portraits have since become canonical records of their sitters' appearance. The straightforward yet monumental style of the portraits, the way they bring out the sitters' intellect and charisma, not to mention humor, and underplay their attire and surroundings, made Nadar famous. These were portraits of artists by an artist.

Gioacchino Rossini, 1856

1820 Born Gaspard Félix Tournachon,
in Paris, France
1837 Starts medical studies in Lyon
and Paris, but abandons them
due to a lack of the required
leaving certificate
1838 Begins to contribute articles to
newspapers and journals under
the pseudonym "Nadar"
1842 Publishes one of his first novellas
1846 His caricatures begin to appear in
Le Corsaire-Satan and *La
Silhouette*, followed by *Journal du
dimanche, Voleur, Charivari, La
Revue comique à l'usage des gens
sérieux*, and *Journal pour rire*
1854 Takes up photography; his
Panthéon Nadar proves a great
success
1855 Wins gold medal at the Paris
World's Fair, for photographs of
Charles Debureau as a mime,
made in collaboration with his
brother, Adrien; years of litigation with Adrien follow
1857 Takes first aerial photographs
1861 Takes out a patent on photography by artificial light
1862 Photographs the catacombs of
Paris
1886 Takes first "photo interview" in
history, with the 100-year-old
chemist Eugène Chevreul, for
L'Illustration
1900 Publishes his memoirs
1910 Dies in Paris

FURTHER READING
Nadar. Les années créatrices: 1854–60,
exh. cat. Paris and New York, 1994–1995
James H. Rubin, *Nadar*, London and
New York, 2001

below
Catacombs of Paris, Crypt 8, 1861/62

right
Young Model, 1861/62

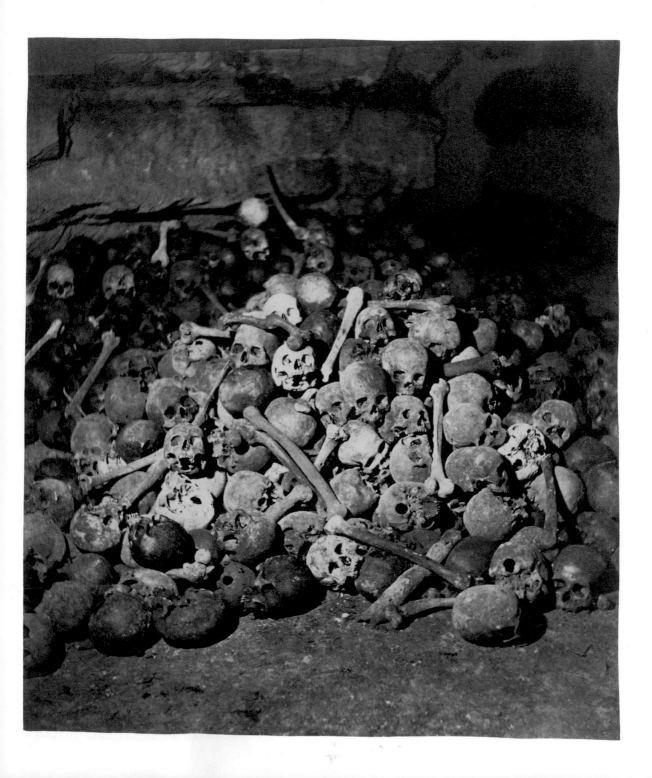

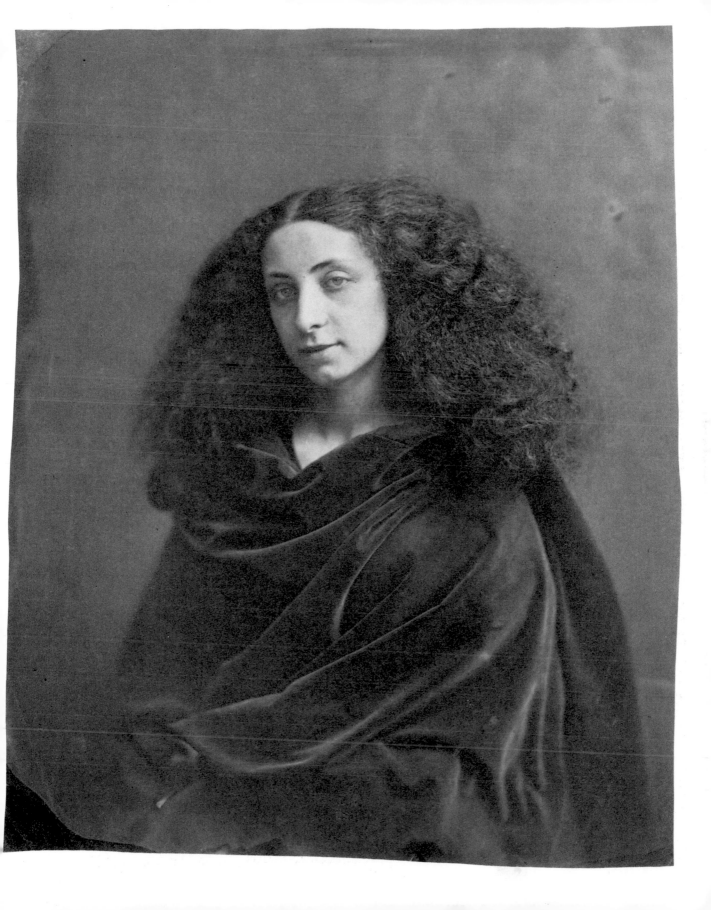

1833 b. Alfred Nobel, Swedish
chemist and innovator

1830 Trail of Tears

1846–1848 Mexican-American War

1853–1856 The
Crimean War

1848 *The Communist Manifesto*
(Karl Marx, Friedrich Engels

1775 1780 1785 1790 1795 1800 1805 1810 1815 1820 1825 1830 1835 1840 1845 1850 1855 1860

61 Abraham Lincoln becomes
 President of the USA
1861–1865 American Civil War
 1866 Civil Rights Act

1879 Thomas Edison demonstrates incandescent
 lighting to the public for the first time

1865 1870 1875 1880 1885 1890 1895 1900 1905 1910 1915 1920 1925 1930 1935 1940 1945 1950

MATHEW BRADY

The name Brady stands for a Hall of Fame of celebrated Americans of the 19th century. Even though he seldom stood behind a camera himself, Brady was the brilliant impresario of a project that for the first time in history conveyed the glories and horrors of the battlefield to audiences far from the scene.

Although the Englishman Roger Fenton had already sent pictures from the front lines—in the Crimean War—a few years previously, neither his nor Brady's Civil War images represented war photography as we now know it. Due to long exposure times and complicated chemical processes, Brady was hardly ever able to capture a battle in progress. He recorded the before and after phases, but when the bullets began to fly, the medium of photography—barely a quarter century after its invention—was still too slow. Brady's archive contains pictures of forts, trenches, cannon and mortars, arsenals and covered wagon parks. We see the armored ships and side-wheel steamers of the Federal Navy, but not the battles they fought in the harbors and at sea. Instead, there is portrait after portrait of groups and individuals: the battalions and crews on deck, the officers, generals, and, finally, President Abraham Lincoln visiting the troops. Hardly has the infantry marched in with fixed bayonets when the men lie dead on the ground. These are the most harrowing images of all—the bodies of Confederate and Union troops littering the battlefields of Antietam, Maryland, and Gettysburg, Pennsylvania. And then the bombed and shelled Richmond, Virginia. This was the seat of the Confederate high command, who shortly before abandoning it blew up the powder stores, devastating the center of town. Not until the uprising of the Paris Commune in 1871 would such ghostly ruins be photographed again.

The Scotsman Alexander Gardner (1821–1882), originally business manager of Brady's Washington branch, worked for him only during the first year of the War of Secession. After a quarrel over the rights to his pictures, he set up shop on his own. Gardner's work as Photographer to the Army of the Potomac culminated in 1866 with a two-volume documentation, *Gardner's Photographic Sketch Book of the War*. Nearly half of its photographs were actually taken by Timothy O'Sullivan (ca. 1840–1882), a former apprentice in Brady's studio, who entered Gardner's employ in 1862–1863.

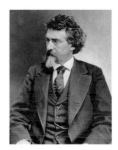

1823 Born in Warren County, New York; the artist William Page will introduce the young man to art
1844 The Daguerrian Miniature Gallery in New York opens; Brady's photographs of famous personalities become a period Hall of Fame
1851 Wins the Grand Prize at the London World's Fair at Crystal Palace
CA. 1855 The damp collodion process introduced
1858 Opens his own gallery in Washington, DC, managed by Alexander Gardner
APRIL 1861 Outbreak of the American Civil War
1862–1863 Breaks with Gardner
1864 Moves his New York gallery to Broadway, but soon goes bankrupt
1865 End of the Civil War
1875 Congress grants $25,000 to pay for Brady's glass negatives
1896 Dies in New York

FURTHER READING
George Sullivan, *In the Wake of Battle: The Civil War Images of Mathew Brady*, Munich, Berlin, London, New York, 2004

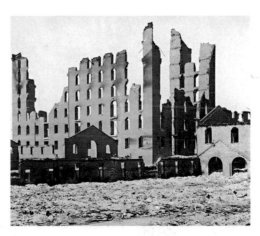

left page
Charleston Harbor, South Carolina, Deck and Officers of USS Monitor Catskill. Photographer unidentified

left
Destroyed Buildings, Richmond, Virginia, 1865. Photographer unidentified

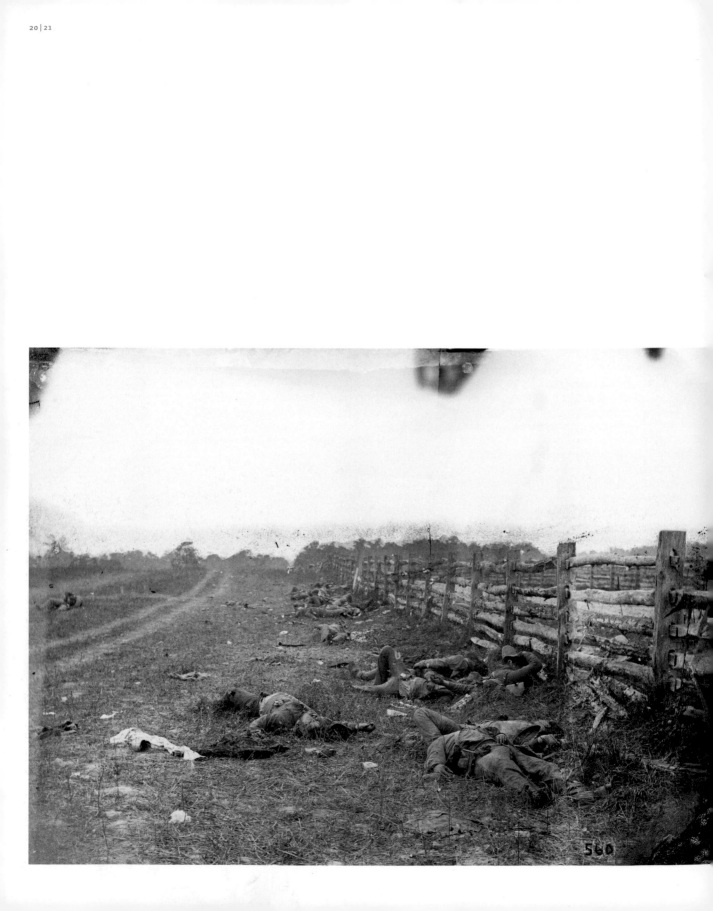

560

left
Confederate dead on the Hagerstown
Road, Antietam, Maryland, September
1862. Photographer Alexander Gardner

below
Ruins of Railroad Bridge, Harper's Ferry,
West Virginia, September-October 1862.
Photographer C.O. Bostwick

HERMANN KRONE

1800 Great Britain passes the Act of Union to join
Great Britain and Ireland into the United Kingdom

1805 Battle of Trafalgar

1809 b. Charles Darwin, English naturalist

1829 Greek Independence from the Ottoman Empire

1833 b. Edward Burne-Jones, English artist

1833 The British Parliament passes the
Slavery Abolition Act

1837 Victoria I. becomes Queen
of the United Kingdom

| 1765 | 1770 | 1775 | 1780 | 1785 | 1790 | 1795 | 1800 | 1805 | 1810 | 1815 | 1820 | 1825 | 1830 | 1835 | 1840 | 1845 | 1850 |

1842 The Treaty of Nanking

1848 Opening of the first Ger-
man National Assembly in
Frankfurt, Germany

1867 *Das Kapital* (Karl Marx)

1855　1860　1865　1870　1875　1880　1885　1890　1895　1900　1905　1910　1915　1920　1925　1930　1935　1940

JULIA MARGARET CAMERON

She photographed three women as if they had just stepped out of the New Testament—mothers like Madonnas, with charming children, stylized into allegories of love, faith, and charity. If these scenes had been no more than visual aids to religious edification, the first great woman in the history of photography would have been long forgotten. It was the aesthetic quality of her works that assured Julia Margaret Cameron of lasting fame.

It was not until the age of 48, and after raising six children, that Cameron took up photography. Back then this was still a laborious activity, involving cumbersome apparatus, glass plates, and difficult chemical processes. Viewing commercial visiting-card portraits as "vulgar, leveling, and literal," Cameron suffused her portraits of relatives or illustrious friends with an aura of piety. A scene with a sleeping child and adults became Christ's birth in Bethlehem; two women with a lily became an Annunciation. She called a girl with billowing hair, taken in profile, *The Angel at the Tomb*. The model, as so often, was Cameron's maid, Mary Hillier. Yet Cameron made no attempt to re-create scenes from the Holy Land historically, with the aid of props or oriental costumes. It was her unconventionally familiar, indeed intimate, treatment of her soberly dressed models that infused her idyllic images with poetry.

Over a third of Cameron's photographs are portraits of women—earnestly gazing from heavy-lidded, soulful eyes as if yearning for a land of beauty. They have the sultry melancholy of the figures of Edward Burne-Jones and Dante Gabriel Rossetti, to whom Cameron made a present of 40 of her pictures. And like the Pre-Raphaelites, she was fascinated by Italian Renaissance art. The titles of her pictures of women with children were themselves a pure homage to Raphael: *La Madonna Adolorata*, *La Madonna della Ricordanza*, *La Madonna Aspettante*. A portrait of a lady with a musical instrument was inspired by Raphael's *St. Cecilia* in Bologna; the portraits of women holding lilies were reminiscent of Perugino or Francia. Yet Cameron also alluded to ancient mythology: her portraits of little Freddy Gould became *The Young Astyanax* (1866) or *The Young Endymion* (1873).

In 1875, Cameron illustrated *Idylls of the King and Other Poems* by Alfred Lord Tennyson, the popular Victorian poet and her sometime neighbor on the Isle of Wight. Unlike her religious subjects, she now resorted to elaborate costumes and settings to evoke the legend of King Arthur, around which Tennyson's poems revolved. Sir Lancelot in chain mail, Queen Guinevere, Vivien and Merlin stepped out to face the audience, as if on stage. As Cameron once described her credo, "My aspirations are to ennoble Photography and to secure for it the character and uses of High Art by combining the Real and Ideal and sacrificing nothing of the Truth by all possible devotion to Poetry and Beauty."

Cameron also created a series of significant portraits, her sitters including the astronomer John F.W. Herschel, Henry Taylor, Thomas Carlyle, Gustave Doré, William Holman Hunt, and Charles Darwin. In a space of only 15 years she produced an extensive photographic oeuvre, of which over 1,200 images have survived.

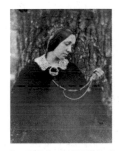

1815 Born in Calcutta, British India; her father is an employee of the East India Company

1818–1834 Makes numerous visits to Europe, especially France, where she receives a large part of her education

1842 Sees her first photographs, which had been sent to Calcutta by John Herschel

1848 She and her husband, an owner of coffee and rubber plantations in Ceylon (now Sri Lanka), move to England

1864 Takes up photography, and becomes a member of the Photographic Societies of London and Scotland

1865 Exhibitions of her works in London, Berlin and Dublin; a number are acquired by the South Kensington Museum

1874 Publication of Tennyson's *Idylls of the King*, with thirteen photographic illustrations by Cameron

1875 She and her husband move to Kalutara, in northwestern Ceylon (Sri Lanka), where she takes only a few more photographs, of domestic servants and plantation workers

1879 Dies in Ceylon (Sri Lanka)

FURTHER READING
Julian Cox and Colin Ford, *Julia Margaret Cameron: The Complete Photographs*, London 2003

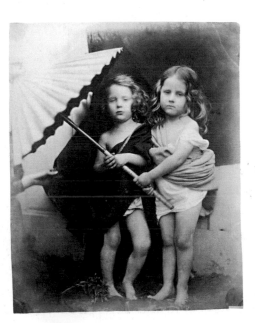

left page
Cupid

left
Paul and Virginia

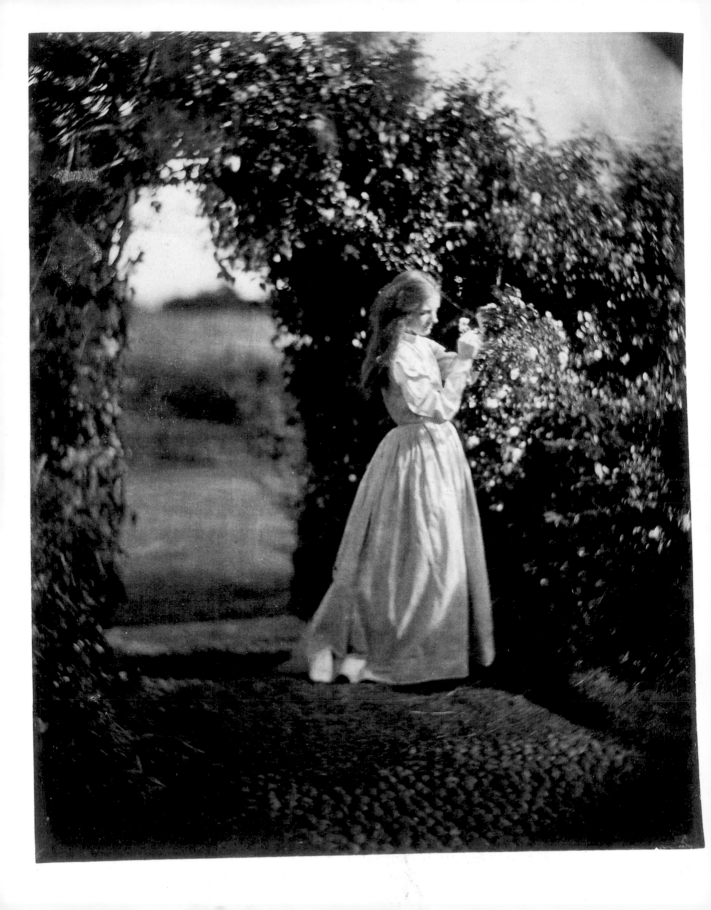

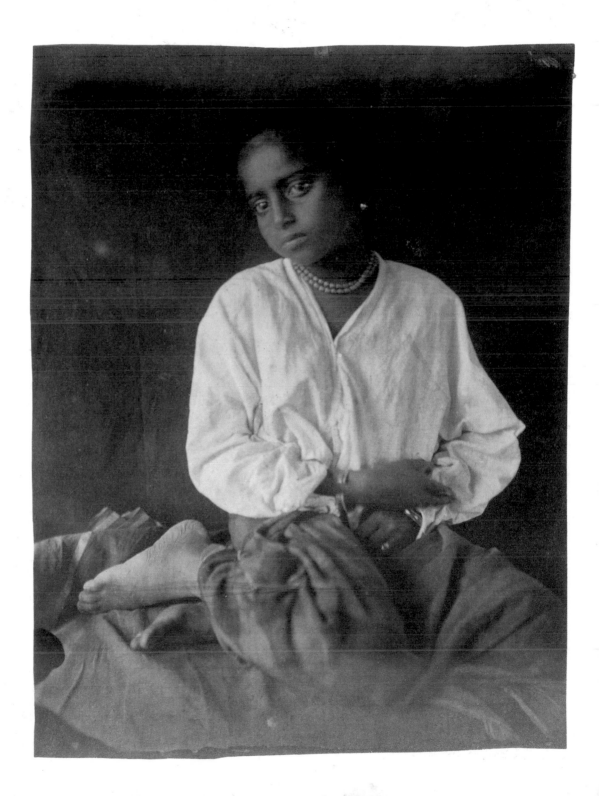

FELICE BEATO

OTTOMAR ANSCHÜTZ

MATHEW BRADY

1824 Beethoven's 9th Symphony
is first performed in Vienna

1848–1849 Start of the
California Gold Rush

1861–1865 American Civil Wa

| 1780 | 1785 | 1790 | 1795 | 1800 | 1805 | 1810 | 1815 | 1820 | 1825 | 1830 | 1835 | 1840 | 1845 | 1850 | 1855 | 1860 | 1865 |

Jumping Over a Boy's Back (Leapfrog)

| 1870 | 1875 | 1880 | 1885 | 1890 | 1895 | 1900 | 1905 | 1910 | 1915 | 1920 | 1925 | 1930 | 1935 | 1940 | 1945 | 1950 | 1955 |

EADWEARD JAMES MUYBRIDGE

A jack-of-all-trades, Muybridge made panoramic photographs 26 feet long of San Francisco, was the first to photograph a solar eclipse, and invented a precursor of the film projector. But his greatest coup was photographic proof that, at full gallop, all four of a horse's hooves briefly lose contact with the ground. With photographs of animals and people in motion, Muybridge opened a new dimension for photography.

It was on a one-month expedition to the Yosemite Valley in California, then still a god-forsaken area, that Muybridge first drew attention to himself. One commentator praised his pictures, "taken from points of view not heretofore used ... climbing to the best points of sight with his camera, often with great difficulty and danger ... 800 pictures, some of which present effects beyond any heretofore taken." These Yosemite pictures marked the beginning of Muybridge's career as a government photographer. One of their much-praised features seems almost banal today: skies full of fluffy clouds combined with a detailed landscape foreground. Muybridge frequently employed the montage technique, permitting him to manipulate landscape photographs such that, for instance, they appeared to have been taken by moonlight.

His major achievement, however, required more than a few darkroom tricks. In order to record a horse in full gallop, an exposure time of less than 1/1000 second was necessary. How was this to be done in an epoch when glass plates still had to be exposed in a wet collodion process for at least ten seconds, if not several minutes? Muybridge, with John D. Isaacs, worked untiringly on improving shutters and light-sensitive emulsions, and in 1877 finally succeeding in making a few instantaneous photographs of the horse Occident in full canter. To his contemporaries, this seemed as sensational as breaking the sound barrier would decades later. In consequence, Muybridge envisioned recording the sequential movements of animals, and later of human beings, with the aid of entire batteries of cameras—first 12, then 24—and sophisticated systems of electrical contacts. The experiments consumed great sums of money, initially provided by Muybridge's patrons, former Governor Stanford, and later the University of Pennsylvania. In 1887, his legendary work *Animal Locomotion* appeared. According to an announcement, the 781 phototypes in 11 volumes contained "more than 20,000 figures of men,

women, and children, animals and birds, actively engaged in walking, galloping, flying, working, jumping, fighting ... which illustrate motion or the play of muscles." This encyclopedia remains a must for physiologists and visual people, a feast for the eye.

Muybridge's inventiveness knew no bounds. In a letter to the editor of 1882, he was the first to suggest the idea of photographing the finishes of horse races in order to exclude judges' errors.

1830 Born in Kingston-on-Thames, England
1852 Gold rush in California; Muybridge leaves for America; begins commercial activities
BEFORE 1867 Learns photography from Carleton E. Watkins (1829–1916) and becomes his business partner; takes photographs of Yosemite Valley, marketed under the title *Helios, the Flying Camera*
1868 Named Director of Photographic Surveys by the US government; documents unsettled regions on the West Coast, in Wyoming, Montana, and later Alaska
1873 Documents the white settlers' war against the Modoc Native Americans in northern California
1874 Muybridge shoots dead a lover of his wife's, who has a child from him; acquitted 1876
1876 Takes photographs in Mexico, Guatemala, and Panama
1877 Takes panoramic photographs of San Francisco; first instantaneous photographs of the horse Occident at full trot
1878 Applies for a patent for the methods and apparatus to photograph objects in motion
1879 Takes his first instantaneous photographs of people in motion; lecture tours in Europe
1884 Begins photography series in collaboration with a committee from the University of Pennsylvania
1887 *Animal Locomotion: An electro-photographic investigation of consecutive phases of animal movement*, 781 phototypes in 11 volumes
1899 *Animals in Motion*
1901 *The Human Figure in Motion*
1904 Dies in Kingston-on-Thames, England

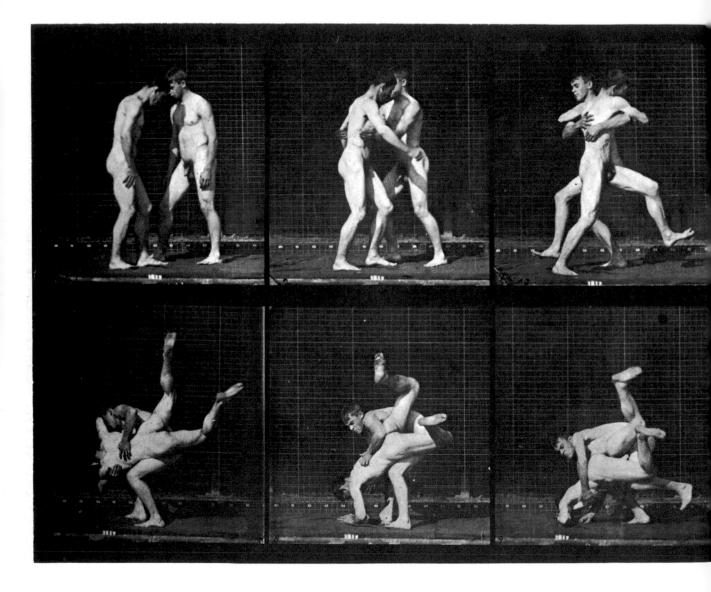

Wrestling, Graeco-Roman

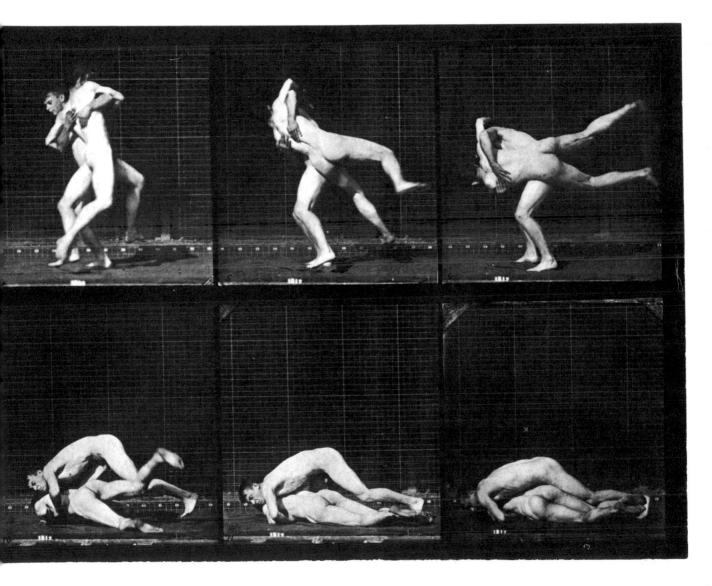

1853–1856 Crimean War

1838–1842 First Opium War in China

1856–1860 Second Opium War

1857 Indian Rebellion

1785　1790　1795　1800　1805　1810　1815　1820　1825　1830　1835　1840　1845　1850　1855　1860　1865　1870

Sumo Wrestler

1867 End of the Late
Tokugawa shogu-
nate in Japan

1895 Wilhelm Röntgen discovers
a type of radiation later
known as X-rays

1894 Tower Bridge in London opened for traffic

1905 Bertha von Suttner awarded Nobel Peace Prize

1908 Child Emperor Pu Yi ascends the
Chinese throne at the age of two

1875 1880 1885 1890 1895 1900 1905 1910 1915 1920 1925 1930 1935 1940 1945 1950 1955 1960

FELICE BEATO

A 19th-century Robert Capa, Felice Beato recorded the Crimean War, the sites of the Indian Mutiny, the battle-fields of the second Opium War in China, and the American war in Korea. Widely traveled, he also took the earliest photographs of architectural monuments in Palestine, India, China, and Japan.

His reputation was established by pictures from Crimea, "photographic views and panoramas" of the Indian Mutiny, and of architecture in cities such as Lucknow, Cawnpore, Delhi, Agra, Benares and the province of Punjab. Not to forget the bone-strewn site of the British massacre at Lucknow (1857). In the last year of the Opium War, Beato was named official photographic reporter. With his shots of Taku In eastern China after it was taken by the English and French on 21 August, 1860, he provided—just a year before Brady's pictures of the American Civil War—a shocking scenario of colonial war: numerous dead bodies on the ramps and positions inside the North Fort. After the capture of Peking a few weeks later, Beato documented the stormed walls and gates, and produced multipartite panoramas of the bastions and the city. Seemingly even more significant in retrospect is his documentation of a great range of buildings, including royal palaces, temples, pago-das, gates and sepulchers, Lamaistic temples, and mosques. A major art historical record is Beato's image of the Imperial Summer Palace, torched by the British on 18 October in retribution for the killing of 20 British soldiers in Chinese custody.

Hardly had the Japanese harbor city of Yokohama been opened to Europeans when Beato and his part-ner established a photographic studio there. He pro-duced the period's finest views of Japan, including panoramas of the cities and harbors of Nagasaki and Yokohama. Beato began photographing Edo half a century before it became the new Japanese capital. He portrayed the Dutch and American legations, members of the European colony over tea, on Queen Victoria's birthday, at the races, rowing, and hunt-ing. In 1866, with the Dutch consul general, he climbed Fujiyama, but was unable to take pictures of the summit.

Incomparable are Beato's photographs of Japanese "native types," representatives of occupations and ordinary people of the kind you would meet on the street—from coolies and tattooed stable boys to itinerant priests, from fishmongers to saké purvey-ors. Especially picturesque are the Kando fencers and the Samurai warriors, whose heyday had passed with the onset of the Meiji period. One of the four Japanese painters who tinted Beato's prints is also portrayed, wearing eyeglasses and with brush at the ready. Then there are the everyday scenes, a doctor with his patient, views of an antique shop, officers drinking tea. In genre pictures, Beato captured women applying makeup, and geishas smoking opi-um or playing music. It was especially Europeans who lived in Japan or were traveling through who bought such pictures from Beato. In 1868 he collect-ed them in a two-volume work, *Photographic Views of Japan.*

CA. 1834 Born in Venice, Italy

1855 Records the Crimean War, in col-laboration with his brother-in-law, James Robertson, followed by travels in Palestine with him

1860 Records the last year of the sec-ond Opium War in China; meets his future companion, Charles Wirgman, illustrator and reporter for the *Illustrated London News*

1861 By way of Henry Hering, publisher to the Queen, Beato offers nega-tives for sale in London, but with little success

1863 Arrives in Japan and, with Wirgman, opens the studio Beato & Wirgman, Artists & Photographers, in the foreigners' district of Yokohama (becoming sole proprietor in 1870)

1864 Documents the Shimonoseki Retribution Campaign

1866 Studio destroyed by fire

1868 His two-volume *Photographic Views of Japan... Compiled from Authentic Sources and Personal Observation During a Residence of Several Years*

1871 Photographs dead soldiers during the American campaign in Korea

1877 Sells his photographic studio, complete with negatives

1885 Records the British campaign in Sudan

1889 Opens a studio in Mandalay, Burma

1907–1908 Dies in Rangoon

FURTHER READING
David Harris, *Of Battle and Beauty: Felice Beato's Photographs of China,* exh. cat. Santa Barbara Museum of Art, 1999
Claudia G. Philipp et al. (eds.), *Felice Beato in Japan,* Heidelberg, 1991

below
Interior of the Secundra Bagh after the
Slaughter of 2,000 Rebels by the 93rd
Highlanders and 4th Punjab Regiment,
November 1857, Lucknow

right
Mosque Inside Asophoo Dowlah's
Emambara, Lucknow

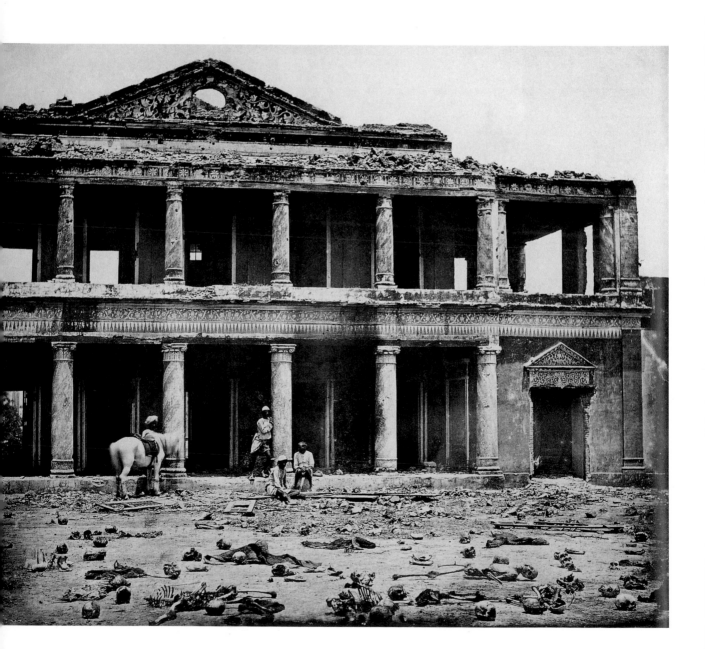

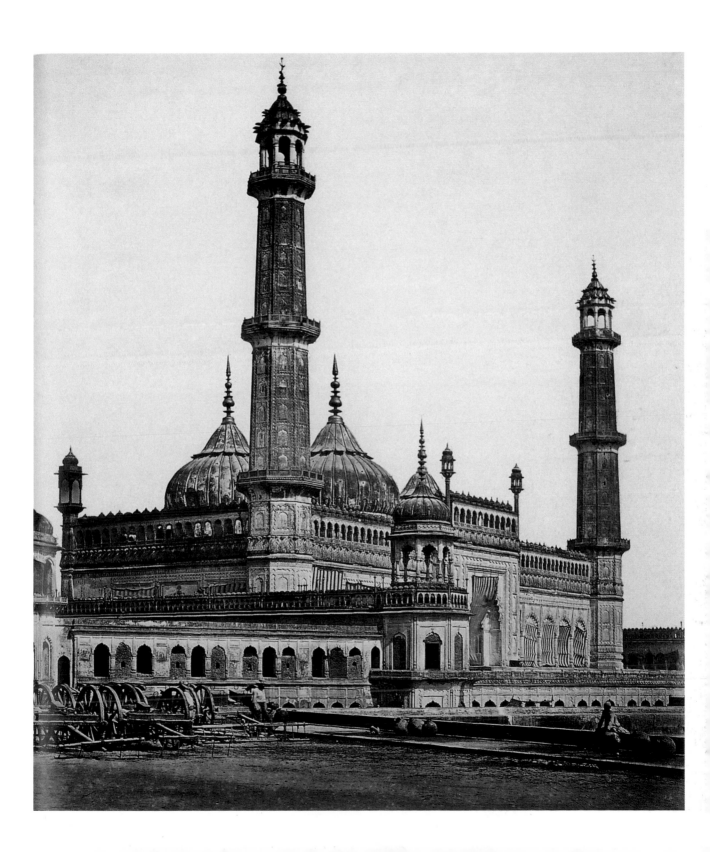

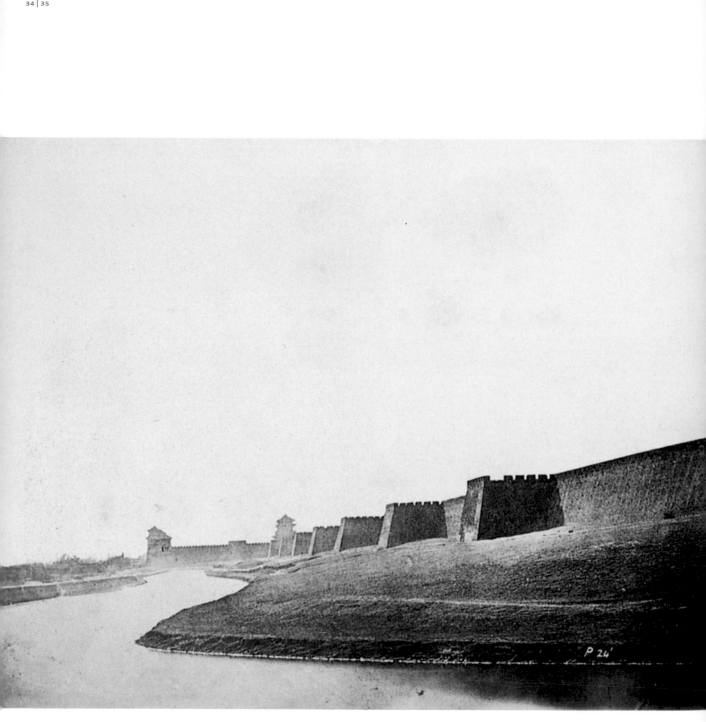

Northeast Corner of the City Wall of Peking

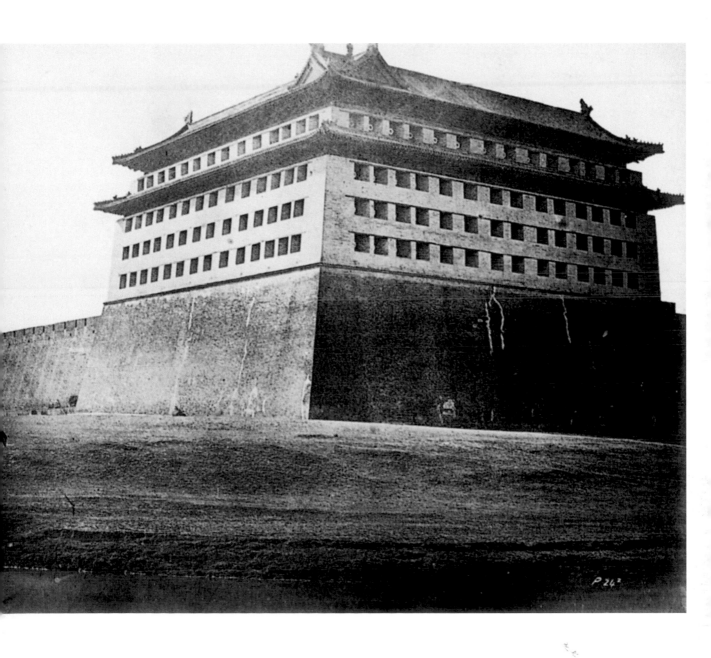

1840 b. Claude Monet, French painter

1871 German troops capture Paris

1814 *Fidelio* (Beethoven)

1841 b. Georges Clemenceau, French journalist and politician

1859 Second Italian War of Independence

1887–1889 Construction of the Eiffel Tower in Paris

1847 First exhibition of the French Impressionists

| 1805 | 1810 | 1815 | 1820 | 1825 | 1830 | 1835 | 1840 | 1845 | 1850 | 1855 | 1860 | 1865 | 1870 | 1875 | 1880 | 1885 | 1890 |

A Corner, Rue de Seine, May 1924

1895	1900	1905	1910	1915	1920	1925	1930	1935	1940	1945	1950	1955	1960	1965	1970	1975	1980

EUGÈNE ATGET

Eugène Atget was a seaman and actor before teaching himself how to use a camera. Initially made as aids to artists, later acquired by museums, libraries, and art schools, Atget's photographs—about 10,000 views of Paris and rural environs, made over the course of almost 40 years—amount to the most extensive and coherent archive of Old Paris and Old France in existence.

His views of villages and Paris in the early modern period were neither official nor representative. Picturesque farmsteads and village squares, old wells and wisteria climbing flaking house walls apparently interested him more than imposing façades. A freshly plowed field, a bare tree, a street flanked by windowless walls—such subjects were more to Atget's taste. Without artfully composing what he saw or charging it with atmosphere, he let things be as they were. And were it not for the sonorous sepia that suffuses the old prints with a nostalgic mood, many of his works might figure as textbook examples of "straight photography." It was things and places—houses, streets, plants that intrigued him, and his pictures rarely show human life directly. Atget went out very early in the morning, or used such long exposure times that chance passersby vanished from the image, or appear as ghost-like smudges.

Atget's Paris is a metropolis of sun-drenched courtyards and lanes, old bridges, and barges silently passing by. For the Bibliothèque Historique de la Ville de Paris and the Bibliothèque Nationale—his most important patrons—the École des Beaux Arts, the Union des Arts Décoratifs, and the Victoria and Albert Museum, he recorded city blocks, buildings, elegant interiors, and stairwells, or architectural details such as portals, door knockers, even the details of a stucco decoration. Other series of works were devoted to wrought-iron grilles and balustrades, or the popular signs over the entrances to bistros. The Paris of the grand boulevards was not Atget's Paris.

Unlike many other photographers' work, Atget's shows barely any stylistic change, being apparently immune to current fashions. At most, one or the other courtyard picture might seem to contain an echo of concurrent Cubism, or a photograph like *Porte de Bercy, sortie du PLM* (1913) to exhibit a Constructivist bent. The displays in the Paris shop windows he recorded would be unthinkable without the "retour à l'ordre" of the 1920s or the Surrealist mystique of objects. Man Ray indeed reproduced four of these images in *La Révolution surrealiste* (1926).

The documentary photographs were supplemented with pictures of representatives of the "petits métiers" —a door-to-door lampshade salesman, a baker, a postman, a hurdy-gurdy man accompanied by a singer. In Versailles, Atget captured women waiting for customers outside a brothel. And then there is his picture of asphalt workers (1899–1900), which spirits us back for a moment into the social reality of France over a century ago.

FURTHER READING
Eugène Atget: 1857-1927, ed. Museum of Modern Art, New York,, 1981 (4 vols.)

left
La Villette, Rue Asselin, 19th Arrondissement, prostitute taking a break, 7 March 1921

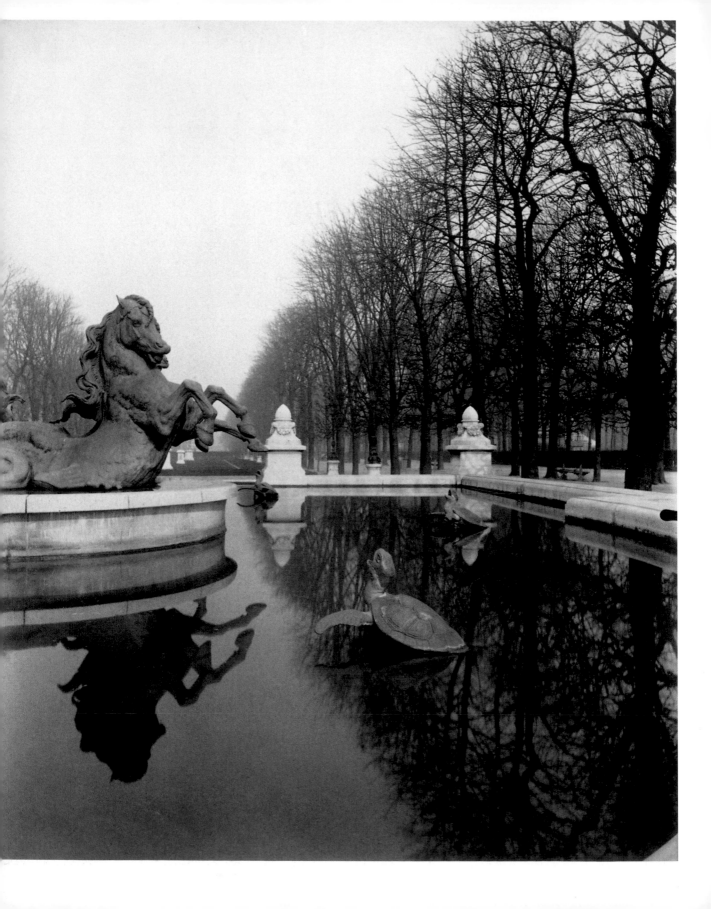

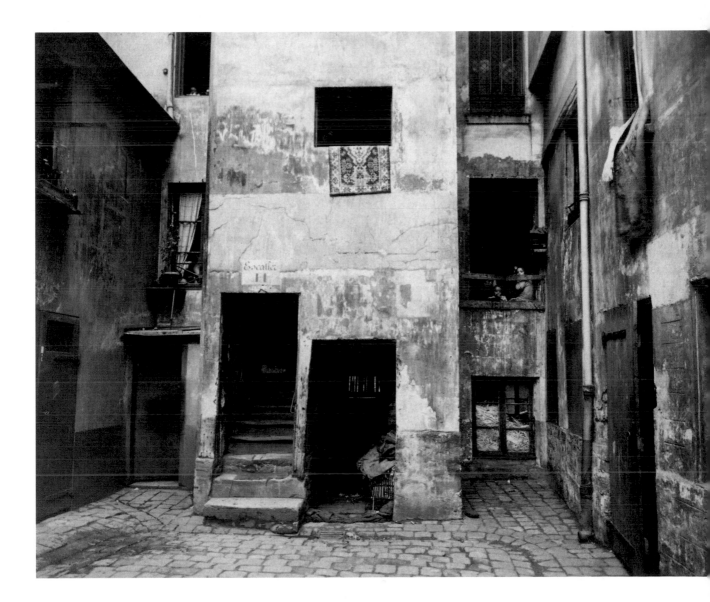

FRED HOLLAND DAY

ERNEST JAMES BELLOCQ

JOSEPH TURNER KEILEY

1890 End of Indian Wars
in the USA

1831 b. Sitting Bull, a Hunkpapa Lakota Sioux
chief and holy man

1876 Battle of
Little Bighorn

1890 The Wounded Knee Massacre

1886 Karl Benz patents the first success
gasoline-driven automobile

| 1815 | 1820 | 1825 | 1830 | 1835 | 1840 | 1845 | 1850 | 1855 | 1860 | 1865 | 1870 | 1875 | 1880 | 1885 | 1890 | 1895 | 1900 |

Four Hopi Women at Top
of Adobe Steps, New Mexico,
ca. 1906

1939–1945 World War II

1933 Adolf Hitler comes to power

1903 Henry Ford founds the
Ford Motor Company

1948 Universal Declaration of Human Rights
before UN General Assembly

1905 1910 1915 1920 1925 1930 1935 1940 1945 1950 1955 1960 1965 1970 1975 1980 1985 1990

EDWARD SHERIFF CURTIS

Curtis projected an alternative image to the policy of eliminating or demeaning Native Americans. He showed the descendants of the country's original inhabitants in all their dignity, as individual, often charismatic personalities. Beyond this, Curtis collected valuable ethnographic information, including sound recordings of their songs and music made with an Edison Cylinder.

Curtis followed in the footsteps of the great painter of Native Americans George Catlin, who, after beginning to visit indigenous tribes in 1832, spent many years recording their religious rites and hunting expeditions, and making individual portraits. His famous "Gallery of the Indians" was widely exhibited in North America and Europe. After that, it was a new invention, photography, with which the demise of the old ways was increasingly recorded. From the end of the Civil War in 1865 to Wounded Knee, the final conflict between Native Americans and Europeans in 1890, most photographs of tribes were taken during visits of delegations to Washington and in connection with large geographic and geological surveys conducted in the 1860s and 1870s. Various "shadow catchers" provided newspaper images and photographic shows on the East Coast.

By the time Edward S. Curtis began to capture "the face of the Indians," their rich culture was long a thing of the past. The majority lived on reservations, wore European clothing, and had abandoned their old customs. Still, Curtis made one last, unprecedented attempt to paint a grand panorama of Native American life. He devoted 30 years to this monumental project, publishing it from 1907 to 1930 in 20 volumes under the title *The North American Indian*.

From the deserts of Mexico to Alaska, he visited over 80 ethnic groups west of the Mississippi, to record their daily life, religious rites, and leading personalities. Fishing and hunting scenes, women at their cooking, pot-making or weaving, and a range of artistic artifacts—innumerable facets of the lives of children, adolescents and adults were reflected in Curtis's imagery. The charm of the exotic, especially the elaborate traditional costumes on which earlier artists and photographers had focused, made way for an interest in the individual character of faces. Many pictures nevertheless seem to reflect an attempt to revive earlier, lost customs.

1868 Born in Whitewater, Wisconsin
1885 Becomes a photography apprentice in St Paul, Minnesota
1887 Family moves to Seattle, Washington; becomes joint proprietor of a photographic studio; co-founder of Curtis and Guptil
1895 First portrait of a Native American: Princess Angeline aka Kickisomlo, daughter of Chief Sealth
1896 Moves to Seattle
1898 Invited by the anthropologist George Bird Grinnell to join an expedition to the Blackfeet in Montana (1900)
1906 Enters contract with John Pierpont Morgan for a 20-volume work, *The North American Indian*; up to 1930 he creates 40,000 images of more than 80 ethnic groups
1907 First volume of *The North American Indian*, "written, illustrated, and published by Edward S. Curtis," with a foreword by Theodore Roosevelt
1911–1912 Slide show, *The Indian Picture Opera*
1915 Book and film, *Indian Days of the Long Ago*
1922 Opens studio in Los Angeles; works as still photographer and second cameraman in Hollywood studios
1924 Sells rights to his film *In the Land of the Head-Hunters* to the American Museum of Natural History
1927 Travels to Alaska
1928 Sells book rights to the son of J.P. Morgan
1930 The 20th and final volume of *The North American Indian* published
1952 Dies in Los Angeles

left
At the old well of Acoma, 1904

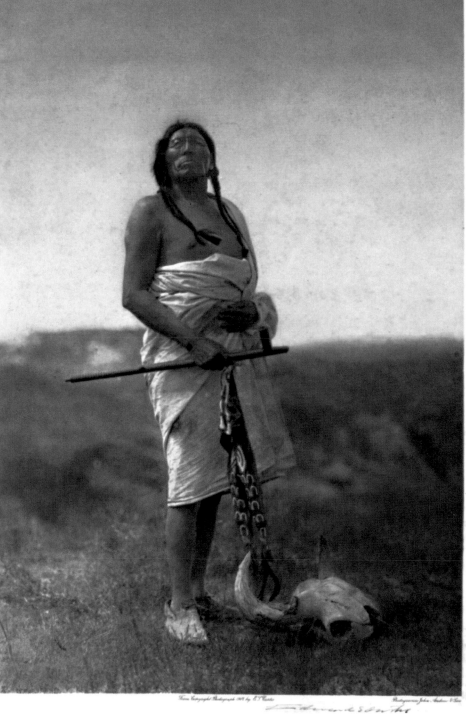

left
The Medicine Man (Slow Bull), ca. 1907

right
Black Eagle-Assiniboin, ca. 1908

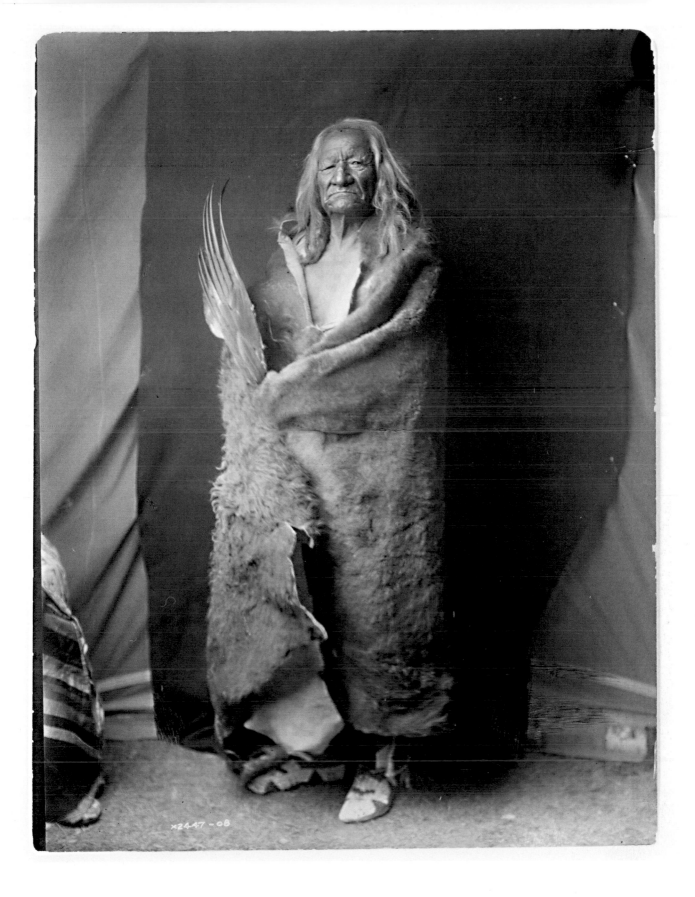

X2447-08

EDWARD STEICHEN

HENRY GOODWIN

1883 Opening of the Metropolitan
Opera in New York

1887 b. Georgia O'Keeffe, American Ar

1893 World's Columbian Expo
sition in Chicago

| 1815 | 1820 | 1825 | 1830 | 1835 | 1840 | 1845 | 1850 | 1855 | 1860 | 1865 | 1870 | 1875 | 1880 | 1885 | 1890 | 1895 | 1900 |

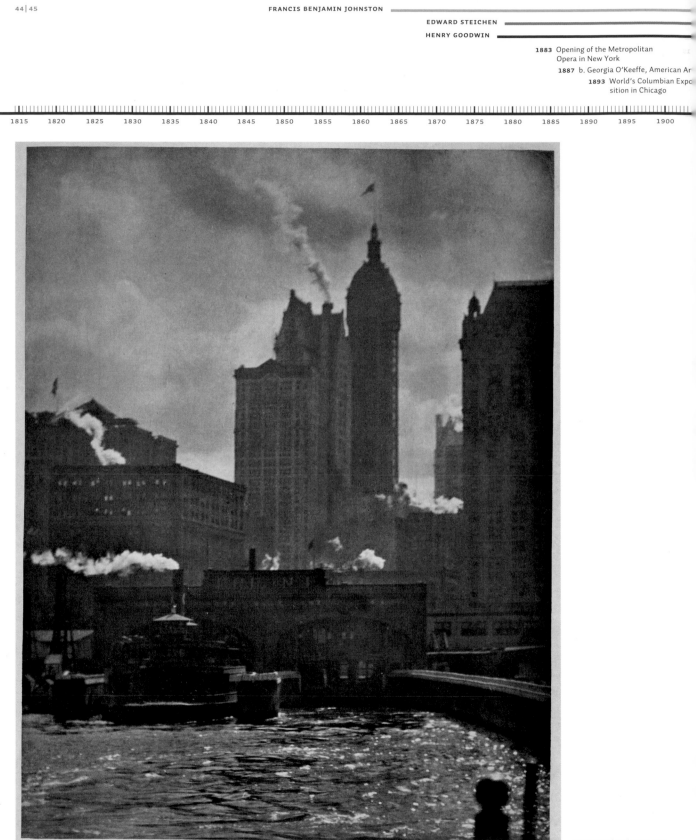

The City of Ambition, 1910

1901 Theodore Roosevelt becomes
President of the USA

1940 *The Great Dictator* (Charlie Chaplin)

1933 Adolf Hitler comes to power

1914–1918 World War I

1939–1945 World War II

1913 Armory Show

1945 Atom bombs dropped on Hiroshima and Nagasaki

1905 1910 1915 1920 1925 1930 1935 1940 1945 1950 1955 1960 1965 1970 1975 1980 1985 1990

ALFRED STIEGLITZ

The photographer and gallery owner Alfred Stieglitz played a major role in introducing modernism to the United States, and in making photography accepted as an art form there decades before anywhere else. In his later years, he focused his camera increasingly on the artist Georgia O'Keeffe, producing a photographic homage to his companion like none before or since.

Stieglitz belonged to the generation of photographers who thought their art was greatly underestimated. By means of literary subject matter, a picturesque, atmospheric style, and elaborate printing techniques, he and his friends attempted to rival painting. Stieglitz's great pioneering act was the founding of the journal *Camera Work*, a forum for avant-garde photography from 1903 to 1917, and at the same time also a window on modern European art. Great care was devoted to reproducing the photographs, in heliogravure on Japan paper, prints that Stieglitz and his friend and co-photographer Edward Steichen viewed as original graphic works. Despite occasionally overly symbolic titles, such as *The Hand of Man* (1903), the Stieglitz images published in *Camera Work* were surprisingly modern: locomotives surrounded by power lines against an urban backdrop, New York street scenes with horse-drawn carriages, crowded ferries. The city in snow or rain, clouds of steam pouring from ships' stacks and chimneys, held a special attraction for him. With his epoch-making photograph *The Steerage* (1907), Stieglitz finally said farewell to atmospheric impressionism.

When in 1905 his friend Steichen moved to a larger apartment, making his previous one at 291 Fifth Avenue available, the success story of Stieglitz's Little Galleries of the Photo Secession, later known simply as "291," began. An ad of the time promised "Permanent Exhibitions (November-April) of Pictorial Photographs—American, Viennese, German, French, British—as well as of modern art not necessarily photographic …"

The culmination of Stieglitz's work came in the 1920s with *Equivalents*, studies of a horizonless sky over Lake George with clouds appearing in ever-changing formations and textures. Here his penchant for painterly effects was subsumed in a form in which the individual image became a variation in an extended sequence of formal studies. Synesthesia provided inspiration: Stieglitz called the first results *Music–A Sequence of Ten Cloud Photographs*. Lake George would become the site of his photographic homage to Georgia O'Keeffe. Between 1917 and 1936 Stieglitz took about 350 pictures of his lover, a collection ranging from intimate, highly stylized portraits to images of her hands and nude studies. When a selection of the latter was shown for the first time in 1921, it touched off a storm of indignation.

1864 Born 1 January, in Hoboken, New Jersey, USA
1881 His father and family move to Karlsruhe, Germany
1883 Buys a camera, and travels extensively through Europe
1885 Wins first prize from the London magazine *Amateur Photographer* for a photograph taken in Italy
1890 Returns to New York
1891 Becomes a member of the Society of Amateur Photographers, New York
1893–1896 Contributor to, and later editor of, *American Amateur Photographer*
1894 Becomes a member of the Linked Ring, England
1897–1902 Contributor to, and editor of, *Camera Notes*, for the Camera Club of New York
1902 Founds the Photo Secession, New York, which will last until 1910
1903 Becomes editor of the journal *Camera Work*, which will be published until 1917
1905 First exhibition at the "291" gallery
1924 Marries Georgia O'Keeffe, whom he had first met in 1916
1925–1929 Runs the Intimate Gallery
1929–1946 Runs the An American Place gallery
1946 Dies 13 July, in New York

FURTHER READING
Alfred Stieglitz: Photographs and Writings, Washington, 1983

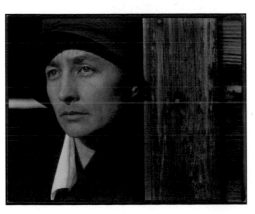

left
Georgia O'Keeffe, 1922

above
Robert Brown, Alfred Stieglitz, 1939

1840 b. Auguste Rodin, French sculptor

1899 *The Interpretation of Dreams*
(Sigmund Freud)

1914–1918 Worl
War I

| 1830 | 1835 | 1840 | 1845 | 1850 | 1855 | 1860 | 1865 | 1870 | 1875 | 1880 | 1885 | 1890 | 1895 | 1900 | 1905 | 1910 | 1915 |

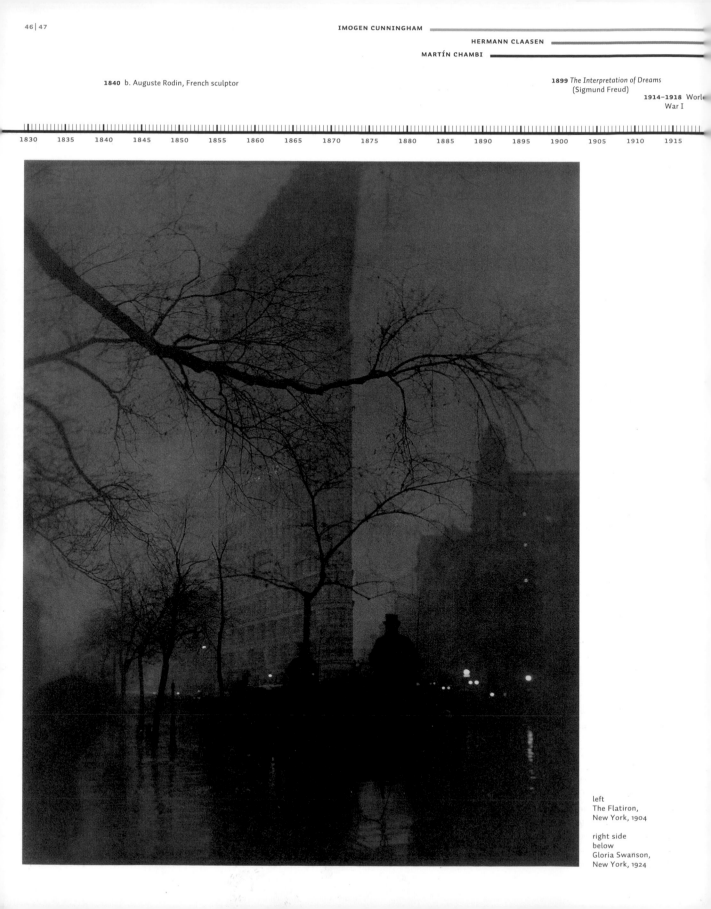

left
The Flatiron,
New York, 1904

right side
below
Gloria Swanson,
New York, 1924

1947 India gains independence
from the British Empire **1962** Cuban Missile Crisis

1929 Wall Street Crash crash

1938 Kristallnacht (pogrom
in Nazi Germany) **1948** Mahatma Gandhi is murdered

1952 *Waiting for Godot* (Samuel Beckett)

1920 1925 1930 1935 1940 1945 1950 1955 1960 1965 1970 1975 1980 1985 1990 1995 2000 2005

EDWARD STEICHEN

Edward Steichen was a man of many gifts, combative and one of the most celebrated if controversial photographers of his time. Successful as a representative of Pictorialism, he was as much at home in aerial photography, society portraits, fashion and advertising, as head photographer for Condé Nast, and as exhibition curator.

Born in Luxembourg and later equally at home in New York and Paris, Steichen for years practiced photography alongside painting, attempting to fuse the two fields in his turn-of-the-century Pictorialism. Favorite subjects were stretches of forest, whose semi-darkness invoked the mystical realm of Symbolism; portraits of famous artists and poets such as Rodin, Mucha, and Maeterlinck; and female nudes. Like somnambulist nymphs, these figures seemed to spring from the spirit of Gustave Doré. Steichen masterfully contrasted large areas of black with brightly illuminated passages. His 1906 *Storm in the Garden of the Gods*, taken in Colorado, calls up memories of the Swiss artist Arnold Böcklin.

The quarterly *Camera Work*, edited by his friend Alfred Steiglitz from 1903, became a stage for Steichen as for no other photographer: three issues and a supplementary volume were devoted to his work. With great inventiveness, Steichen attempted to expand the painterly potentials of the medium, using such techniques as carbon, platinum and gumbichromate printing, or combinations of these. He also experimented in color photography. Steichen's art photography culminated in his images of Rodin's statue *Balzac*, in which the bronze figure of the poet appears like an epiphany in a dramatically evocative twilight.

The changeover in his work came with the First World War, when in 1917 Steichen suggested to the Air Force that a department of aerial photography be established to clarify details in military maps and record the battlefields and destruction on the Western Front. In the rank of colonel, he provided shocking images of devastated villages and landscapes effaced by bomb craters. The demand for "sharp, clear images" would open his eyes to the unsentimental objectivity that came to the fore in the 1920s. To that point still a successful society portraitist, Steichen abruptly ended his painting career in 1923 by piling up the remaining paintings in his studio and setting fire to them.

Over the next 15 years, Steichen experienced a meteoric rise as head photographer at *Vogue* and *Vanity Fair*. After having produced the first fashion photographs in history worthy of the name, for *Art et Décoration* in 1911, his images now became style-shaping. Innumerable works for the day's leading couturiers and fashion designers followed. When he was advised not to risk his reputation as an art photographer and to publish these pictures anonymously, Steichen made a point of signing them. Nor did he reject lucrative advertising jobs or think himself too good for wallpaper designs or object photographs such as cigarette lighters. Many colleagues looked on such things as a betrayal of the ideals of photography; to him, they represented an expansion of his repertoire. In the meantime, the line outside his portrait studio grew ever longer. The rich, beautiful and famous had themselves portrayed by "America's foremost photographer," avid to "get steichenized," as the phrase then was. In 1938, Steichen withdrew from commercial photography for good.

1879 Born in Bivange, Grand Duchy of Luxembourg
1881 Family moves to the USA
1894–1898 Studies painting at the Art Students' League, Milwaukee; apprenticed in a lithographic printing office
1895 Begins to take photographs in the Pictorialist style
1902 Founding member of Photo Secession, New York; long-term stay in Paris and travels in Europe
1903, 1906, 1913 Issues 2, 42, 43 and a supplementary volume of the magazine *Camera Work* are dedicated to Steichen
1917–1918 As colonel in the American Expeditionary Forces, he works as director of a department of aerial photography in western Europe
FROM 1922 Active as head photographer for Condé Nast (*Vanity Fair*, *Vogue*)
1923 Burns the paintings in his possession
1940S Acts as Director of the Naval Photographic Institute; documents the war in the Pacific
1942 Exhibition *Road to Victory*, The Museum of Modern Art, New York
1945 Exhibition *Power in the Pacific*, The Museum of Modern Art
1945 *U.S. Navy War Photographs. Pearl Harbor to Tokyo Bay* (with Tom Maloney)
1947 Appointed director of the Department of Photography, The Museum of Modern Art
1955 Exhibition *Family of Man*, The Museum of Modern Art
1973 Dies in West Redding, Connecticut

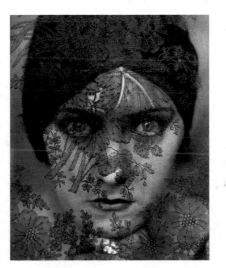

above
Carl Björncrantz, Edward Steichen, 1900

He was over 60 when the United States—not uncontroversially—entered the Second World War. With an eye to marshalling domestic support for the war in the Pacific, Steichen was commissioned to mount a propaganda exhibition, *Road to Victory*, shown in 1942 at the Museum of Modern Art, followed in 1945 by *Power in the Pacific*. His book *U.S. Navy War Photographs: Pearl Harbor to Tokyo Bay*, with Tom Maloney as author, became a million-seller.

Named director of the Department of Photography at the Museum of Modern Art, Steichen would mount a total of 46 shows over the next 15 years, including the legendary *Family of Man*. After its New York premiere in 1955, the show traveled around the world for years and attracted over nine million visitors. During the Cold War, weary of the "beastiality and brutality of war," Steichen recommended that people recall the experiences shared by all humanity. Only in hindsight has it become clear that the *Family of Man*, like some photographic campaign, included a glorification of the American Way of Life.

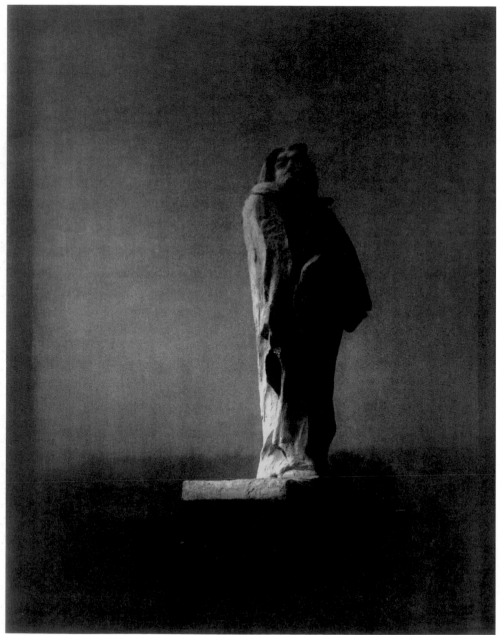

left
The Open Sky, II: P.M.–Rodin's
"Balzac," Meudon, 1908

right
George Washington Bridge,
New York, 1931

JACOB A. RIIS ═══════════════════════════════

FRANK EUGENE ═══════════════════════════════

FRED HOLLAND DAY ═══════════════════════════════

1869–1883 Construction of the Brooklyn Bridge

1825 1830 1835 1840 1845 1850 1855 1860 1865 1870 1875 1880 1885 1890 1895 1900 1905 1910

below
Workmen eating lunch on the 69th floor
of the GE Building during the con-
struction of Rockefeller Center, New
York, 1932

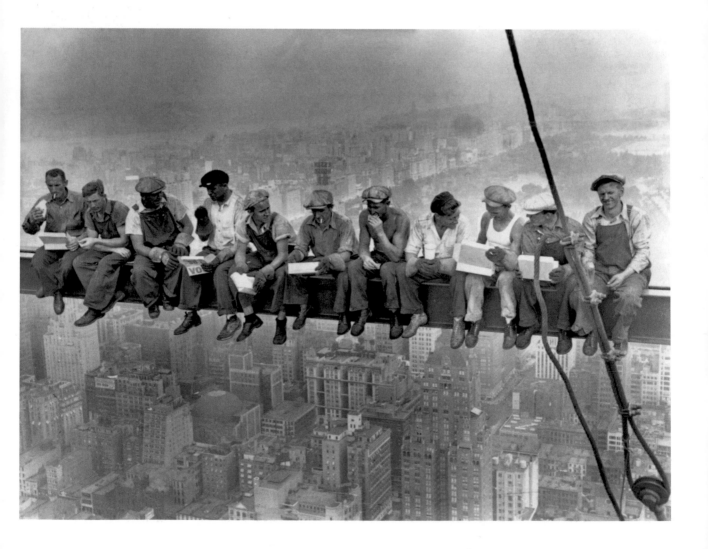

1949 Foundation of the SOS Children's Villages

1929 Wall Street Crash crash **1950–1953** Korean War

1912 b. Jackson Pollock, American painter
1931 Completion of the Empire State Building
1962 Cuban Missile Crisis

1933 Franklin D. Roosevelt becomes President of the USA

1914–1918 World War I
1939–1945 World War II

1915 1920 1925 1930 1935 1940 1945 1950 1955 1960 1965 1970 1975 1980 1985 1990 1995 2000

LEWIS W. HINE

Though one of the fathers of investigative photojournalism, Hine's significance in the field was not recognized until decades after his death. He is best known for his moving portraits of immigrants on Ellis Island, and shocking pictures of child workers in American spinning mills and coal mines. And just 20 years ago an archive from the final months of the First World War came to light.

"Yes, I want to learn, but can't when I work all the time." These are the words of a 12-year-old who never learned to read, photographed by Hine in 1909 in a cotton mill in Columbia, South Carolina, where the child had already been working for four years. Children labored there as sweepers or back-ropers, repairing torn threads or changing empty spools. Many had no shoes. When inspectors came, the foreman would say, "he just happened in," or "he's helping his sister." In fact the exploitation of child labor was part of the system. Of 40 employees of a mill in Newton, ten were under age. In textile factories in Dallas and Tifton, Hine came across 20 or more child laborers, and dozens in Lancaster—many of them obviously under ten. Textile manufacturing was not the only field that relied on cheap labor. Hine found child workers in coal mines, canning factories, and glass-blowing companies, and he photographed them as newsboys, shoe shiners, cigar makers, fruit pickers, shrimp shellers. And there were armies of children working morning to night in cottage industries, making doll's dresses, lace, and artificial flowers, or cracking nuts for years on end. Many disadvantaged families, especially immigrants, earned a meager living this way.

Having himself become a factory worker at 18 due to his father's early death—putting in 13-hour days six days a week—Hine spent his life combating child labor, publishing and tirelessly lecturing. An associate then full member of the National Child Labor Committee (NCLC), he published in magazines such as the liberal *Survey*, in newspapers, on posters, and in committee publications that urged Congress to enforce existing laws and improve the protection of children. Hine's "photo stories" were a milestone in the development of photojournalism, which emerged as we now know it only in the 1920s. In 1909 alone, Hine traveled through Georgia, Connecticut, the New England states, Maryland, New Jersey, and North Carolina to visit factories. Some-

times he assumed the identity of a fire protection official or insurance agent in order to gain access. Not seldom was he shown the door.

Towards the end of World War I, Hine went to Europe and photographed war refugees for the American Red Cross and soldiers in French hospitals. He visited ravaged areas in Italy, Greece, and Serbia, then continued his documentation in Belgium and North France. Only a few of these images, movingly attesting to people's will to survive in great need, were published at the time. It was not until the late 1980s that they were finally identified in the Library of Congress, Washington, DC.

Years followed in which, despite professional successes (including the New York Art Directors Club Medal for *The Engineer*), Hine had trouble keeping his head above water, leading him to accept the offer to photograph the construction of the Empire State Building (1930). His pictures of steelworkers balancing at dizzying heights over the city became legendary. Thereafter Hine resumed his unwearying pursuit of social documentary themes.

1874 Born in Oshkosh, Wisconsin, USA
1892 Graduates from high school
1892–1900 After his father's fatal accident, works in various jobs
1901 Attends teaching college, then works as an assistant science and geography teacher at the Ethical Culture School, New York
1903 Takes up photography; a series on immigrants on Ellis Island
1906 Begins freelance work for National Child Labor Committee (NCLC)
1907 Documents cottage labor in New York tenements for NCLC; studies sociology at Columbia University
1908 Takes a post at NCLC; works for the New York State Immigrant Commission
1913–1914 Serves as head of the exhibition department at NCLC
1918 Transfers to the American Red Cross; in spring and summer, documents French hospitals, in November in Italy and the Balkans
1919 Takes photographs of northern France and Belgium
1921–1929 Again active for the NCLC; works for industrial corporations
1930 Documents the construction of the Empire State Building
1931 Records the drought in Kentucky and Arkansas for the Red Cross
1932 *Men at Work*, an illustrated book for young people
1939 Retrospective in New York, Des Moines, and Albany
1940 Dies in Hastings-on-Hudson

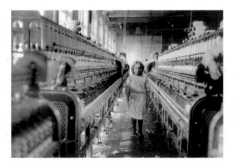

left
The Overseer Said Apologetically, "She just happened in." Newberry, South Carolina, Dec. 1908

PAUL CITROEN

MAURICE TABARD

1905/07 Die Brücke and Der Blaue
Reiter artist's associations
founded

1825 1830 1835 1840 1845 1850 1855 1860 1865 1870 1875 1880 1885 1890 1895 1900 1905 1910

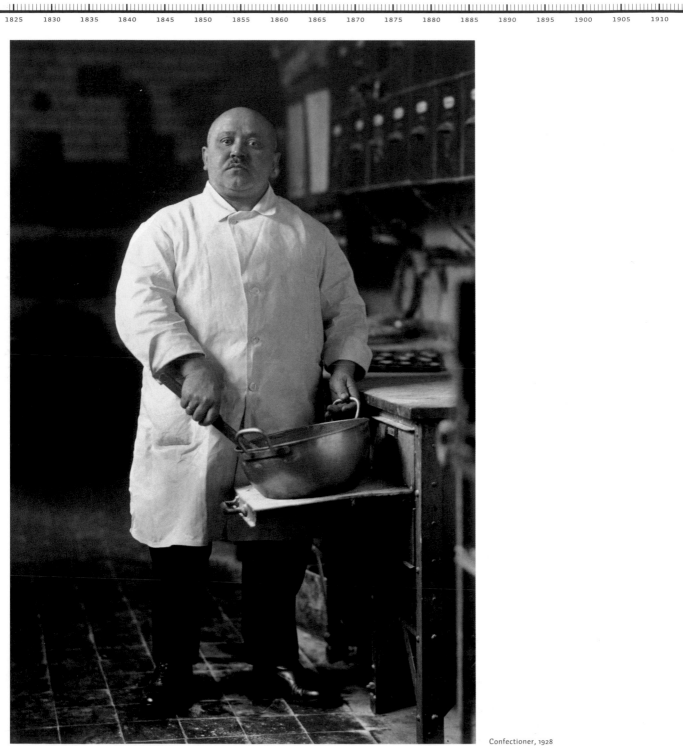

Confectioner, 1928

1914–1918 World War I

1922 Albert Einstein
awarded Nobel
Prize in Physics

1929 Wall Street Crash crash

1938 Kristallnacht (pogrom
in Nazi Germany)

1939 Germany invades Poland,
World War II commences

1948 Universal Declaration of Human Rights before UN General Assembly

1949 Konrad Adenauer becomes the first Chancellor of West Germany

1950 First photokina trade fair

1964 Vietnam War begins

1915 1920 1925 1930 1935 1940 1945 1950 1955 1960 1965 1970 1975 1980 1985 1990 1995 2000

AUGUST SANDER

Sander was still very young when he envisaged depicting "People of the 20th Century" in a systematic photographic overview arranged by origin and occupation. After an initial selection of 60 prints was published in 1929, he devoted years to completing his ambitious standard work, covering 500 to 600 "types." It would become a manifesto to an uncompromising fidelity to reality, humanism, and tolerance.

"The prints in the portfolio were made in the vicinity of my home region, the Westerwald. Due to their closeness to nature, people whose habits I had known from boyhood seemed suitable for realizing my idea of a genealogical portfolio. With this the beginning had been made, and I subordinated all of the types I found to a prototype that possessed all the qualities of the universally human," wrote Sander in 1954. As prototype he chose the small farmer, devoting to this occupation the genealogical portfolio and the first five of more than 45 portfolios. The work as a whole was divided into seven groups: "The Farmer," "The Artisan," "The Women," "The Estates," "The Artists," "The Big City," "The Last Men." Sander's categories in the so-called genealogical portfolio were based on a then-popular doctrine of temperaments, in which people were classified as "earthbound," "philosophical," "impetuous/revolutionary," or "wise." However, he did not pursue this in the portfolios that followed. Hardly any occupation, profession, or status in life was overlooked. Sander's encyclopedia ranged from confectioner, mason and gardener to industrialist and union member, from Dadaist to wholesale businessman, from mayor to asylum inhabitant, from widower to high school student ... He rarely supplemented the sitters' job description by their name; writers, artists and intellectuals were at first identified only by their initials, and only in the posthumous editions by their full name.
Sander always adapted his concept to changes in society. Thus he included Nazis, individuals persecuted by Nazism, foreign workers, and political prisoners in separate portfolios. One of the prisoners was his own son, Erich, a member of the Socialist Workers' Party of Germany who was then serving a ten-year sentence (he would die in prison in 1944). "Persecuted Jews" formed a group of their own in *Menschen des 20. Jahrhunderts*. The final portfolio brought together "Idiots, the Sick, Mentally Ill and the Dead," with portraits of, among others, a

"Cretin," blind people, midgets, and deceased people on biers. "We must be able to bear seeing the truth," Sander had written about his first exhibition, at the Cologne Art Association, then stated his credo as a photographer: "There is nothing I detest more than sugar-coated photography with its frills, poses and effects." Even the Nazi Chamber of Art got the message, and confiscated *The Face of the Times* and destroyed the printing plates.
Apart from his systematic completeness, Sander's individual portraits have a stringency and penetration that places them among the most significant works in the history of photography. They had a profound influence on many other masters, including Diane Arbus, Robert Häusser, and Richard Avedon. Sander also photographed landscapes, including those along the Rhine, made botanical studies, and created an architectural record of Cologne as it appeared before the war, as well as a documentation of the war-damaged city. Finally, he also carried out commissioned works for architects, artists, and industrial clients.

1876 Born in Herdorf (Sieg), Germany
1899–1901 Becomes assistant to an itinerant photographer, traveling through Magdeburg, Halle, Leipzig, Berlin and Dresden
1901 Employed at Atelier Greif, Linz, which he takes over the following year and renames "Sander and Stuckenberg," and of which he is sole proprietor from 1904 onward
1910 Moves to Cologne; begins taking portraits on a regular basis in the Westerwald
1927 Exhibition *Menschen des 20. Jahrhunderts* (People of the 20th Century), Kölnischer Kunstverein, Cologne
1929 *Antlitz der Zeit* (The Face of the Times) published by Transmare Verlag/Kurt Wolff Verlag, Munich, with a foreword by Alfred Döblin
1936 National Socialist Chamber of Art confiscate *Antlitz der Zeit*, the plates being destroyed
1946–1952 Selects photographs for *Köln wie es war* (Cologne as It Once Was)
1964 Dies in Cologne

FURTHER READING
Manfred Heiting and Susanne Lange, *August Sander, 1876–1964*, Cologne and London, 1999

LÁSZLÓ MOHOLY-NAGY

GEORGI PETRUSSOW

IWAN SCHAGIN

1912 *Concerning the Spiritual in Art*
(Wassily Kandinsky)

1913 *Black Square* (Kazimir Malevich)

1917 October Revolution
in Russia

1893 b. Vladimir Mayakovsky, Russian poet

1840　1845　1850　1855　1860　1865　1870　1875　1880　1885　1890　1895　1900　1905　1910　1915　1920　1925

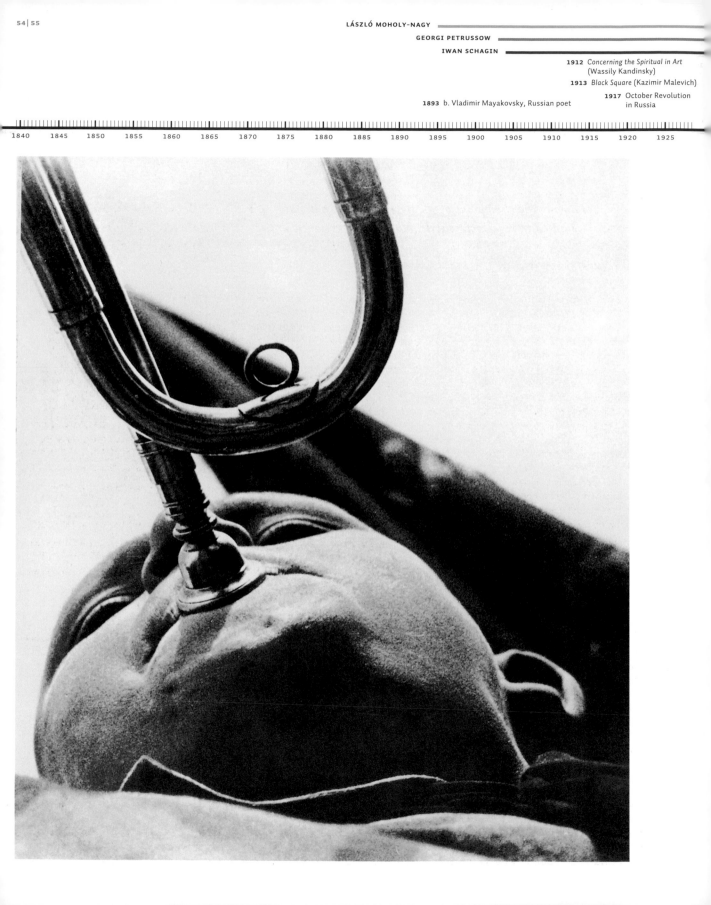

1918 Construction of the first Soviet Gulag
1940 Trotsky murdered in Mexico
1939–1945 World War II
1922 Josef Stalin becomes General Secretary of the Soviet Communist Party
1949 The Soviet Union commences its first atomic test
1925–1926 Construction of the Bauhaus in Dessau

1930 1935 1940 1945 1950 1955 1960 1965 1970 1975 1980 1985 1990 1995 2000 2005 2010 2015

ALEXANDER RODCHENKO

Rodchenko was among the champions of the new aesthetic that was propagated in the wake of the Russian Revolution. He painted in a geometric style, made photo-collages, and created Constructivist sculptures suspended from the ceiling. The vertiginous perspectives of his photographs became symbols of the intoxication with the future that pervaded Bolshevist Russia.

In the years following the overthrow of Czarist rule, the young USSR rapidly recapitulated the cultural innovations that had been denied to the country for centuries. Never did the future seem more promising than in 1920s Moscow. Every field of art became a laboratory, devoted to a modernization of perception and a "New Vision." As a sculptor, Rodchenko had already turned the world upside down in his suspended *Constructions in Space*, and when he bought a camera in 1924, his photographs proved no less revolutionary.

His first extensive cycle, *Views of a Building on Myasnicka Street*, 1925, show a ten-story brick building in precipitous perspective from below, with iron-railed balconies stacked tightly over one another. In other views, the fire escape shoots up nearly vertically— a daring anticipation of Laszlo Moholy-Nagy's *Balconies of the Bauhaus in Dessau*, 1927. In his images of courtyards and squares, Rodchenko likewise abandoned the "normal" point of view, picturing people and things obliquely from above, and employing cast shadows as compositional means. "Especially from above looking downwards and from below looking upwards—these are the most interesting vantage points for contemporary photography," he stated in 1928.

The forced industrialization of agrarian Russia entailed a great social and aesthetic challenge for the avant-garde. Rodchenko first tested the new field of photo-reportage in 1928, in a series on the daily *Pravda* that recorded the paper's production from typesetting and layout to printing. For the journal *DAES*, in 1929, he documented manufacturing at the AMO automobile plant, proving a master of the "gripping detail," as he himself put it. For his 1930 record of a mass scene like *Dynamo—Moscow*, Rodchenko likewise found a new visual idiom.

His photo series on the Pioneers, including *Pioneer with Horn*, 1930, the boy's face pictured from below in daring foreshortening, became icons of the new cultural upheaval in the USSR. *Dive into the Water*, a brilliant photographic experiment, showed a high diver rolled almost into the shape of a ball in the upper right corner of the picture. With images of his mother and the poet and publicist Vladimir Mayakovsky (both 1924), Rodchenko produced master portraits of the new era. Under Stalin, the burgeoning cultural and political orthodoxy harassed the artist with charges of formalism. In 1942 Rodchenko abandoned photography.

1891 Born in St Petersburg, Russia
1908–1910 Serves an apprenticeship as a dental technician
1910–1914 Attends art school in Kasan
1915 Studies graphic art at the Stroganov Institute, Moscow
1916–1917 Serves in the army
1920–1930 Teaches at the WChUTEMAS and WCHUTEIN, Moscow
1924 Takes first original photographs
1927 Abandons painting in favor of photography
1928 Publishes *Paths of Contemporary Photography*
1942 Abandons photography
1956 Dies in Moscow

FURTHER READING
Alexander Lavrentiev, *Rodchenko: Photography 1924-1954*, Edison, NJ, 1996

left page
Pioneer with Horn, 1930

left
Portrait of Vladimir Mayakovsky, 1924

above
Alexander Rodchenko, Self-portrait, 1938

1907 b. Frida Kahlo,
Mexican painter

1914–1918 World War

1835 1840 1845 1850 1855 1860 1865 1870 1875 1880 1885 1890 1895 1900 1905 1910 1915 1920

Nude, 1925

1933 Franklin D. Roosevelt becomes
President of the USA
1939–1945 World War II

1929 Wall Street Crash crash

1959 In New York City, the Solomon R. Guggen-
heim Museum opens to the public
1959 Tenzin Gyatso, the 14th Dalai Lama, flees
Tibet and travels to India

1950–1953 Korean War

1925 1930 1935 1940 1945 1950 1955 1960 1965 1970 1975 1980 1985 1990 2000 2005 2010

EDWARD WESTON

Weston's name stands for a search for absolute form. Far from the madding cry of everyday life, he celebrated the beauties of the American West Coast, the female body, and the plainest of objects. The social realities of the period found no entry into Weston's art.

Weston's early work was entirely indebted to Pictorialism, with its penchant for profound meanings and a mysterious chiaroscuro or sfumato. A 1920–1921 series devoted to a mansard room with figure, however, revealed a considerable feel for structural clarity and highly sensitive illumination. At the time—as for most of his life—Weston earned a living with studio portraits, especially of children Straightforward photographs of the seven enormous smokestacks of Armco Steel, an Ohio industrial plant, marked the turning point in Weston's career. The year was 1922. Conversations with Alfred Stieglitz and Paul Strand during the New York trip that followed may have contributed to his decision to take the path of "straight photography" from that point on. The break with everything that had gone before was biographical as well. Weston left his family of five behind in California and spent three years traveling in Mexico with the Italian photographer Tina Modotti. Portraits of his lover ensued, photographs of pyramids, humble houses and squares, objects of folk art, popular murals, and cacti. His objectivity went so far that he lent a palm tree (*Palma Cuernavaca*, 1925) the rigorous look of a factory chimney. Pictures of a washbasin or a toilet bowl (*Excusado*, 1925) had a lapidary beauty of monumental effect. "Here was every sensuous curve

of the 'human form divine,' " noted Weston in his day book, "but minus imperfections."
After his return to California, there emerged his renowned "object-icons," whose majestic lucidity still remains unmatched: a nautilus shell photographed frontally and from various angles, like a chalice; fruit, pumpkins, onions, radishes—but especially peppers, whose velvety shimmer prompted him to ever-new variations. A leaf of cabbage was lent the dignity of a Rubens drapery. Feminist commentators have taken offence at the dispassionate care Weston devoted equally to vegetables and his female models. As a reviewer in the *Village Voice* remarked on a New York retrospective years later, "Since he was both a vegetarian and a great lover, he also treated them equally as delicacies."
A bay on the California coast near Big Sur, known as Point Lobos, became as great a treasure trove for the photographer as Galapagos was for Charles Darwin, inspiring images of the beach littered with driftwood and animal cadavers, bones and seaweed, tide pools, and surf-hollowed rocks. For Weston, this was a laboratory for the generation of a new, sculptural cosmos.
Two Guggenheim fellowships, in 1937 and 1939, freed Weston from commercial jobs. He traveled through California, Arizona, New Mexico, Oregon and Washington, concentrating on landscapes. One quarter of his superb life's work emerged during these two years alone. From beetles' tracks in the sand to monumental panoramas, Weston captured the entire range of landscape features and events. Many of the views and texture studies were so strongly abstracted as to anticipate the painting of Abstract Expressionism, notably those of Jackson Pollock, Mark Tobey, and Willem de Kooning.

1886 Born in Highland Park, Illinois, USA
1902 Takes his first photographs
1907 Attends Illinois College of Photography
1908 Moves to California and works for various portrait photographers
1909 Marries Flora Chandler
1911 Opens his first photographic studio, in Tropico, California
1922 Moves with his lover, Tina Modotti, and his son, Chandler, to Mexico; opens a photographic studio there
1926 Returns to Southern California, without Tina
1928 Moves to Carmel, California
1929 Participates in the exhibition *Film und Foto*, Stuttgart; lives with Sonya Noskowiak
1930 Hold his first one-man exhibition in New York
1932 Publishes his first book, *The Art of Edward Weston*
1933 Travels to New Mexico
1935 Lives with Charis Wilson, whom he will marry in 1939 after separating from Flora
1937–1939 Receives Guggenheim fellowships
1946 A retrospective at the Museum of Modern Art; divorces Charis
1958 Dies at his home, Wildcat Hill, in Carmel, California

FURTHER READING
Gilles Mora, et al, *Edward Weston: Forms of Passion*, New York, 1995

above
Tina Modotti, Edward Weston with Seneca View Camera, 1924

left
Arrangement of Shells and Rocks, 1931

1914–1918 World War I

1840 1845 1850 1855 1860 1865 1870 1875 1880 1885 1890 1895 1900 1905 1910 1915 1920 1925

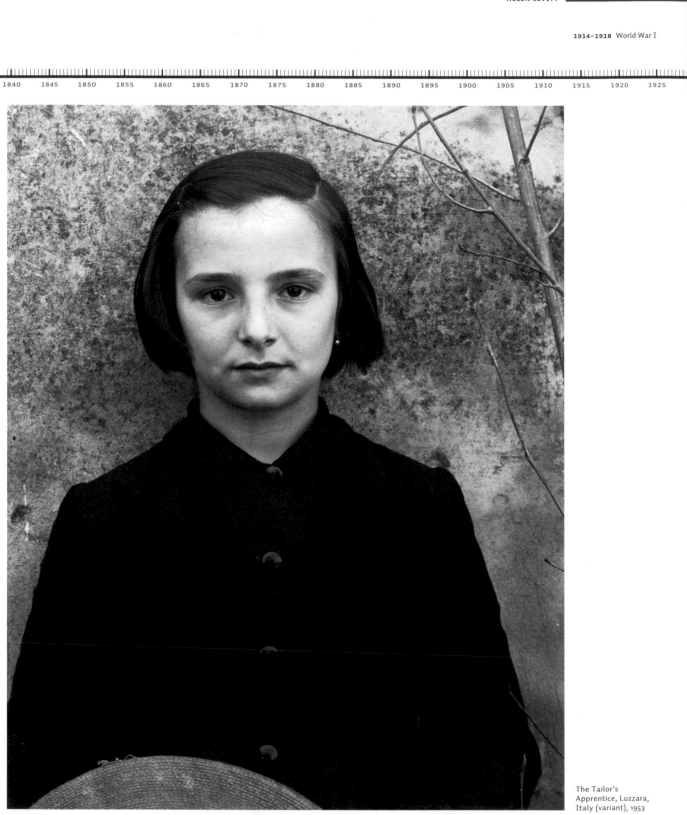

The Tailor's
Apprentice, Luzzara,
Italy (variant), 1953

1939–1945 World War II

1953 Ernest Hemingway wins the Nobel Prize in Literature

1957 Ghana gains independence from Great Britain

1951 The European Coal and Steel Community is founded

1964 Vietnam War begins

1964 Civil Rights Act of 1964

1973 Watergate scandal

1968 Rudi Dutschke assassinated in Berlin

1930 1935 1940 1945 1950 1955 1960 1965 1970 1975 1980 1985 1990 1995 2000 2005 2010 2015

PAUL STRAND

The photographs by Paul Strand that were published in the final, 1917 issue of Camera Work struck with the force of a bombshell. As the reveries of Pictorialism faded, Strand supplanted its tranquillizing soft-focus with a bracing stimulant—Verism.

The years 1915–1916 had brought a change in Strand's work. Still lifes with fruit, passersby in New York parks, and steamers emitting picturesque plumes of smoke, suddenly made way for the turned rungs of a chair back, porcelain bowls, and the shadows cast by a balcony balustrade forming dramatically plunging lines. Strand replied to Stieglitz's studies of clouds over Lake George by showing a section of house roof against the cloudy sky over the Twin Lakes in Connecticut at such an oblique angle that it seemed caught in an earthquake. Sergei Eisenstein or Alexander Rodchenko would have enjoyed these "Constructivist" experiments, done at a time when the terms to describe them had yet to be invented. The name Paul Strand stands for an objective, documentary style that extends both to figures and landscapes, objects and episodes. After his hoped-for breakthrough as a film director came to nothing and he moved to the French provinces, Strand devoted himself in 1950–1952 to a book—*La France de profil*—in which the face of rural France was recorded in an unusually objective way. Avoiding touristic clichés, Strand focused on normal, everyday village life. He photographed the doors of humble houses, geraniums on window sills, the facades of bistros. Portrait after portrait of the inhabitants emerged, from artisans to elderly people resting on benches. The village world was framed by gently rolling hills under a spacious sky. Crosses and gravestones evoked the natural cycle of life.

Even on his earlier trips to the American Southwest, in 1926 and following years, Strand had shown less interest in the monumental scenery than in the ordinary beauties of the towns. He exploited the play of light and shade to produce images of great intensity. Bare house walls shorn of decoration and crumbling façades seemed impregnated with the life of these places, past and present. The back of the white stucco church of San Francisco de Assisi, in Ranchos de Taos, New Mexico, appeared in many photographs of 1930 and the two following years. The "pure form" of this cubic ensemble intrigued many artists. Yet indicatively, instead of making a modernistic form of the building, as he had in his earlier work, Strand now let it speak with its own voice.

1890 Born in New York, USA
1912 Works as a commercial photographer
1916 Hold his first one-man show, *Photographs of New York and Other Places, by Paul Strand*, Gallery 291, New York; six of his prints are published in Stieglitz's Camera Work
1917 Eleven photographs are published in the final issue of *Camera Work*, along with Strand's essay, "Photography"
1920 Makes the six-minute film *Manhatta*, in collaboration with Charles Sheeler
1922 Films sports and other events for newsreels
1926 Photographs scenes in New Mexico and Colorado; he will return to New Mexico several times in the years to come
1930s Undertakes numerous photography projects: *Heart of Spain* (on the Spanish Civil War), *China Strikes Back* (on Mao Tse-tung), *Native Land* (on civil rights in the US), etc.
1945 Hold a one-man exhibition at The Museum of Modern Art
1950 Moves to France
1952 Publishes *La France de profil*
1955 *Un paese* appeares, containing photographs from Italy, especially the small town of Luzzara (Reggio Emilia)
1953 Takes photographs on the island of Uist, Outer Hebrides, published in 1962 in the book *Tir a'Mhurain*
1959 Visits Egypt
1960 Visits Romania and Hungary
1963 Visits Ghana at the invitation of President Kwame Nkrumah
1976 Dies in Orgeval, France

FURTHER READING
Sarah Greenough, *Paul Strand: An American Vision*, Washington, 1990

Church, Ranchos de Taos, New Mexico, 1930

1913–1927 *In Search of Lost Time* (Marcel Proust)

1892 b. Walter Benjamin, German philosopher

1887 b. Marcel Duchamp, French artist

1916 Cabaret Voltaire founded in Zurich

| 1840 | 1845 | 1850 | 1855 | 1860 | 1865 | 1870 | 1875 | 1880 | 1885 | 1890 | 1895 | 1900 | 1905 | 1910 | 1915 | 1920 | 1925 |

Violon d'Ingres, 1924

1924 First Surrealist Manifesto

1945 Atom bombs dropped on Hiroshima and Nagasaki

1973 Watergate scandal

1939–1945 World War II

1940–1944 Occupation of Paris by the German united armed forces

1928 *Nadja* (André Breton)

1930 1935 1940 1945 1950 1955 1960 1965 1970 1975 1980 1985 1990 1995 2000 2005 2010 2015

MAN RAY

Man Ray was a tireless experimenter and a crosser of borderlines between media. He created unforgettable Dada sculptures, was a painter and film director; yet his most important works were done in a visual twilight zone, in a tense interplay among painting, sculpture and photography that literally set sparks flying.

Man Ray was no conventional photographer who combed the city and countryside in search of motifs. His world was the studio, and especially the darkroom, where he coaxed visions from photographic paper with silver and salt, like an alchemist. A Surrealist and friend of Marcel Duchamp, he probably thought it too banal to simply portray his artist friends. Ray sought unconventional poses and arrangements, alienated his subjects by means of surprising accessories, extreme cropping, or solarization. As his working prints reveal, the definitive—frequently extreme—croppings were often established in a second step. Some of his models appeared on the verge of sleep (*Dora Maar*, 1936), others emerging from nocturnal darkness (*Salvador Dalí*, 1929), still others flipped from positive to negative (*André Breton*, ca. 1930). He pasted glass beads on the cheeks of a girl, Lydia, to show her "crying" in the famous photograph *Tears* (1932), an artificiality derived by the director Man Ray from the props of the film world.

Man Ray was a specialist in the field of the female nude. The list of illustrious befriended beauties he photographed unclad was a long one: Meret Oppenheim, Lee Miller, Nusch Eluard, Suzy Solidor, and his favorite model, the legendary Kiki de Montparnasse, queen of the bohemian world of Paris. Nor did he shy away from objects of a fetishistic character, portraying Mlle. Dorita in the coils of a python (1930), or Lee Miller with anatomical weaves of wire placed around her head or arm (1930). This was the Art Deco period, intrigued by the theme of man and machine.

His series of female faces, stylized and made-up to the verge of the mask-like, culminated in an unusual composition. Next to the head of Kiki, resting with eyes closed, he placed an African Baule mask (Ivory Coast), creating a highly evocative Surrealist icon (*Noire et Blanche*, 1926). The power of this image was surpassed only by *Le Violon d'Ingres* (1924), the back view of a nude wearing a turban, dadaistically alienated by the addition of the two "clefs" of a —cello. Man Ray's sense of the puzzle of human perception was so strong that even his photographs for the fashion magazine *Harper's Bazaar* showed that he was not taken in by beautiful illusion.

In his Rayograms, made without a camera, Man Ray's visual fantasies came to full flower. Placing various objects directly on photographic paper under the enlarger and exposing them, he fixed the shadows they cast. Feathers, coils of string, springs, and other unorthodox objects formed semi-abstract compositions in white on black. The process enriched the repertoire of Surrealist techniques by a new and enthusiastically received variant.

1890 Born in Philadelphia, Pennsylvania, USA
1915 Meets Marcel Duchamp; buys a camera in order to reproduce his own paintings
1916 Takes his first photographic portraits
1917 Makes his first airbrush works, and first *clichés-verre* (glass plates)
1921 Moves to Paris; participates in *Salon Dada*; makes reproductions of numerous artists' works (until the 1930s); takes photographic portraits of artists and writers; *Exposition Dada Man Ray*, at Librairie Six
1922 (?) Makes his earliest Rayograms
1922 Publishes his book *Champs Délicieux* (preface by Tristan Tzara)
1923 Makes *The Return to Reason*, the first of his many films
1924 Starts working for *Vogue*
1928 Participates in the *Exposition Surréaliste*, Paris
1929 Participates in the exhibition *Film und Foto*, Stuttgart; discovers the solarization technique
1934–1936 Photographs mathematical objects at the Institut Poincaré
1935 His first fashion photographs for *Harper's Bazaar* are published
1937 Devotes himself to painting; publishes *La photographie n'est pas l'art*
1976 Dies in Paris

FURTHER READING
Emmanuelle de l'Ecotais and Alain Sayag, *Man Ray: Photography and its Double*, London, 1998

left
Tears

above
Man Ray, detail of a self-portrait, ca. 1930

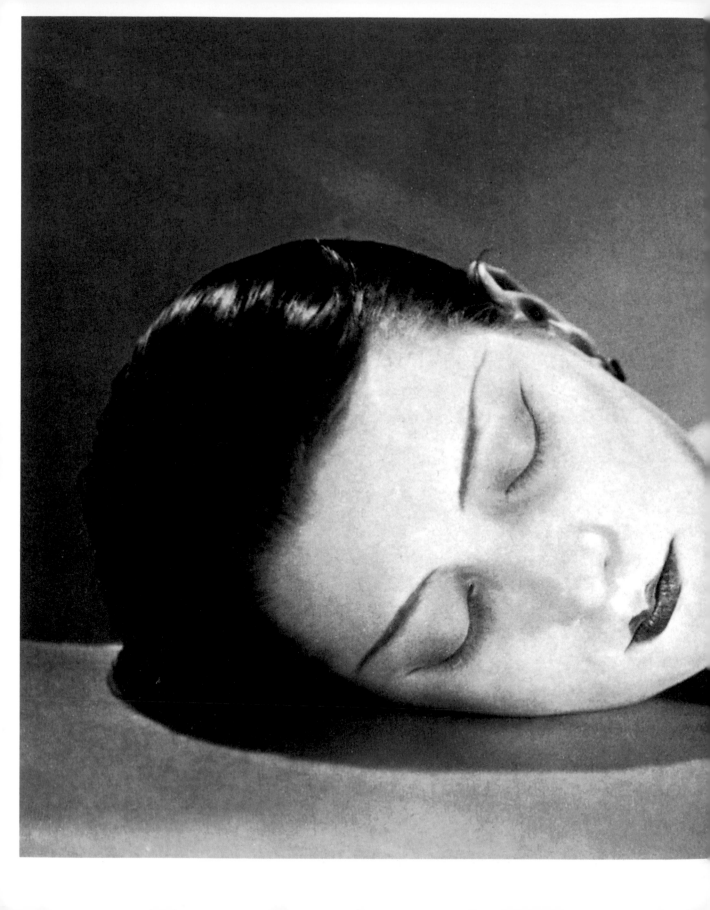

Noire et Blanche, 1926

1914–1918 World War I

1918 Dissolution of the Austro-
Hungarian Empire

1925 Alban Berg's opera *Wozzeck*
is first performed in Berlin

| 1845 | 1850 | 1855 | 1860 | 1865 | 1870 | 1875 | 1880 | 1885 | 1890 | 1895 | 1900 | 1905 | 1910 | 1915 | 1920 | 1925 | 1930 |

1938 Munich Agreement **1953** Death of Stalin **1980** In Poland, the independent trade union
 Solidarity is established
 1945 Beneš decrees

1939–1945 World War II **1968** The Prague Spring of political liberalization ends

1935 1940 1945 1950 1955 1960 1965 1970 1975 1980 1985 1990 1995 2000 2005 2010 2015 2020

JOSEF SUDEK

Sudek spent his entire life in one city—Prague—and became one of the greatest poets among photographers. Working in the isolation of his studio and the gardens of the environs he developed a hermetic world, consisting of simple things—and light.

If we looked at Sudek's early images without knowing his dates, we might be excused for thinking him a turn-of-the-century Pictorialist. So important was atmosphere to him that the pictures he took in 1922–1927 for *Invalid War Veterans' Home* recall scenes from a cozy inn. Objective social reportage was not Sudek's aim. Yet over the following years he would find a link with certain tendencies of the period. The complex geometries in some of the images taken in St. Veit's Cathedral in Prague (1924–1928) recalled the spirit of Russian Constructivism. The straightforward object, advertising, and architectural photographs he began in 1927 to supply to an aesthetically advanced clientele were very much along the lines of the Bauhaus and the "New Vision." Apart from his commercial activities, Sudek produced highly sophisticated series: *Window in my Studio* (1940–1959), *Vanished Statues* (1952), *In the Enchanted Garden* (1954–1959), *Glass Labyrinths* (1968–1972), *Labyrinths* (1972–1975). These were supplemented by numbers of still lifes, composed of various seashells, eggs, simple drinking glasses, bread, an unexposed roll of film, even a sponge and head of cabbage. Into these images entered the poetry for which his daily business left him no time. A sculptor in light, a true "light-painter," for over 14 years Sudek recorded the changing light at his studio window: dotted with raindrops, steamed with humidity, frosted over—by day, in twilight, by night. "He wrestled with light like Jacob with the angel," as the poet Jaroslav Seifert recalled. Cellophane and oiled paper with a seashell placed on it could form the point of departure for a drama in light on which he worked for hours on end. In parallel, photographs of Prague gardens and parks, and of landscapes in the city's environs emerged (the latter taken from about 1947, with a panorama camera). Many of these images showed a return of the numinous mood of Pictorialism, mentioned above. In several works taken in the garden of his architect friend Otto Rothmayer, Sudek rang changes on the theme of the *Enchanted Garden*. Modern white garden furniture, occasionally supplemented by sculpture fragments or stone balls, figured as accessories to a locale spirited into a state of mystery. Touches of surrealism alternated with lyrical moods.

As the piles of crumpled paper he later captured in his *Labyrinth* series indicate, up to a year before his death Sudek not only remained on a search for a bygone era but reacted to the aesthetic ferment of the present day.

1896 Born in Kolín, Bohemia (today Czech Republic)
1908–1910 Attends the Royal Technical Trade School, Kutná Hora; begins taking photographs
1910–1913 Serves an apprenticeship in book binding
1914–1918 Loses his right arm in the First World War
1922–1924 Attends the State School of Graphic Arts, Prague
1922 Co-founds the Prague Photographic Club (from which he will be expelled in 1924)
1924 Co-founds the Czech Photographic Society
1927 Establishes a studio for portrait and advertising photography in central Prague
1930S Runs the Sudek Gallery of Visual Art
CA. 1947 Begins working with a panorama camera
1956 First monograph (with 232 intaglio plates) published
1976 Dies in Prague

FURTHER READING
Anna Farova, *Josef Sudek: Poet of Prague*, New York, 1990

left
Walk on the Schützeninsel, 1946–66

above
J. Sauer, Josef Sudek, 1960

In the Magic Garden, 1954–59

1914–1918 World War I

1926 Gustav Streseman
Aristide Briand a
ed Nobel Peace P

| 1845 | 1850 | 1855 | 1860 | 1865 | 1870 | 1875 | 1880 | 1885 | 1890 | 1895 | 1900 | 1905 | 1910 | 1915 | 1920 | 1925 | 1930 |

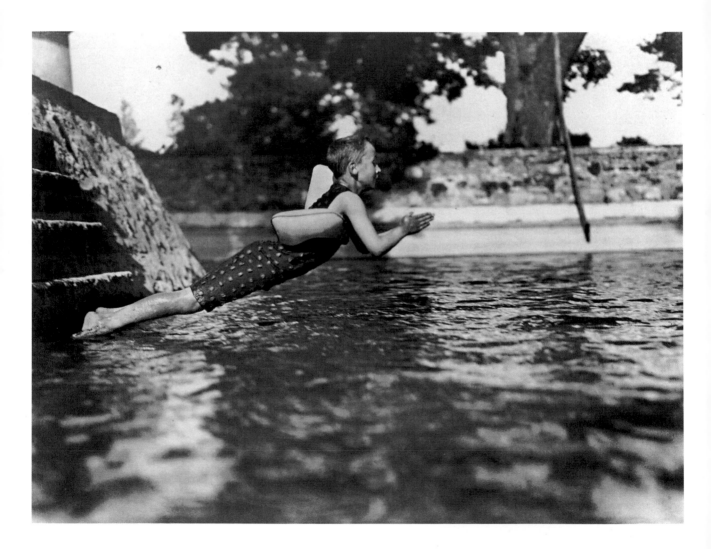

Dédé Rouzat, 1911

1944 France liberated by allied forces

1939–1945 World War II **1954–1962** The Algerian War **1974** Giscard d'Estaing becomes President of France

1937 The World Exposition in Paris **1981** François Mitterand becomes President of France

1925 1940 1945 1950 1955 1960 1965 1970 1975 1980 1985 1990 1995 2000 2005 2010 2015 2020

JACQUES-HENRI LARTIGUE

His father already kept the young Lartigue equipped with the newest model in cameras. Later he would pilot one of the first automobiles along the Côte d'Azur. Lartigue's life, spent between Cannes, Nice, Deauville and Paris, was like a serialized novel in the glossies. He used his privileged background to capture the lives of the happy few with incomparable grace.

Jacques-Henri was a wunderkind of photography. At ten, he snapped his cousin, Simone, with her dog on the beach of Villerville, and his brother, Maurice (Zissou), jumping off a boat. By the time he was a teenager he had already filled an album with snapshots worthy of a master. People jumping, hopping, suspended in midair, falling—the young photographer loved such motifs. And because movement intrigued him most, he always had a camera at hand when cycling, swimming, at soapbox derbies, auto races, and flying contests. The photographs of Zissou and his exuberant cousins were merely the point of departure for a vibrant photographic career. It was the spontaneous gaze of the child that saved Lartigue from emulating the melancholy mood of the art photography of the day.

His oeuvre is reminiscent of the private album of a privileged family, later supplemented by a circle of prominent friends. What diversions they enjoyed, from airfield to beach, outings on the yacht or in the Hispano-Suiza, at tennis, the horse races, skiing or skating in Chamonix. Astonishing, how many months of his life Lartigue spent in luxury hotels—the Negresco, in Nice, being only one of many. To him the good life, so temptingly illustrated in *Vogue* or *Harper's Bazaar*, was simply his birthright, and he

lived it among film stars, artists, and countesses. An ambitious painter throughout his life, Lartigue discovered moments of very personal grace beyond the galas and premieres of this *dolce vita*. He captured the fleeting joys of life under the Mediterranean sun like no other. And perhaps this is the real secret behind his art: Lartigue's images are full of *esprit*, that irony-spiced, so quintessentially French attitude to life.

1894 Born in Courbevoie, France
1900 Takes his first photographs, with a camera of his father's, who in the coming years will present him with the latest models
1907 He and his brother, Maurice, visit the airfields of the aviation pioneers
1911 Photographs automobile races in Monaco
1915 Attends the Academie Julian, Paris
1920–1921 Takes first autochromes, in the park of La Garoupe palace, Cap d'Antibes
1922 Exhibits his paintings at the Galerie Georges-Petit, Paris
1923 Takes earliest photographs with flash
1925 Takes photographs of the Promenade des Anglais, Nice, in a heavy storm
1932 Contributes to the filming of *Les Aventures du roi Pausole*
1963 Retrospective at the Museum of Modern Art, New York
1970 Publishes *Instants de ma vie* (Diary of a Century)
1986 Dies in Nice

FURTHER READING
Richard Avedon, Shelley Rice and John Szarkowski, *Jacques-Henri Lartigue: Le choix de bonheur*, Paris, 1992
Vicki Goldberg, *Jacques Henri Lartigue*, Boston, 1998

Le jour des Drags, Aux Courses à Auteuil, Paris, 1911

following double page
Véra, Bibi and Arlette, Cannes, May 1927

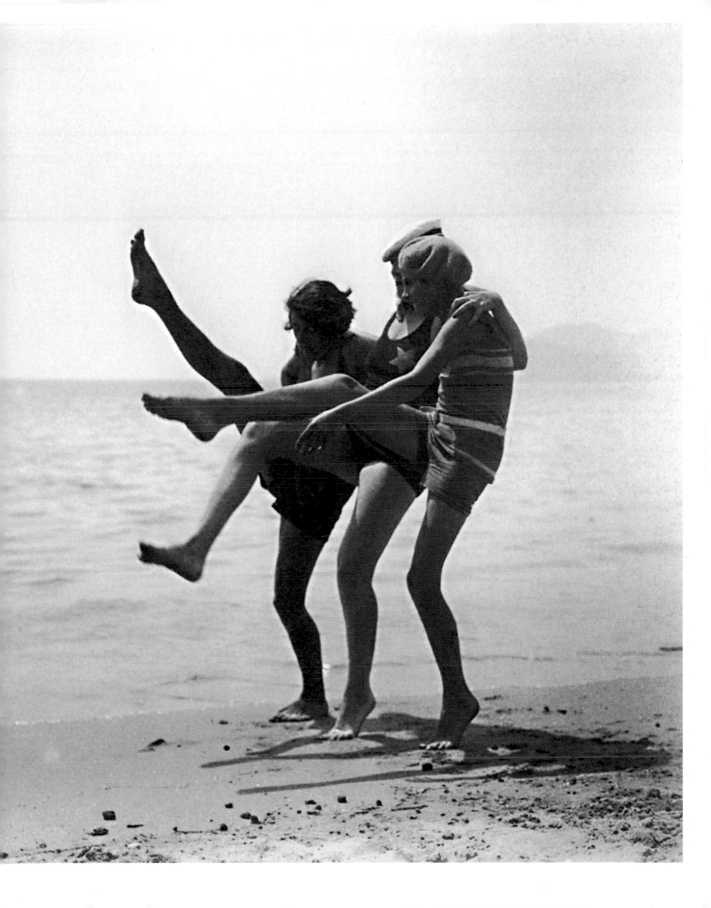

1911 *Bluebeard's Castle* (Béla Bartók)

1872 b. Piet Mondrian, Dutch painter

1920 Treaty of Trianon

1918 End of Austro-Hungarian empire

| 1845 | 1850 | 1855 | 1860 | 1865 | 1870 | 1875 | 1880 | 1885 | 1890 | 1895 | 1900 | 1905 | 1910 | 1915 | 1920 | 1925 | 1930 |

Danseuse Burlesque, 1926

1956 Hungarian Revolution
1959 Completion of the Guggenheim Museum in New York (Frank Lloyd Wright)
1962 The U.S. announces its trade embargo against Cuba
1939–1945 World War II
1964 Vietnam War begins

1935	1940	1945	1950	1955	1960	1965	1970	1975	1980	1985	1990	1995	2000	2005	2010	2015	2020	

ANDRÉ KERTÉSZ

Perhaps it was his self-evaluation as an amateur, a perpetual beginner who continually rediscovers the world anew, that ensured the vitality of Kertész's work over seven decades. His professional path took him from Budapest via Paris to New York, then back to Paris.

Kertész was a master of the grand form and plane, the laws of volume and space. His photographs of city squares and streets from a high vantage point lent order to the bustle of life. New York's Washington Square became an especially fruitful site for Kertész: footprints and tire tracks in the snow, tree branches, fences, benches, and milling passersby provided the elements from which he composed visual chamber music. Rather than practicing street photography as a form of close-up sociology, he produced finely equilibrated urban views. This tendency had already marked his early work in Hungary, even though his holiday scenes, images of gypsies and itinerant musicians, village communities, friends, and moments in the trenches of the First World War amounted to an eloquent record of the final days of the Austro-Hungarian Empire. *The Underwater Swimmer*, taken in 1917 in Esztergom, was Kertész's most famous early work.

In his French period (1925–1936), apart from portraits, direct views of the human face became rarer. Kertész focused his lens on the structure of the city, finding comprehensive spatial harmonies in which people tend to figure as accessories. Unlike Brassaï's, his images of Paris by night had no air of vice about them. Where the former sensed low instincts, Kertész found plays of light and shadow.

On visits to painters and sculptors, he portrayed not only them but also their studios, in still lifes of utensils. *Mondrian's Studio* (1926) is a light-flooded interior reminiscent of a Cubist collage by Picasso; *Mondrian's Glasses and Pipe*, of the same year, a still life composed in the style of the New Vision, whose compositional clarity is surpassed only by the famous *Fork* (1928), an advertising photograph for the Bruckmann Company, of Heilbronn, Germany. Perhaps intentionally spoofing the idea of valid form, for the humor magazine *Le Sourire* Kertész posed nude models in front of a distorting mirror (1933) that stretched and compressed their limbs into novel sculptural configurations. People, faces

and objects were subjected to the same treatment. Finally, the skyscraper city enriched the works of Kertész's American period (1936–1962) with new motifs. Yet the poetic spirit that marked the Hungarian's art throughout his career, objective in a rather un-French way, continued to inform these late images.

1894 Born in Budapest, Hungary
1912 Gets his first camera; works on the stock exchange
1925 Moves to Paris, and works for French, German, and English periodicals
1927 Holds his first exhibition, at the gallery Au Sacre de Printemps, Paris
1928–1935 Contributes to *Vu*
1929 Participates in the exhibition *Film und Foto*, Stuttgart
1933 Publishes his first book, *Enfants*, followed by *Distorsions* in *Le Sourire*
1934 Publishes *Paris vu par André Kertész*
1937 First one-man show in New York; works for American magazines
1944 Takes US citizenship
1946 Makes contract with Condé Nast
1964 Exhibits at the Museum of Modern Art, New York
1979–1981 Takes Polaroids, under the title *From my Window*
1982 Publishes *Hungarian Memories*
1985 Dies in New York

FURTHER READING
Pierre Borhan, *André Kertész. La biographie d'une oeuvre*, Paris, 1995
Danièle Sallenave, *André Kertész*, London, 1990

left
The Underwater Swimmer, Esztergom, 1917

below
Meudon, 1928

right
Distortion no. 168, 1933

1914 Werkbund exhibition in Cologne

1914–1918 **1923** Troops from France
World War I and Belgium occupy
the Ruhr area in
Germany

| | | | | | | | | | | | | | | | | | | |
|1845|1850|1855|1860|1865|1870|1875|1880|1885|1890|1895|1900|1905|1910|1915|1920|1925|1930|

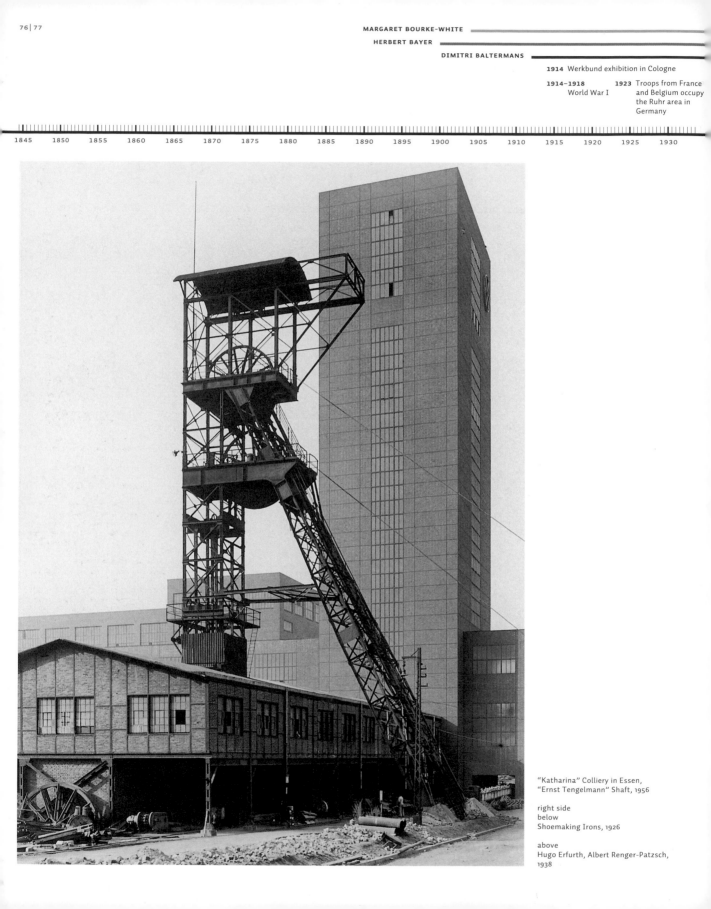

"Katharina" Colliery in Essen,
"Ernst Tengelmann" Shaft, 1956

right side
below
Shoemaking Irons, 1926

above
Hugo Erfurth, Albert Renger-Patzsch,
1938

1925 Paul von Hindenburg becomes President of Germany

1939–1945 World War II

1949 Federal Republic of Germany officially founded

1956 Labour riots at Poznań, Poland

1962 The U.S. announces its trade embargo against Cuba

1935 1940 1945 1950 1955 1960 1965 1970 1975 1980 1985 1990 1995 2000 2005 2010 2015 2020

ALBERT RENGER-PATZSCH

Renger-Patzsch's oeuvre is a pictorial universe that encompasses technology, architecture, landscape, and nature in equal measure. He devoted himself as passionately to the microcosm of plants and crystals as to the giant industrial plants of the Ruhrgebiet. Whatever his field of activity, he set high standards for his many successors.

Others would have gone farther afield, but even the dingy tenements and suburban streets on the city periphery caught Renger-Patzsch's eye. A diverse agglomeration of poster pillar, power line and factory chimney next to the firewall of a building could inspire him to an image—a celebration of austerity. He was even satisfied with a sagging fence outside an isolated house in the Froschlake Development in Dortmund-Marten. Almost all of these pictures were uninhabited, yet they told an eloquent story about the difficult lives of the people who lived under such conditions.

Drama was far from Renger-Patzsch's mind. His Ruhr Valley landscapes were not heroic panoramas of the kind Edward Weston found in California and New Mexico. Tailing piles, a sandpit, or a garden colony near Essen, with a row of smoke-belching factory stacks along the upper margin (1929), sufficed him for a composition. He also sought out "intact" landscapes, devoting photography books to the North Sea Halligen Islands, the Ore Mountains, Lake Möhnsee, and the Rheingau region—and especially to forests and even individual trees. Admittedly the drama of a factory chimney taken from a very low vantage point interested him (*Kauper, Viewed from below*, 1928), but Renger-Patzsch made no dogma of Constructivism (in the manner of Alexander Rodchenko), preferring to capture industrial plants from a detached middle distance. The images of the two Essen mines Bonifacius (1940–1941) and Katharina (1956) were compelling compositions of cubic masses, framed in daring excerpts. His photographs of pitheads, heaters, Bessemer converters, and trestle bridges were pioneering achievements in the field of modern industrial archaeology.

Renger-Patzsch lent his manufacturing and advertising photographs an intensity far beyond the norm for commercial photography. Jobs for Kaffee Hag, Ruhrglas and Schott inspired him to aesthetically ambitious still lifes. "The charms of photography,"

in his eyes, lay "in halftones, the division of the plane, and the course of lines." Photographs like *Pressing Iron for Shoe Manufacturing* and *Shoe Lasts in the Fagus Works, Alfeld*, both 1926, became icons of the genre, worthy of being placed alongside Weston's *Peppers* (1930). The retorts for the Schott Glassworks in Jena (1934) possess a virtually celestial transparency. The scaly skin of an adder, the spines of a cactus, not to mention blossoms and plants (*Agave americana*, 1923), reflected the same dedication to detail. If he had had his own way, Renger-Patzsch would have entitled his 1928 book, *Die Welt ist schön* (The World is Beautiful), introduced by 20 botanical photographs, simply *Things*.

1897 Born in Würzburg, Germany
1909 Begins to take photographs
1919–1921 Studies chemistry at Dresden Technical College
1921–1924 Works as head of photographic archive; takes photographs for *Die Welt der Pflanze* (The World of Plants)
1916–1918 Serves in the army
1925 Publishes photo book *Das Chorgestühl von Kappenberg* (The Choir Stalls of Kappenberg)
1925 First one-man show, at the Behnhaus, Lübeck
1928 *Die Welt ist schön* (The World is Beautiful)
1929 Publishes *Dresden* (a volume of photographs including seven by László Moholy-Nagy)
1929–1932 Photographs cityscapes and industry in the Ruhrgebiet
1933 Teaches two semesters as head of the department of "pictorial photography" at the Folkwangschule, Essen
1933–1945 Wins commissions from industry, publishers, and architects
1943 Photographs the Western Wall fortifications in Normandy and Brittany
1944 A large part of his archive is destroyed during the bombardment of Essen
1952 Begins a series of photo books on his own initiative
1966 Dies in Wamel, near Soest, Germany

FURTHER READING
Ann Wilde, Jurgen Wilde and Thomas Weski, *Albert Renger-Patzsch*, Cambridge, MA, 1998

below
Shoe Lasts at the Fagus Factory,
Alfeld, 1926

right
Glass Tumbler, Jenaer Glaswerke
Schott, 1934

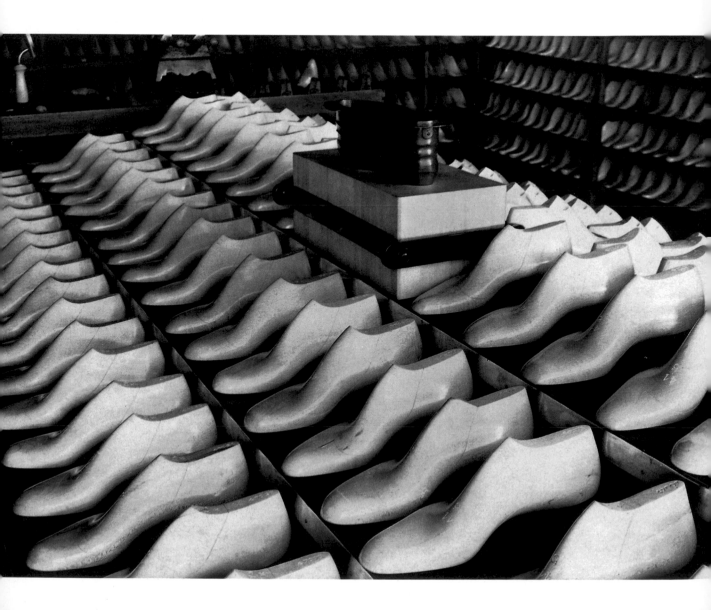

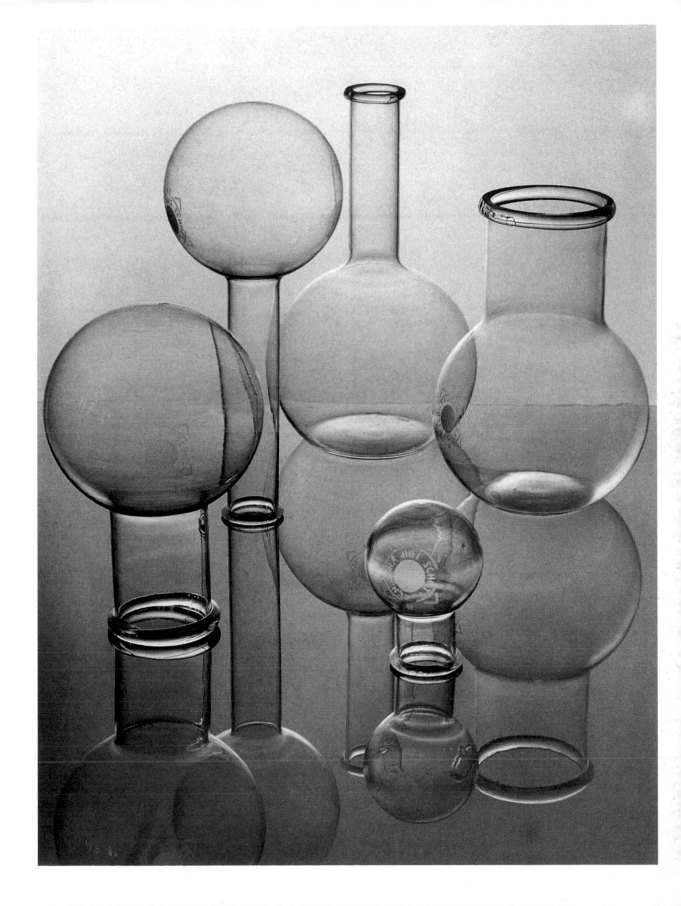

ARNOLD GENTHE

CLARENCE WHITE

WALKER EVANS

1910–1929 Mexican Revolution

1929 Wall Street Crash crash

1914–1918 World War I

1845 1850 1855 1860 1865 1870 1875 1880 1885 1890 1895 1900 1905 1910 1915 1920 1925 1930

White Angel
Breadline, San
Francisco, 1933

| 1939–1945 | World War II | 1957 | *Moses und Aaron*
(Arnold Schönberg) |

1946 UNESCO is established 1960 John F. Kennedy becomes President of the USA

1937 Margaret Mitchell wins Pulitzer 1950 Racial segregation abolished in the USA
Prize (*Gone with the Wind*)

| 1935 | 1940 | 1945 | 1950 | 1955 | 1960 | 1965 | 1970 | 1975 | 1980 | 1985 | 1990 | 1995 | 2000 | 2005 | 2010 | 2015 | 2020 |

DOROTHEA LANGE

Dorothea Lange was the Florence Nightingale of photography. One of her images from the Great Depression, Migrant Mother (1936), even appeared on a postage stamp, and was so famous that it became almost a synonym for Lange and obscured the remainder of her rich and diverse oeuvre.

The misery that followed in the wake of the 1929 New York stock market crash was devastating, costing millions their jobs and homes, forcing them to go on the road in search of work. Dorothea Lange's photographs show lines of people waiting for welfare payments, people sleeping in the streets, people looking for a job, moving from town to town. Others had long since been forced to exchange their apartment for a car, a tent, or a hovel. Lange visited workers' camps at the edge of cotton and tobacco fields and orchards, the city slums, San Francisco's soup kitchens (*White Angel Breadline*, 1933), and the demonstrations and general strike that took place there in 1934. On commission from Roy Striker of the Resettlement Administration (RA, later FSA), Lange sought out areas worst hit by the Depression, to record the fate of the stranded and destitute. From fall 1935 to fall 1936 alone, she covered 1,700 miles through 14 states. She photographed families with undernourished children in ragged clothes, once-proud workers and farmers at the end of their endurance. The terrible drought that hit the Oklahoma Dust Bowl in 1936 forced even sharecroppers to abandon their fields. And yet, even in the face of such strokes of fate, Lange firmly believed these people retained their pride, resolution, and courage. In 1942, citizens of Japanese origin were confined in internment camps built expressly for the purpose. Lange recorded these, as well as the harvest workers who streamed in from Mexico to offset the dearth of farm labor caused by the war. A portrait photographer from the start, Lange devoted herself to street photography only marginally. She looked for the traces of human experiences and feelings in people's faces, the expression in their eyes, their gestures. And her pictures teach us what confrontation with reality means. A statement by the Elizabethan writer Francis Bacon was pinned to her darkroom door: "The contemplation of things as they are, without error or confusion, without substitution or imposture, is in itself a nobler thing than a whole harvest of invention."

There were three rules to which Lange always adhered: "Whatever I photograph, I do not molest or tamper with or arrange. Second: a sense of place. Whatever I photograph, I try to picture as part of its surroundings, as having roots. Third: a sense of time. Whatever I photograph, I try to show as having its position in the past or in the present."

1895 Born in Hoboken, New Jersey, USA

1913–1914 Decides to become a photographer; trains with Arnold Genthe and others

1917 Attends Clarence H. White's class at Columbia University

1918 Settles in San Francisco as a portrait photographer

1935 Hired by Roy Striker for the Resettlement Administration (RA); takes photographs in California and New Mexico; works published in *Survey Graphic*

1937–1940 Continues work, with interruptions, for the RA, now renamed FSA (Farm Security Administration)

1939 She and Paul Taylor publish *An American Exodus: A Record of Human Erosion*

1941 Awarded a Guggenheim Fellowship; photographs cooperative communities

1942 Photographs US citizens of Japanese origin who have been interned

1943–1944 Works for the Office of War Information

1958 Travels through Asia, Indonesia and Europe with Paul Taylor

1962 Visits Egypt

1965 Dies in San Francisco

FURTHER READING
Elizabeth Partridge, *Restless Spirit: The Life and Works of Dorothea Lange*, New York, 1998

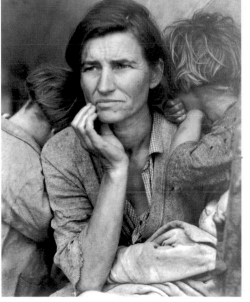

left
Homeless Mother, Nipomo, California, March 1936

above
Paul S. Taylor, Dorothea Lange working on Texas Plains, ca. 1936

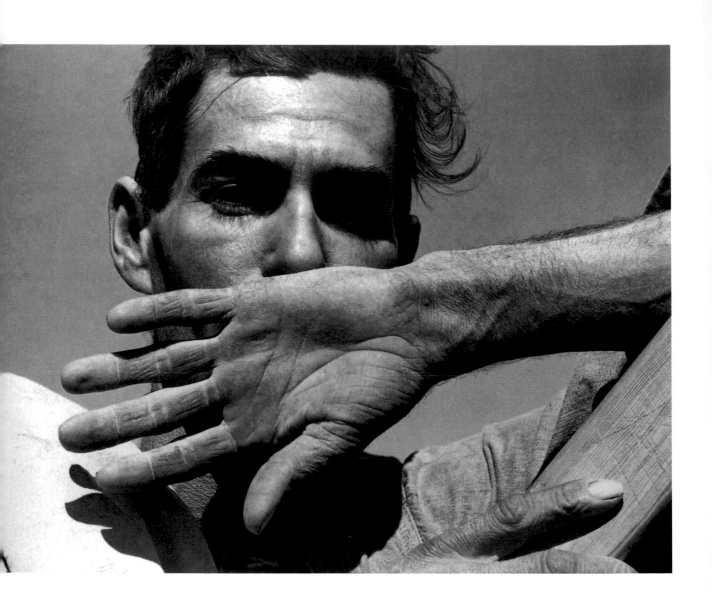

Cotton Picker, Eloy, Arizona, 1940

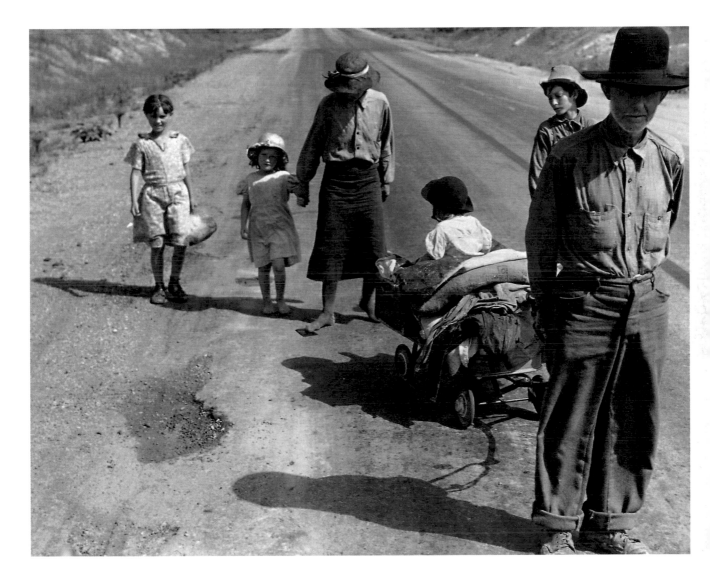

Homeless Family, Oklahoma, June 1938

1914–1918 World War I **1929** Wall Street
Crash crash

1924 b. Truman Capote, US American/Canadian writer

1920–1930 Harlem Renaissance

1850 1855 1860 1865 1870 1875 1880 1885 1890 1895 1900 1905 1910 1915 1920 1925 1930 1935

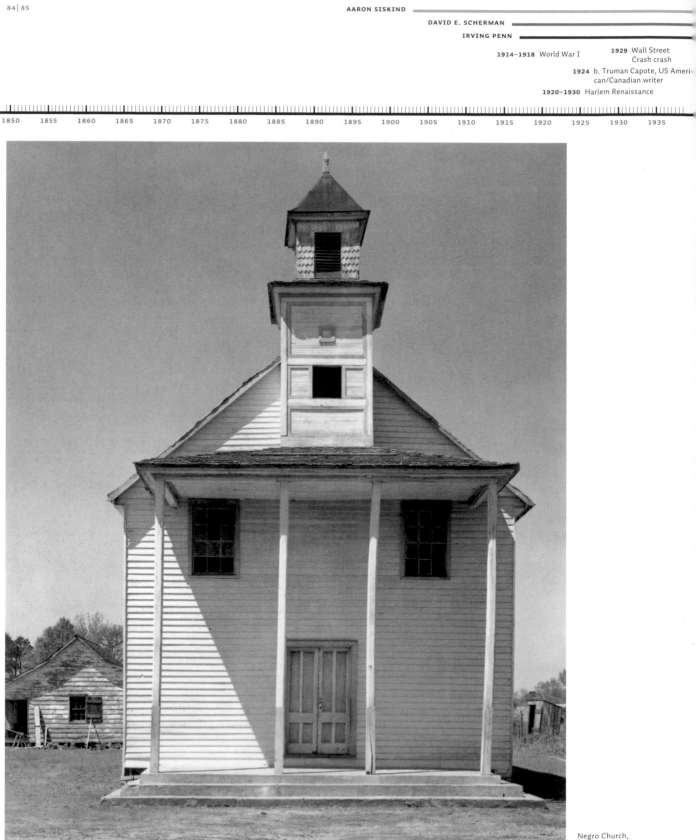

Negro Church,
South Carolina, 1936

WALKER EVANS

Walker Evans was the leading American documentary photographer. Without sentimentality or accusation, he soberly recorded the Victorian architecture of New England, the life of impoverished itinerant laborers in the South, and passengers in the New York subway. Evans embodied the dispassionate, objective eye par excellence, simply recording what appeared in his viewfinder.

The photographs collected in his most famous book, *Let Us Now Praise Famous Men* (1941) were taken on commission for the Farm Security Administration (FSA), a division of the US Department of Agriculture interested in obtaining an impression of the lives of the rural population, especially in the Deep South. Evans focused on farmers and their families—especially children—the poor furnishings of their dwellings and their outward appearance, the fields and meager harvests. His lapidary stocktaking had nothing of the social reform agenda about it. Still lifes with family photographs and bric-a-brac on board walls, a white-sheeted bed, interiors with carefully arranged household goods, were master-pieces of the genre, taking the objective style of the 1920s and 1930s to a culmination. Not surprisingly, Evans's early pictures of show windows and interiors in New York and buildings in "old New England" occasionally recall the unpretentious realism of a Eugène Atget.

In 1938, Evans began photographing passengers in the New York subway with a concealed lens. The resulting portraits, of which the sitters were oblivi-ous, were of a quite unprecedented kind: people lost in thought, unaware of being observed, their gazes empty, waiting without expectation. Out of discre-tion, Evans did not publish a selection of these images until 1966, under the title *Many Are Called.* The book represented street photography of a spe-cial kind, a panorama of anonymity and human alienation—an American counterpart to the "humanistic" photography of a Doisneau, Ronis, or Cartier-Bresson, whose insouciant charm glossed over the fact that we are all, ultimately, alone.

In his early 40s, Evans made a name for himself at *Fortune* magazine, initially as a photographer, later with increasing editorial responsibility. During these 12 years emerged several series, including one of tools in sharp focus (*Auger Drill Bit with a Flared Screwdriver End*, 1955), and a color series on hydrants, street posts, and traffic and information signs entitled *Street Furniture*: expression of a prosa-ic realism far from all symbolic metaphor. Evans cautioned against the temptations of color photog-raphy, saying that "Many photographers are apt to confuse color with noise." Still, this did not prevent him from buying a Polaroid camera a year before his death ("nobody should touch a Polaroid until he's over sixty"), with which in one great splurge he shot over 2,650 more pictures, of houses and sheds, inte-riors, people—and, of course, signs.

1903 Born in St. Louis, Missouri, USA
1922–1923 Studies literature and lan-
guages at the Phillips Academy,
Andover, Massachusetts
1926–1927 Visits Europe; attends
literature lectures at the
Sorbonne, Paris
1931 Photographs Victorian architec-
ture in New England
1933 Takes photographs for Carleton
Beals's book *The Crime of Cuba*;
first one-man show at the
Museum of Modern Art, New York
1935 Documents the exhibition *African
Nego Art*, Museum of Modern Art
1935–1937 Commissioned by the
Resettlement Administration
(RA), later renamed Farm Security
Administration (FSA), in West
Virginia and Pennsylvania, fol-
lowed by the Deep South
1938 Begins his *Subway* series
1941 Publishes *Let Us Now Praise
Famous Men*, with James Agee
(31 photographs); the 1960 edition
will contain 62
1942 Takes photographs for Karl A.
Bickel's book *The Mangrove
Coast: The Story of the West Coast
of Florida* (32 photographs)
1945–1955 Works as the staff pho-
tographer, later associate editor,
of *Fortune* magazine
1966 Publishes *Many Are Called*, with
an introduction by James Agee
(89 photographs)
1975 Dies in New Haven, Connecticut

FURTHER READING
Maria M. Hambourg et al., *Walker
Evans*, exh. cat. The Museum of Modern
Art, Princeton, 2000
Judith Keller, *Walker Evans: The Getty
Museum Collection*, London, 1995

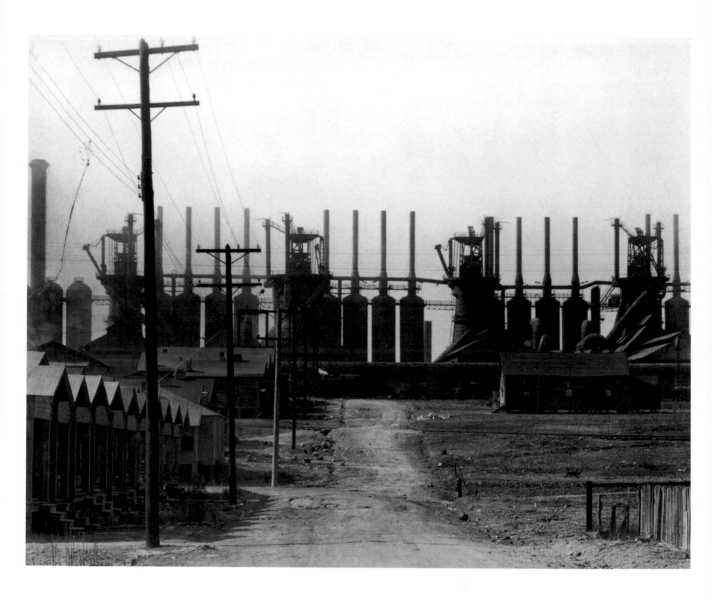

Birmingham Steel Mill and Workers'
Houses, 1936

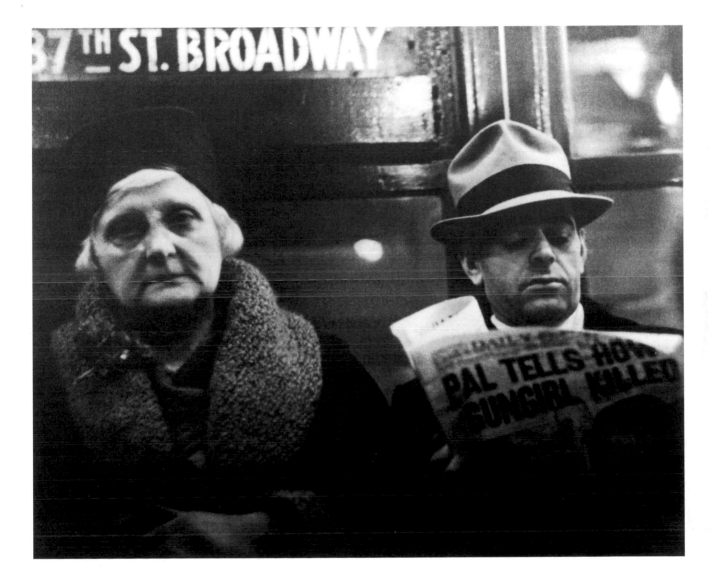

Subway Passengers, New York, 1938

1887 b. Le Corbusier, Swiss-born
French architect

1915 b. Frank Sinatra,
US American singer

1931 Construction of the
Empire State Building
is completed in New
York City

1919 Bauhaus founded by Walter Gropius in Weimar

1855 1860 1865 1870 1875 1880 1885 1890 1895 1900 1905 1910 1915 1920 1925 1930 1935 1940

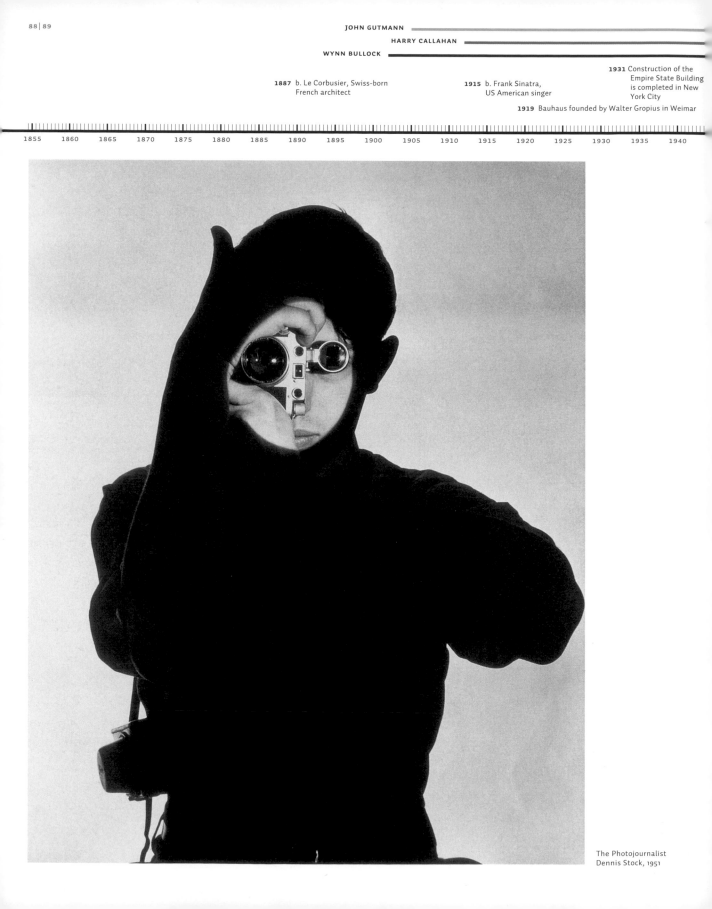

The Photojournalist
Dennis Stock, 1951

1939–1945 World War II **1969** Apollo Moon landing

1988 Red Army begins withdrawing
from Afghanistan

1955 The Family of Man exhibition at the
Museum of Modern Art, New York

1990 Summit Meeting of the 34 OSCE countries
in Paris decrees the end of the Cold War

| 1945 | 1950 | 1955 | 1960 | 1965 | 1970 | 1975 | 1980 | 1985 | 1990 | 1995 | 2000 | 2005 | 2010 | 2015 | 2020 | 2025 | 2030 |

ANDREAS FEININGER

Feininger's extreme telephoto images of New York streets are classics: lunch hour crowds milling along Fifth Avenue, the world's then-tallest building seen from across the Hudson River with the New Jersey meadows in the foreground, the cemeteries of Brooklyn. Feininger was a tireless observer of the metropolis, and—a truly unusual combination—of objects in nature.

Unlike Weston and Evans, Feininger discovered the United States not as an American but as a newly arrived émigré. To his eye everything appeared gigantic, the country's wide open spaces magnificent. His photographs of New York, Chicago, the East Coast, Florida and California were those of a perpetually astonished traveler. He recorded the harbors of New York, skyscrapers under construction, branching railroad tracks and elevated trains, the beaches at Coney Island and along the Atlantic coast. For Feininger, the enormous size and age of the redwood trees and bristlecone pines made them Californian monuments, and on the way there he captured the humble sights along Route 66, small towns with their filling stations, motels, and outgrowths of signs. Death Valley, Yellowstone, Pueblo Acoma, the great dams … avoiding postcard clichés, Feininger discovered a new world, of lakes freezing over, beaver dams, a cave entrance with hosts of bats flying out of it.

Having studied at the Bauhaus and worked in Le Corbusier's studio, Feininger tended to prefer architecture over people as a subject. It is noteworthy that as well as well-known buildings he photographed modern housing developments (*Van Nuys Gardens* and *Valejo*, both in California, 1947), the no-man's land of parking lots (*Houston, Texas*, 1947), and industrial plants (Standard Oil, Baton Rouge, Louisiana). The Signal Hill oilfields in California provided a contemporary counterpart to the redwoods.

In parallel, Feininger tirelessly investigated nature. Linking up with Man Ray, he experimented with solarization, the photogram, or a combination of these techniques, placing oak leaves, dragonfly wings, and other transparent objects in the enlarger or directly on photopaper. As early as 1939, a selection of these studies appeared under the title *New Paths in Photography*.

Close-ups of seashells were styled "goddesses of victory," or "ancient Roman architectures." Devilfish

bones metamorphosed under the photolamps into monuments whose beauty, Feininger thought, surpassed that of many a modern abstract art work. He focused on beetle tunnels in tree bark, on grasses, on ice crystals on window panes, convinced that design was not only a human activity but occurred in nature as well. Feininger's aesthetic sensibility opened new fields for photography. Using apparatus he developed himself, he took macrophotography to a creative highpoint. He tempered the New Objectivity of the 1920s with imagination, built a bridge between nature and technology, and—very much the Bauhaus teacher—he passed his experiences along to the next generation in textbooks on the grammar and syntax of photography.

1906 Born in Paris, France, the eldest son of the artist Lyonel Feininger and his wife, Julia
1922–1925 Trains in cabinetmaking at the Weimar Bauhaus, followed by architecture studies
1927 Installs a darkroom
1919–1931 Works as an architect in Dessau and Hamburg; supplies photographs to the Dephot picture agency in Berlin
1932–1933 Works as an architectural assistant to Le Corbusier
1933–1938 Works as an architectural photographer in Stockholm
1939 Moves to New York
1940–1941 Works for the Black Star Agency
1941 Transfers to *Life*
1943–1962 Permanent employment at *Life*, to which he contributed nearly 350 images
1955 Represented in "The Family of Man" exhibition, Museum of Modern Art
1957 One-man exhibition, *The Anatomy of Nature*, Smithsonian Institution, Washington, DC, which subsequently traveled to 27 cities
1959, 1962, 1969, 1971 Visits Europe
1963 Retrospectives shown at the Smithsonian Institution, Washington, DC, and 1976 at the International Center of Photography, New York
1999 Dies in New York

FURTHER READING
Thomas Buchsteiner and Otto Letze, *Andreas Feininger: That's Photography*, Ostfildern-Ruit, 2004

The United States Leaving New York
Harbor for Europe, 1950

1914–1918 World War I

1933 Surrealist art
magazine *Mino-
taure* founded

1918 End of Austro-Hungarian empire

| 1850 | 1855 | 1860 | 1865 | 1870 | 1875 | 1880 | 1885 | 1890 | 1895 | 1900 | 1905 | 1910 | 1915 | 1920 | 1925 | 1930 | 1935 |

Love (undated)

1945 Yalta Conference	1961 Construction of the Berlin Wall begins	1979 The Soviet Union invades Afghanistan
1950–1953 Korean War	1969 Apollo Moon landing	
1939–1945 World War II	1956 Hungarian Revolution	1973 Picasso dies

1940　1945　1950　1955　1960　1965　1970　1975　1980　1985　1990　1995　2000　2005　2010　2015　2020　2025

BRASSAÏ

Brassaï discovered and photographed grafitti on the walls of Paris buildings—photographs over which Picasso, Dubuffet, and L'Informel artists enthused. He recorded "unintentional sculptures" of crumpled tickets and toothpaste. But above all, Brassaï was a professional night owl who captured the life in the streets of Paris after dark like no other.

He woke up at sunset and did not return home until sunrise—this was the nocturnal life Brassaï led after his arrival in Paris. His first book, *Paris by Night*, collected the most picturesque images from his nightly jaunts: buildings looming over empty streets from whose depths the gaslight filtered magically skywards, the ghostly quais along the Seine, the deserted station of Saint Lazare. Cascades of light over the fountain on the Place de la Concorde were confronted with a warming fire built under a bridge by homeless men. Paris by night—stray cats, patrolling gendarmes, tired prostitutes, workers tarring a street. It would be over 40 years before Brassaï entrusted his most drastic pictures to a publisher: the "secret Paris" of prostitutes and bordellos, the gay and lesbian clubs, the "Negro balls," backstage at the Follies-Bergère …

In 1932, Brassaï began to record the scrawls and scratchings on the walls of Paris buildings, and in 1934 published them in the Surrealist journal *Minotaure*— a "language of the walls" that was more than mere childish pranks. In addition to figures and heads that recalled cave paintings and prehistoric rock drawings, in addition to masks, faces and animals, he discovered configurations he would later collect under the titles "La Magie" and "Images primitives." "These terse symbols," wrote Brassaï in *Minotaure*, "are

nothing less than the beginnings of language; these monsters, these demons, these heroes, these phallic gods are nothing less than elements of a mythology." In 1950, Brassaï became virtually an archaeologist of this unofficial art when he began noting the locations of the images in a sketchbook, "in order to revisit them later under better lighting conditions, or to find them again many years later and record their changes." It was this appreciation for marginal art that prompted John Szarkowski to contrast the "angel of darkness" Brassaï to the blithe spirit of Cartier-Bresson, saying that Brassaï's sensibility, his pleasure in the primitive, fantastic, ambivalent, even bizarre, originated from an earlier age.

To Brassaï we owe the first documentation of Picasso's work in sculpture, including many fragile creations in paper that have since been lost or destroyed, as well as a record of the conversations he had with the artist. And he was an avid visitor of the studios of his illustrious artist friends, whose personalities he recorded for posterity.

1899 Born Gyula Halász in Brasov, Hungarian Transylvania
1918 Attends the Budapest Art Academy
1920 Spends 16 months in Berlin; begins working as a journalist; continues his studies at the College of Visual Arts
1924 Moves to Paris; become a correspondent for Hungarian and German newspapers
1930 Takes up photography
1932 Adopts the pseudonym of Brassaï; contributes to the Surrealist journal *Minotaure*; publishes *Paris by Night*
1932–1934 *Transmutations* (photogravures)
1934 First graffiti photographs appear in *Minotaure*
1964 Publishes *Conversations with Picasso*
1968 Retrospective at the Museum of Modern Art, New York
1976 Publishes *Paris secret des années 30*
1982 *Les Artistes de ma vie*
1984 Dies in Nice

FURTHER READING
Alain Sayag and Annick Lionel-Marie, *Brassaï*, exh. cat. Centre Georges Pompidou, Paris, 2000
Diane Elisabeth Poirier, *Brassaï*, London, 2005

left
Involuntary Sculpture, ca. 1932

page 96
A Suit for Two in the Magic City, Paris, ca. 1931

page 97
Billiards, Boulevard du Rochechouart, Montmartre, ca. 1932

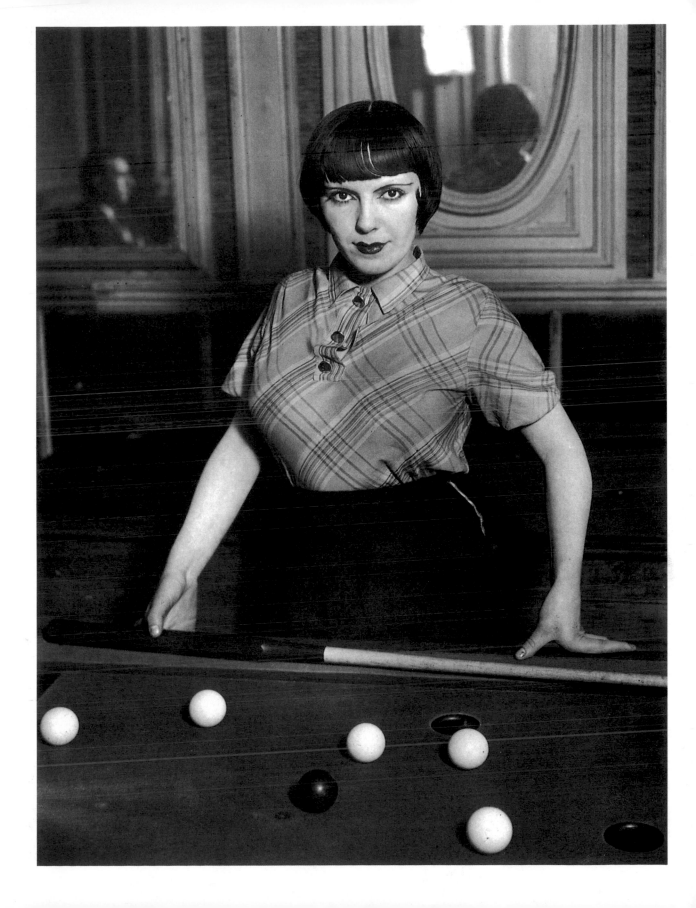

1918 The Treaty of Versailles

1924 Olympic Games in Paris

1939–1945 World War II

1915 b. Edith Piaf, French singer

| 1860 | 1865 | 1870 | 1875 | 1880 | 1885 | 1890 | 1895 | 1900 | 1905 | 1910 | 1915 | 1920 | 1925 | 1930 | 1935 | 1940 | 1945 |

1960 The majority of France's Colonies gain their independence
1959 China annex Tibet
1959 Charles de Gaulle becomes President of the French Republic
1972–77 Construction of the Centre Georges Pompidou in Paris

| 1950 | 1955 | 1960 | 1965 | 1970 | 1975 | 1980 | 1985 | 1990 | 1995 | 2000 | 2005 | 2010 | 2015 | 2020 | 2025 | 2030 | 2035 |

ROBERT DOISNEAU

While other photographers were able to devote themselves to their original projects only in their spare time, Doisneau was lucky enough to be able to use his many commissions for magazines and newspapers to pursue his favorite pastime: exploring Paris by day and night.

Like hardly another photographer, Doisneau captured the *gaieté*, charm and nonchalance of the Parisians, even doing what he could to perpetuate this cliché. For his famous *Kiss in Front of Paris City Hall* (1950), done as part of a reportage on lovers in Paris for *Life*, he hired professional actors and posed them at various "typically Parisian" locations. Several attempts were needed before the scene looked "authentic." Although helping chance along on this occasion, he generally adhered to the following credo: "I always keep my foot a little in the door to let chance come in, pilfer something, or bring something I hadn't thought of."

Doisneau had begun his career with much less nonchalance, as a photographer for Renault, responsible for advertising, industrial, and product photography as well as graphic design, until the automaker fired him after five years for repeatedly manipulating his hated punchcard. Then, thanks to a continuous stream of jobs for French and American magazines, he became a chronicler of Parisian life. In parallel, he illustrated over 60 books with his photographs.

The beginning of Doisneau's career was overshadowed by the war. In 1940, he fled to Poitou, where he took refuge with a farmer's family. In several subsequent reportages he recorded life in Paris, which had come to a standstill under the German Occupation: empty shops, coal and food rationing, the severe war winters. Then the city's liberation: the building of barricades, firefights, respites in the battle, and finally the entry of Charles de Gaulle. A year later, for the Communist magazine *Regards*, he recorded the plight of the *galibots*, child mineworkers—not with the social realism of a Lewis W. Hine in his famous series *Children at Work*, but an array of smiling kids, faces smudged with coal. Soon the economic and cultural upswing brought a range of new subjects. In 1948—nearly 15 years before Ed van der Elsken's *Love in Saint-Germain-des-Près*—Doisneau made a reportage on the quarter that would lastingly shape the popular image of

Existentialist bohemianism. A humorous culmination was a sequence on passersby transfixed by the oil painting of a female nude in the window of the antique shop owned by his friend, the part-time journalist Romi Giraud. Such reportages, or pictures like *The Last Waltz on July 14, 1949*, cemented the image of a perpetually and irrepressibly gay Paris in people's minds on both sides of the Atlantic. On commission from *Vogue* in 1948, a photo series on concierges emerged ("True concierges exist only in Paris ..."). That same year, with Blaise Cendrars as author, Doisneau published *La Banlieue de Paris*. In both this series and his 1951 photographs of clochards (tramps), he struck a more thoughtful note, yet without transcending the boundaries of "humanistic photography." Among his most original creations was a series on scarecrows, published in 1965 under the title *Epouvantables épouvantails* (Scary Scarecrows).

1912 Born in Gentilly sur Seine, France
1926–1929 Trains as a lithographer in Paris, followed by work as an engraver and lithographer
1931–1933 Works as a photographic assistant to André Vigneau
1934–1939 Employed as a photographer for Renault
1939–1940 Serves in the army
1945 Becomes a member of the "Alliance" (Adep) photographic agency, Paris
1946 Starts working for the "Rapho" agency
1949–1952 Regular contributor to *Vogue*
1994 Dies in Paris

FURTHER READING
Peter Hamilton, *Robert Doisneau: A Photographer's Life*, New York et al., 1995

left
Picasso's Bread, Vallauris, 1952

above
Marion Kalter, Robert Doisneau, Paris 1980

1901 b. André Malraux, French Minister of Culture
1901 b. Alberto Giacometti, Swiss sculptor
1900 b. Jacques Prévert, **1914–1918** World War I
French author

1931 2nd Spanish Republic
proclaimed in Spain

1939–1945 World War II

1860 1865 1870 1875 1880 1885 1890 1895 1900 1905 1910 1915 1920 1925 1930 1935 1940 1945

Le Pont de l'Europe, Paris, 1932

1950 1955 1960 1965 1970 1975 1980 1985 1990 1995 2000 2005 2010 2015 2020 2025 2030 2035

HENRI CARTIER-BRESSON

Elegance, sheer beauty, and a wonderful order of forms dominate Henri Cartier-Bresson's oeuvre. With apparent effortlessness this Raphael of photography shot one masterpiece after another. Stroke of luck—the heyday of photojournalism coincided with his best years.

Of the 96 years of his life, Cartier-Bresson devoted half a century to photography, and if he had not succumbed to the temptation of seeking recognition as a painter and draftsman in his old age, this period would have been even longer. "The eye of the century," as Pierre Assouline called him, was an incomparable eyewitness and observer. "It makes one shudder to imagine what all this eye has seen." Cartier-Bresson captured the world in a veritably encyclopedic way. With somnambulistic sureness he was often at places where history was in the making. He visited Mahatma Gandhi shortly before his assassination, and recorded an India in agony (1948). In China, he witnessed the last six months of the Kuomintang government and the victory of Mao Zedong (1949). In Indonesia, he was on the spot as the country was throwing off Dutch colonial rule (1950).

Active for two decades for the Magnum cooperative, which he co-founded in 1947, Cartier-Bresson was a photojournalist, but this apparently light-hearted world traveler and *flâneur* was more than a reporter. He was an adventurer of vision, who not only traveled through countless countries but lived in some of them for a time, in order to gain intimate knowledge of cultures and peoples. He turned his large, childlike eyes not only on historically significant events but also on the vicissitudes of daily life. A gentleman photographer, he detested making his own prints, and entrusted this darkroom work to others.

No other photographer left behind so many icons of the medium as Cartier-Bresson. Take the picture of those two gentleman of Brussels, covertly peeping through holes in a canvas fence (1932), the hatted fellow jumping over a huge puddle behind St. Lazare Station (1932), the ladies of pleasure in Alicante, or—icon of icons—the boy with the bottles on Rue Mouffetard in Paris (1952). Or one thinks of Matisse, photographed in Vence as he was drawing a dove, and the wonderful portraits of Alberto Giacometti. How many timeless portraits Cartier-Bresson pro-

duced, of artists, composers, and writers—sometimes in an unobserved moment, sometimes in a studio session that would have done justice to a psychoanalyst's couch.

The son of a prosperous manufacturing family, whose butler addressed him as "Monsieur Henri" from an early age, Cartier-Bresson belonged to the bright young people of the day, moved easily in high society, and found entry to intellectual circles. He was a habitué of the group around André Breton, high priest of Surrealism, and on friendly terms with Max Ernst, Michel Leiris, and Jacques Prévert. This background explains the meaning of the "decisive moment" in his work, that celebrated fraction of a second or chance instant that became Cartier-Bresson's prime accomplice. It is thanks to the English translation—*The Decisive Moment*—of his book *Images à la sauvette*, published in Paris in 1952, that he became almost too exclusively associated with the "serendipitous moment"—the photographer as hunter, prowling the streets with his Leica, to expose people *in flagranti*. With his demand that photography be unplanned, unexpected, that it simply *happens* by chance, Cartier-Bresson provided a counterpart to Surrealist "automatic writing." "One mustn't force anything," he once said. "If you try to force something, nothing will come of it." Yet more than accident, what really counted for him were geometry and structure. Geometry, infused with musicality and a sense of rhythm, was the true formula of his art. Fittingly, Cartier-Bresson held a lifelong admiration for Paul Cézanne, the father of Cubist abstraction. "Mind, eye and heart must be brought into line," was his photographic credo. And with this classic combination of feeling, rationality, and a clear eye, Cartier-Bresson became the major representative of "humanistic photography" in the 20th century. In 1966, and so during his lifetime, the Louvre honored him with an exhibition, the first ever devoted to a photographer by this illustrious institution.

FURTHER READING
Pierre Assouline, *Henri Cartier-Bresson*, New York, 2005

The Banks of the Marne, France, 1938

1936–1939 Spain's civil war
1937–1945 Sino-Japanese W
1937 *Guernica* (Pablo Picasso
1914–1918 World War I **1931** 2nd Spanish Republic
proclaimed in Spain

1860 1865 1870 1875 1880 1885 1890 1895 1900 1905 1910 1915 1920 1925 1930 1935 1940 1945

| 1950 | 1955 | 1960 | 1965 | 1970 | 1975 | 1980 | 1985 | 1990 | 1995 | 2000 | 2005 | 2010 | 2015 | 2020 | 2025 | 2030 | 2035 |

ROBERT CAPA

It would be misleading to say that Capa took up the profession of war photographer, because it is only since Capa that we know what war photography truly is. He recorded five wars, leaving him very little time for civilian subjects. Capa was a prime representative of a generation of photographers for whom political engagement, profession, and adventure were one.

As early as 1938, the English magazine *Picture Post* described him as "the greatest war photographer in the world," before the Spanish Civil War—Capa's first campaign—had even come to an end. His reportages on the Japanese invasion of China (1938), on the Second World War (1941–1945), the first Israeli-Arab War (1948), and on Indochina (1954), were still to follow. And he was only 40 when he was killed by an anti-personnel mine in North Vietnam. Capa left behind over 70,000 photographs, made for *Life* and *Collier's* magazines, the British *Weekly Illustrated* and *Holiday*, the Magnum Agency, and many more.

Many people thought he was a Spaniard, on account of his short stature and black hair. And his personality must have been charismatic, if even General Ridgway, Commander of the US 82nd Airborne Division, could write to the editors of *Life*: "Mr Capa, by reason of his professional competence, genial personality, and cheerful sharing of all dangers and hardships has come to be considered a member of the Division."

His images reveal not only Capa's mastery of the medium but his empathy and feeling of solidarity with the people he photographed: the Spanish Republican fighters and the victims of the civil war perpetrated by Franco and the Catholic Church; the Chinese child soldiers; Allied troops at the front in Africa, Sicily, Lower Italy, Normandy, the Rhineland. Asked how he managed to make the inhabitants of a Welsh mining region look so relaxed and natural in his pictures, Capa reportedly replied, "Like people and let them know it!"

Twice a refugee himself—from Hungary, then from Nazi Germany—Capa knew what it meant to be forced to leave a city or country. Wherever he went, he recorded the plight of displaced persons—fleeing from bombardments and advancing enemy troops, of the Japanese or Vietminh, or fleeing Israeli immigrants. He focused especially on the misery of children living in wartime.

Two of Capa's images have justifiably become especially famous. One is that of Federico Borrell Garcia, a member of the Republican Army, falling, rifle in hand, on 5 September, 1936, near the village of Cerro Muriano, outside Córdoba. Known as *The Falling Soldier*, this image has become emblematic of the heroic courage of Free Spain. The second photograph shows a helmeted GI swimming ashore on D-Day, June 6, 1944, when the Allied invasion of Normandy began. This image embodies the bravery and sacrifices undergone by Americans, Britons and others as they set out to liberate Europe from Hitler's despotism. The two rolls of film Capa shot at the risk of his life on Omaha Beach were dried at too high a temperature by a laboratory technician at *Life* in London, causing the emulsion to melt. Although 61 of the 72 frames were ruined, the resulting blurred and grainy effect lent this one image its extraordinary effect.

FURTHER READING
Alex Kershaw, *Blood and Champagne: The Life and Times of Robert Capa*, New York, 2003

Naples, October 7, 1943, Central Post Office

IRVING PENN

GILLES PERESS

EVELYN RICHTER

1937 Expo in Paris

1924 Olympic Games in Paris

1914–1918 World War I

1939–1945 World
War II

1860 1865 1870 1875 1880 1885 1890 1895 1900 1905 1910 1915 1920 1925 1930 1935 1940 1945

1964 Vietnam War begins
1961 Construction of the Berlin Wall begins
1968 Student protests
1970 Charles de Gaulle dies
1954–1962 Algerian War
1973 Oil crisis
1988 Red Army begins withdrawing from Afghanistan
1990 Final year of the Cold War era

1950 1955 1960 1965 1970 1975 1980 1985 1990 1995 2000 2005 2010 2015 2020 2025 2030 2035

WILLY RONIS

Even at the age of almost one hundred, Willy Ronis remained a vital and humorous man who could still recount detailed anecdotes about the photographs he had shot 60 or 70 years before. He always took the people we see in his pictures to heart, which likely explains the incomparable humanity that suffuses his work.

The photographs he took in Paris add up to a *voyage sentimental* through half a century, "a living memory," as Henri Raczymow put it, "our own, that of our parents, and that of our grandparents." Ronis's special interest was in people he met in the streets: tradesmen, market vendors, children. The Paris of gala receptions tended to leave him cold. He preferred to roam the quais and markets, the railway stations and parks, the bistros and cafés. He captured the after-work and holiday diversions along the Canal Saint-Martin, the banks of the Marne, and other popular outing destinations. In 1947, he discovered the quarters of Belleville and Ménilmontant, whose unpretentious simplicity and poetry he memorialized in an eponymous book, perhaps Ronis's finest album.

Photography trips took him beyond the Paris city limits to the Vosges, the Alps (1937), to Limousin and Vivarais, to Greece, Yugoslavia, and Albania (1928–1939). After the war, Ronis traveled to Algiers, East Berlin, Prague, Moscow and Venice. "I don't arrange, I deal with chance," he once described his photographic recipe. While many of his colleagues were likewise in league with chance, Ronis never aimed at the humorous point—like Doisneau—or the classical composition—like Cartier-Bresson—but focused on the human aspects of unspectacular, everyday life.

Instructed in piano and violin as a boy and later animated by the desire to become a composer, musicality played a special role in Ronis's art throughout his career. In many of the compositions of this great admirer of Bach and Mozart, we come across structures reminiscent of polyphony. It is a combination of emotionality and rationality that makes Ronis's art special. As he himself once put it, "The beautiful image is geometry modulated by the heart."

1910 Born in Paris
1926 Gets his first camera
1932 Ends his law studies to help his sick father in a laboratory
1936 Takes first photographs for *Regards*; thereafter active as a freelance photojournalist
1938–1939 Documents current events, including the strikes at Citroën
1941–1944 Lives in southern France during the war; takes odd jobs
1945 Begins working for the magazines *Point de Vue*, *L'Écran français*, *Regards*, *L'Illustration*, *Le Monde illustré*, and others. Joins the Rapho Agency; in addition to reportages, commissions for industry, advertising and fashion
1953 Participates in the exhibition *Five French Photographers*, at the Museum of Modern Art, New York (with Brassaï, Cartier-Bresson, Doisneau, and Izis)
1954 Publishes his book *Belleville-Ménilmontant*
1972–1983 Spends most of his time, with wife and son, in Gordes (Vaucluse); teaches in Avignon, Aix-en-Provence, and Marseille
1978 The French nation accepted his archive as a *patrimoine*
1985 Large retrospective in Paris, New York, Moscow and Bologna
Willy Ronis lives and works in Paris

FURTHER READING
Willy Ronis: Mon Paris, foreword by Henri Raczymow, Paris, 1985–1991

left
Provençal Nude, Gordes, 1949

1928 b. Andy Warhol,
US American artist

1941 b. Bob Dylan, US American musicia

1898 b. George Gershwin,
US American composer

1946 UNESCO is established

1950 Racial segregation
abolished in the USA

1939–1945 World War II

1870 1875 1880 1885 1890 1895 1900 1905 1910 1915 1920 1925 1930 1935 1940 1945 1950 1955

1973 Oil crisis
1964 Vietnam War begins
1957 *West Side Story* **1969** Apollo Moon landing
(Leonard Bernstein) **1969** Woodstock Festival
 1969 Richard Nixon becomes President of the USA
1960 John F. Kennedy becomes President of the USA

| 1960 | 1965 | 1970 | 1975 | 1980 | 1985 | 1990 | 1995 | 2000 | 2005 | 2010 | 2015 | 2020 | 2025 | 2030 | 2035 | 2040 | 2045 |

DIANE ARBUS

Initially a fashion photographer, Diane Arbus began freelance work at a relatively late date. Focusing on the human image, in the space of only 13 years she produced an oeuvre that belongs among the most consistent and compelling of the 20th century.

This phase of her career began with a sequence on an autopsied corpse with open ribcage, lying on a dissection table (1959). These images are emblematic of her merciless striving for truth in her approach to human reality. A familiarity with the photographer August Sander is reflected not only in her psychological portrayal of the people of her time, covering a great range of social groupings and individuals—the laconic objectivity of her portraits may also have been inspired by her great German predecessor. Yet Arbus left Sander's system of social classes and social etiquette behind to scrutinize the polarized America of the 1960s.

Again and again it is average people who seem to reveal most about the country: the boy in a straw hat, waiting to march in a pro-Vietnam War demonstration (1967); the kid with a toy hand grenade in Central Park (1962); or *Teenage Couple on Hudson Street, N.Y.C.* (1963). Normal families with children, elderly couples dancing or sitting on a park bench, a few celebrities, and a great many lonely outsiders were the people Arbus captured. And when the inhabitants of an apartment were unavailable, their living room furniture or a Christmas tree with presents in the corner told their story with equal eloquence.

"Everybody has that thing where they need to look one way but they come out looking another way that's what people obeserve." Arbus once aptly described the fine fissure in our self-image, that "gap between intention and effect" on which her portraiture focused. "Scrutinizing reality"—she made no greater or lesser demand of her art.

Her images from the fringes of society perhaps did most to invalidate stereotypes. Arbus pictured transvestites applying make-up in their dressing rooms, celebrating a birthday, or with their hair in curlers; she photographed side-show performers, circus artists, and dwarfs; she attended dances for the handicapped. It was the rites of contemporary America she set out to record, the parties, contests, waiting rooms, theater rehearsals, initiations. The couple in *The Junior Interstate Ballroom Dance Champions, Yonkers, N.Y.* (1962), hardly more than children, reflect the potential of this superb project. Paradoxically, yet quite logically, her images frequently include masked or costumed figures, her concern being to look behind the masks we all wear. A special twist on the unmasking theme was provided by the nudist camps Arbus visited several times—a world diametrically opposed to that seen in fashion photography.

Although she focused on individuals, her portraits convey general statements on the human condition. In view of the impossibility of taking pictures of everybody on the planet, she dared—by depicting individual idiosyncrasies—to convey the image of "a kind of generalized human being."

1923 Born Diane Nemerov in New York, USA
1950s Works as a fashion photographer for *Vogue* and *Glamour*, with her husband, Allan Arbus
1958 Encouraged by her teacher, Lisette Model, she turns to freelance photography
1964 Receives a stipend from the John Simon Guggenheim Memorial Foundation for the project *American Rites, Manners and Customs*
1967 Exhibition *New Documents: Diane Arbus, Lee Friedlander, Garry Winogrand*, Museum of Modern Art, New York
1971 Commits suicide, 26 July, Greenwich Village, New York

FURTHER READING
Diane Arbus Revelations, exhibition catalogue San Francisco Museum of Modern Art, New York, 2003

Teenage Couple on Hudson Street, NYC

OTTO STEINERT

1959 *The Tin Drum* (Günter Grass)

1888 b. Giorgio de Chirico, Italian painter

1929 Wall Street Crash crash

1949 Democratic Republic of Germany (DDR) established officially

1939–1945 World War II

1949 The Federal Republic of Germany is established

| 1875 | 1880 | 1885 | 1890 | 1895 | 1900 | 1905 | 1910 | 1915 | 1920 | 1925 | 1930 | 1935 | 1940 | 1945 | 1950 | 1955 | 1960 |

1965 UNICEF awarded Nobel Peace Prize **1990** Reunification of Germany

1963 Ludwig Erhard becomes **1980** In Poland, the independent trade
Chancellor of Federal Republic union Solidarity is established
of Germany **1974** Guillaume Affair; Willy Brandt resigns as Chancellor of Federal Republic of Germany

961 Construction of the Berlin Wall begins

1965	1970	1975	1980	1985	1990	1995	2000	2005	2010	2015	2020	2025	2030	2035	2040	2045	2050	

ROBERT HÄUSSER

At a time when no one in Germany dared to give photography the status of an art, Häusser made it absolutely clear that he considered himself an artist. He called his works "photographic images," precluding any association with random snapshots.

In retrospect, the abstract titles he gave his works were not necessary to underscore their artistic character: *Relative Orientations* (1972) for the picture of a street with white markings and reflecting posts; *Lost Place* (1982) for a brick façade with walled-up entrance. Works from his "Bright Period," which followed upon the dark pictures taken in a rural environment during the war and reconstruction years, drew their charm from many a fleeting moment and a fascination with serial structures typical of the period of "Subjective Photography."

Later, nothing lay further from Häusser's mind than momentary impressions. His images were built with a truly architectural solidity. A sonorous black is set against bright textures, and the range of halftones reduced. Häusser is a master of minimalism, focusing on only a few objects and lending them monumentality. He is intrigued most by massive, cubic forms. Yet he avoids a purely abstract play of forms by means of backgrounds reminiscent of Italian Metaphysical Painting or Surrealism. In

his self-portrait (1981) he looks like an actor on stage.

Objects concealed under cloth, such as a concert piano or Jochen Rindt's race car after his fatal accident (1970), reflect Häusser's Magic Realism at its best. It was no coincidence that he always felt attracted to cemeteries, like Père Lachaise in Paris (1957), in San Miniato (1981) and Staglieno (1982), as they provided ideal sites for a combination of cubism and symbolism. Animals appear in his work either dead and skeletized or as cadavers hung on hooks. With a hermetic approach not dissimilar to Josef Sudek's, Häusser attempted to set something timeless against the increasing secularization of society. Ordinary everyday life is almost completely excluded from this static world. People appear—as if in continuation of August Sander's approach—as representatives of occupations: *Musician* (1958), *Fishmonger* (1959), *Head Waiter* (1963), *Racing Driver* (1967). In addition, Häusser created a series of remarkable portraits of artists and art dealers.

1924 Born in Stuttgart, Germany
1940 Takes first photographs
1941–1942 Attends the College of Graphic Arts, Stuttgart; serves in the army and is takes as a prisoner of war
1946 Settles at his parents' farm in Mark Brandenburg
1950–1951 Studies at School of Applied Art, Weimar
1951 Sets up his own studio in Mannheim; jobs for industry and in advertising; numerous commissioned trips through Europe, to North and South America, and East Asia
1972 Begins concentrating solely on freelance work
Robert Häusser lives in Mannheim and on Ibiza

FURTHER READING
Robert Häusser, Claude Sui, Fritz Gruber, *Robert Häusser: From the Photographic Oeuvre 1938–2004*, Heidelberg 2004

left page
Cimetière I. Classe, 1957

left
Market, Early Morning, 1953

above
Robert Häusser, Self-portrait, 1981

1939–1945 World
War II

1948 Universal Declaration
of Human Rights before
UN General Assembly

1957 Ghana gains independ-
ence from Great Britain

1875 1880 1885 1890 1895 1900 1905 1910 1915 1920 1925 1930 1935 1940 1945 1950 1955 1960

Man in Wide Boubou with Daughter,
Bamako, 1950–1960

1960 The Mali Federation between Senegal and Sudanese
Republic gains independence from France
1965 UNICEF awarded Nobel Peace Prize
1962 Algeria gains independence from France
1967 Six-Day Arab-Israeli War

South East Essex College
of Arts & Technology
Luker Road, Southend-on-Sea Essex SS1 1ND
Tel:(01702) 220400 Fax:(01702) 432320 Minicom: (01702) 220642

1965 1970 1975 1980 1985 1990 1995 2000 2005 2010 2015 2020 2025 2030 2035 2040 2045 2050

SEYDOU KEÏTA

During the golden age of African portrait photography, Seydou Keïta was the doyen in the field. Okwui Enwezor once called him "the August Sander of West African photography." His life's work in fact amounts to a single great portrait of society in French Sudan, which celebrated its independence in 1960 as the Republic of Mali.

During the final years of French colonial rule in West Africa, and thus of white-run portrait studios, local people began to take the place of their former mentors and provide photographs "by Africans for Africans." Keïta began with a simple box camera and basically taught himself the craft of photography. It was a Frenchman, Pierre Garnier, who encouraged him to develop his films and make his own prints. At 25 he opened a studio, complete with electric light, still a rarity at the time. Soon Keïta was in great demand as a portraitist of the bourgeoisie, and his reputation spread far beyond the region. The citizens of French Sudan—individuals, couples, families, groups of friends—posed for his camera in their Sunday best, complete with an array of status symbols.

Keïta's portraits are characterized by great care in the choice of accessories. With a fine sense of decorative effect, he posed his sitters in front of elaborately patterned fabrics that transform the portraits into luxurious interiors. These backgrounds combined with the vivid patterns of the sitters' attire to evoke dazzling "tapestries," an image of urban opulence and sophistication on the eve of independence. It was Keïta's aesthetic refinement that set his portraits off from those of his colleagues Abdourahmane Sakaly (Mali), Cornelius Y.A. Augustt (Ivory

Coast), James K. Bruce-Vanderpuye (Ghana), and Narayandas V. Parekh (Kenya).

Keïta was the only one of these early African portraitists to use 13 x 18 cm flat negatives, from which he generally took contact prints and made enlargements when the client so desired.

Due to the high cost of equipment and materials, none of the representatives of the first generation of African portrait photographers were able to extend their activities beyond commissioned work. Keïta's oeuvre as we now know it originated in the late 1940s and the 1950s. In the early 1960s, he entered the employ of the Sûreté Nationale. His work for this institution remains publicly inaccessible. Keïta retired in 1977. It is thanks to the research of André Magnin that his work, after years of obscurity, was brought to light during Keïta's lifetime and earned him great international recognition.

1923 Born in Bamako, French Sudan, now Mali
1948 Opens his own photographic studio on his father's premises
EARLY 1960S Works for the Sûreté Nationale (until 1977)
1993 Retrospective at the Fondation Cartier pour l'art contemporain, Paris
1994 Participates in 1ères Rencontres de la Photographie Africaine, Bamako
1996 Retrospective at the National Museum of African Art, Smithsonian Institution, Washington, DC
1996 Represented in the exhibition *In/sight: African Photographers, 1940 to the Present*, Solomon R. Guggenheim Museum, New York, and numerous further exhibitions in Arles, Barcelona, Birmingham, Copenhagen, London, Paris, Rouen, and other European cities
2001 Dies in Bamako

FURTHER READING
André Magnin (ed.), *Seydou Keïta*, Zurich, Berlin and New York, 1997

left
Portrait of a Woman, Bamako, 1950–1960

1885 b. Ezra Pound, American poet

1850 1855 1860 1865 1870 1875 1880 1885 1890 1895 1900 1905 1910 1915 1920 1925 1930 1935

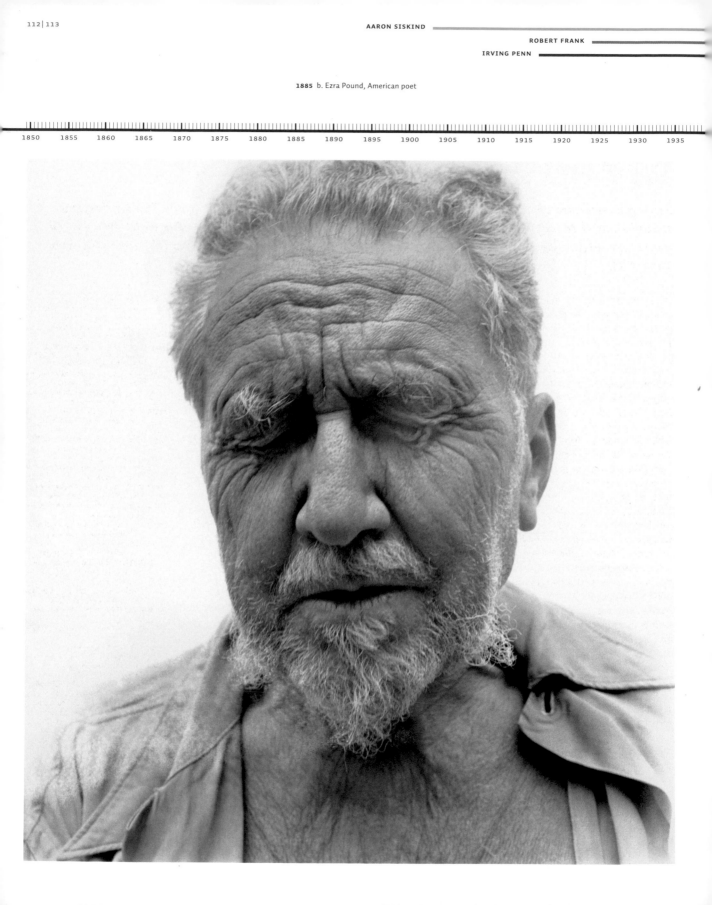

1939–1945 World War II 1957 *West Side Story* (Leonard Bernstein) 1969 Apollo Moon landing

1963 "I Have a Dream" speech (Martin Luther King)

1964 Vietnam War begins

1946 UNESCO is 1962 The Rolling Stones is formed 1980 John Lennon is murdered

established 1960 John F. Kennedy becomes President of the USA

1940 1945 1950 1955 1960 1965 1970 1975 1980 1985 1990 1995 2000 2005 2010 2015 2020 2025

RICHARD AVEDON

Already a celebrated photographer by the age of 22, Avedon began taking photographs for Harper's Bazaar. *When he was 31 Marilyn Monroe came to his studio. He himself had the looks of a male model and collected awards and prizes galore. He was on the road again for* The New Yorker *when he died during a photo shoot. He was 81.*

In his 20s, Avedon had already achieved a success other photographers only dream of. Pictures of a street actress on Piazza Navona, taken in Rome in July 1946, of children in Trastevere and Palermo, marked his farewell to "everyday life" before his meteoric rise in the glamorous world of fashion tycoons and mannequins. For 45 years Avedon served as staff photographer, first with *Harper's Bazaar*, then with *Vogue*. For over 35 years he flew every summer to Paris to record for *Harper's Bazaar* the presentations of the great fashion houses.

Yet Avedon's true fame rests on his portraits. These unforgettable images include those of the contralto Marian Anderson (1955), the Danish author Isak Dinesen (1958), and the poet Ezra Pound, eyes tight shut (1958). His shot of Peter Orlowski and Allen Ginsberg embracing each other in the nude (1963) was just as scandalous as the group portraits of members of Andy Warhol's Factory undressing (1969). Then there was the shocking image of Warhol's stomach, scarred by a feminist's assassination attempt (1969).

Avedon's portrait style was inventive and monumental. He invariably attempted to show a personality from an unfamiliar angle. Without striving for effects, he often relied on compositional devices to look behind the cliché.

No one appeared more often in his viewfinder than his father, Jacob Israel Avedon. The resulting sequence is at once a unique document of the respect and admiration of a son after a period of estrangement, and a poignant record of ageing and physical decline. Avedon's exhibition of these portraits at the Museum of Modern Art in 1974 amounted to an homage both to his father and to the dignity of man.

Avedon's greatest portrait project occupied him for over six years. On the initiative of the Amon Carter Museum in Fort Worth, Texas, he took a portable white backdrop through 17 western states and photographed 752 people. As an exhibition and book entitled *In the American West*, the series caused a furor, showing average Americans from housewives, salesgirls and mine workers to butchers, and ranchers. Bill Curry, a drifter he met on Interstate 40 in Yuko, Oklahoma, appeared alongside the truck driver Billy Mudd, of Alto, Texas, and the beekeeper Ronald Fischer, his naked body covered with bees.

1923 Born in New York, USA
1942–1944 Serves as a photographer in the US Merchant Marine
1944–1950 Studies under Alexey Brodovitch, art director of *Harper's Bazaar*, at the Design Laboratory of the New School for Social Research, New York
1945–1965 Works as the staff photographer at *Harper's Bazaar*
1947–1984 Photographs Paris fashion collections for *Harper's*
1959 Publishes his first book, *Observations*, with texts by Truman Capote
1962 Exhibits for the first time, at the Smithsonian Institution, Washington, DC
1963 Photographs members of the civil rights movement
1964 Publishes *Nothing Personal*, with an essay by James Baldwin
1966–1990 Serves as staff photographer with *Vogue*
1970 Travels to Hanoi in connection with his anti-Vietnam War engagement
1976 Special issue of the magazine *Rolling Stone*, *The Family*, comprising 73 portraits of the US political elite
1978 Retrospective at the Metropolitan Museum of Art, New York
1979–1985 Works on *In the American West*
1985–1992 Works for the French journal *Egoiste*
1992 First staff photographer for *The New Yorker*
1993 Publishes *Avedon: An Autobiography*
1994–1995 *Richard Avedon: Evidence 1944–1994* exhibition in New York (Whitney Museum of American Art) Cologne, Milan, London
2002 *Richard Avedon Portraits*, The Metropolitan Museum of Art
2004 Dies 1 October, in San Antonio, Texas
2007 Retrospective at Louisiana Museum of Modern Art, Humlebaek/Denmark, Milan, Paris, Berlin, Amsterdam, San Francisco

FURTHER READING
Mary Shanahan (ed.), *Evidence 1944–1994: Richard Avedon*, Munich, 1994

Ezra Pound, at the home of William Carlos Williams, Rutherford, New Jersey, June 30, 1958

Charles Chaplin leaving America,
New York, September 13, 1952

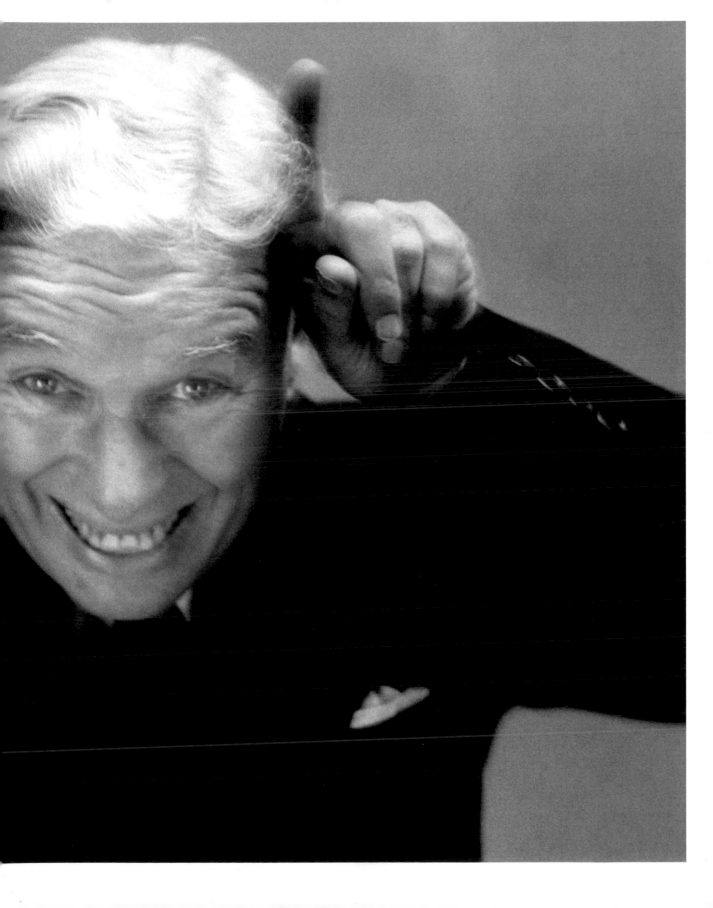

INGE MORATH

RON GALELLA

1939–1945 World War II
1937 *Guernica* (Picasso)
1949 Democratic Republic of German
(DDR) established officially
1929 Wall Street Crash crash **1949** The Federal Republic of German
is established

1870 1875 1880 1885 1890 1895 1900 1905 1910 1915 1920 1925 1930 1935 1940 1945 1950 1955

1953 *Playboy* magazine is founded

1980 In Poland, the independent trade
union Solidarity is established

1961 Construction of the Berlin Wall begins

1990 Reunification of Germany

1962 First James Bond Film (*Dr. No*)

1960　1965　1970　1975　1980　1985　1990　1995　2000　2005　2010　2015　2020　2025　2030　2035　2040　2045

HELMUT NEWTON

Newton's nudes and fashion photographs are imbued with an aura of glamour and luxury of the kind readers of Vogue *like to associate with the world of the upper crust. The charm of his photography lies in a sophisticated, exaggerated staging, suffused with irony. It would seem that in some of his best shots, Newton takes revenge on the decadent world of illusion he himself helped to create.*

Considered the high-heel photographer par excellence, Newton worked with the highest-paid mannequins and extras, but not in the studio, because "A woman does not live in front of white paper. She lives in the street, in a motor car, in a hotel room." Miami, Paris and Beverly Hills were such locations, and Newton reputedly transformed his place of residence, Monte Carlo, into an open-air studio. Yet even more often than at exotic sites, he photographed in familiar surroundings or at places "no farther than three kilometers" from his hotel.

The effect of Newton's brazen nudes and seminudes derives from choice of setting, which frequently evokes a James Bond film, a road movie, thriller, or indeed a soft porno. There is doubtless a frisson in seeing females with cigars, handcuffs, and drawn guns, as if in some movie still, or in a leather corsage, in the role of *domina* or prostitute. Newton was also partial to the device of contrast, posing his beauties beside backhoes, tractors, or on a ledge above Hoover Dam—Amazons invading a man's world.

Renowned fashion houses commissioned Newton—a "gun for hire," as he jokingly styled himself—to photograph their new collections for the catalogues: Chanel, Yves Saint Laurent, Versace, Thierry Mugler, Blumarine. For other companies he did advertising, carefully respecting his clients' wishes and preferences. This commercial work gave him all the more freedom to do as he liked in his freelancing.

Newton also took outstanding portraits, of the Cardins, Ferrés and Versaces, but also of personalities such as Heinrich Harrer, Anthony Hopkins, Leni Riefenstahl.

Alice Springs once photographed her husband Helmut Newton clad only in a blouse, ladies' hat and pumps on the terrace in Monte Carlo, an image that perhaps more than any other attests to the humorously ironic relationship of the master of eroticism to such subjects, and to himself.

1920 Born in Berlin, Germany
1936–1938 Serves an apprenticeship with Yva (Else Simon)
1938 Flees Germany for Singapore; works for the *Singapore Straits Times*
1940–1945 Works as a truck driver and rail-worker for the Australian Army
1946 Opens a photographic studio in Melbourne; becomes an Australian citizen
1948 Marries the actress Jane Brunell (Browne), who will take up photography in 1970, under the name Alice Springs
1961 Begins regular contributions to French, American, Italian, and German *Vogue*, and to *Linea Italiana, Queen, Nova, Jardin des Modes, Marie Claire, Elle*, and other magazines
1976 Publishes his first book, *White Women*
1981 Settles in Monte Carlo; publishes *Big Nudes*
1984–1985 *Helmut Newton: Mode et Portraits*, Musée d'Art Moderne de la Ville de Paris
1986 *Helmut Newton: Portraits*
1992 *Pola Woman*
1998–2000 *Us and Them: Helmut Newton & Alice Springs: 50 Years Together—Personal Photographs*, shown internationally
1999 *Helmut Newton: SUMO*
2000–2001 *Helmut Newton: Work*, Neue Nationalgalerie, Berlin
2004 Dies in Los Angeles

FURTHER READING
Helmut Newton. Work, exh. cat. Neue Nationalgalerie, Berlin, Cologne, 2000
Helmut Newton: A Gun for Hire, Cologne and London, 2005

left
Self-portrait with Wife and Model

right
Niklaus Stauss, Helmut Newton in his exhibition at Fotomuseum Winterthur, Switzerland, July 1994

1939–1945 World
War II

1950 Racial segregation
abolished in the USA

1946 UNESCO is established

1875 1880 1885 1890 1895 1900 1905 1910 1915 1920 1925 1930 1935 1940 1945 1950 1955 1960

Hair Blowing in Face (undated)

60 John F. Kennedy becomes President of the USA
1964 Vietnam War begins
1962 Cuban Missile Crisis **1970** Martin Luther King is murdered
1968 Fall of Salvador Allende
1963 John F. Kennedy is murdered

1965 1970 1975 1980 1985 1990 1995 2000 2005 2010 2015 2020 2025 2030 2035 2040 2045 2050

GARRY WINOGRAND

The sites of Winogrand's compelling photographs range from the New York club El Morocco to the zoo, from the boxing world to the rodeo. A true "street photographer," he was at his best capturing images of the streets and squares of New York and other US cities.

When a city is still intact, its streets are not merely traffic arteries but places where people meet and greet each other, a theater where neighbors and passersby make their entrances and exits—the world stage begins right outside our front door. Winogrand viewed this stage from ever-different angles, exchanging the psychologist's lens for that of the amused *flâneur* or the social commentator. He focused just as much on street artists and parades with acrobats performing on a trampoline as he did on random, anecdotal moments, looking passersby in the face or capturing their hurrying steps in experimentally daring excerpts. Yet unlike William Klein, he kept a respectful distance. Equally diverse are the images Winogrand collected on the road during cross-country trips. He found motifs even in curves of the highway, house driveways, on sidewalks, or glimpses into an open convertible. Many of these pictures add up to an anatomy of American society. Those taken in the late 1960s in particular reflect a country divided against itself, when a state dinner for the Apollo 11 astronauts and upper-class balls and receptions are followed by Vietnam demonstrations and election candidates' public appearances.

Winogrand was also very influential as a teacher, holding countless workshops, teaching at over a dozen colleges and universities, and serving as instructor in Austin, Chicago, and several institutions in New York.

1928 Born in New York, USA
1948 Attends painting class at Columbia University, New York; takes up photography
1949 Holds workshops with Alexey Brodovitch, Design Laboratory, New School for Social Research, New York
1951 Works for *Harper's Bazaar*
1955 Takes photographic trip through the United States; represented in Steichen's exhibition *The Family of Man*, Museum of Modern Art, New York
1964 Receives a Guggenheim Foundation Fellowship for "photographic studies of American life" and spends five months traveling through Texas, Colorado, etc.
1966 Takes part in the exhibition *Toward a Social Landscape*, The George Eastman House, Rochester, New York
1967 Takes photographs in England, Scotland, and France
1968 Represented in the *New Documents*, Museum of Modern Art
1969 Receives his second Guggenheim Fellowship, "to study the effect of the media on events", visits Europe
1970 Publishes *The Animals*
1975 Receives a stipend from the National Endowment of the Arts; publishes *Women are Beautiful*
1977 Publishes *Public Relations*
1978 Third Guggenheim Fellowship
1980 Publishes *Stock Photographs: The Fort Worth Fat Stock Show and Rodeo*
1984 Dies 19 March, in Mexico

FURTHER READING
John Szarkowski, *Winogrand: Figments from the Real World*, New York, 1988

Hollywood Boulevard, Los Angeles
(PC 795), ca. 1980/81

1925 b. Malcom X, US American
Civil Rights activist

1939–1945 World War II

1960 John F. Kenn
president of
USA

1875 1880 1885 1890 1895 1900 1905 1910 1915 1920 1925 1930 1935 1940 1945 1950 1955 1960

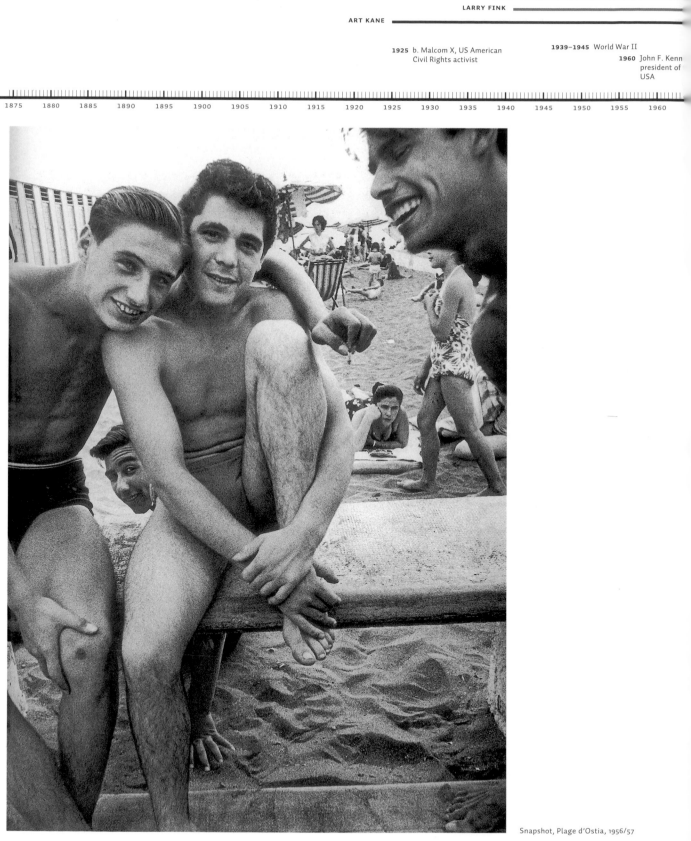

Snapshot, Plage d'Ostia, 1956/57

1969 Apollo Moon landing

1964 Vietnam War begins

1966 Black Panther Party is founded

1987 Mikhail Gorbachev
announces perestroika

2001 Terrorist attacks in the USA

2003 The War in Iraq begins

| 1965 | 1970 | 1975 | 1980 | 1985 | 1990 | 1995 | 2000 | 2005 | 2010 | 2015 | 2020 | 2025 | 2030 | 2035 | 2040 | 2045 | 2050 |

WILLIAM KLEIN

People, people, and more people—for William Klein, the earth is a planet of human beings, who live packed together in New York, Rome, Tokyo, and Paris. He has devoted a book to each of these great cities, or rather to their inhabitants, and has missed hardly a public event in order to get as close to their stories as he can.

Compiled in 1954–1955, when Edward Steichen prepared and opened his exhibition *The Family of Man*, his book *New York* is a homage to the human turbulence of the metropolis. Klein combines extreme close-ups of faces with merciless excerpts, daring worm's-eye views with blurring. He brings us face to face with city dwellers who, young or old, are not put off by the camera lens and whose reactions to the photographer contribute much to the expressiveness of many scenes. It is thanks to Klein's communication skills that he was able to infuse "anonymous" groups of people with such life. Over the years he would make about 30 films (and over 250 ad spots), on Muhammad Ali (*Cassius le grand*), the Black Panthers, and other subjects. The dynamism of his photographs already contained a seed of the cinematic. Klein denied both racial segregation and aesthetic categories. In his imagery high and low blend, signs, posters and billboards merge in the great visual melting pot of New York.

Over the following years he photographed in Rome, Moscow, and Tokyo. The city of Paris, on the other hand, though he knew it well and had an apartment there, he approached only with hesitation. Seen through the lens of hundreds and hundreds of earlier photo books, Paris initially seemed to him romantic, foggy, and above all monoethnic, a gray city inhabited by whites. When he finally began to focus on it, Klein discovered the city's modernity, its incredible futurism, by comparison to which New York suddenly looked old-fashioned. Using color film, Klein photographed crowds, demonstrations and riots, not to mention nightclubs, tournaments, and debutante balls. And then the funerals of Charles de Gaulle, Tino Rossi, Charles Trenet, and Yves Montand, with which, ironically, Klein opened his book. No other city, one gains the impression, could boast more civil courage and political consciousness than Paris. Interspersed images from commercial jobs for fashion houses add a note of profligate elegance.

This was Paris before the riots in the *banlieus* began, which made it clear that the inhabitants inside the periphery lived in a show window to the world and had almost forgotten the hordes of underprivileged immigrants around them.

1928 Born in New York
1947 Visits Paris for the first time as a GI; later, enters the studio of André Lhote and Fernand Léger
1956 First winner of the Prix Nadar, for his photographic diary
1954–1955 Takes photographs for the book *New York*
1955–1956 Takes fashion photographs for *Vogue*
1956–1957 Compiles images for *Rome*
1958 Begins series of over 20 documentary and feature films
1959–1961 Compiles images for *Moscow*
1961 Photographs for *Tokyo*
1962 Makes the film *Les français et la politique*
1966 Makes the film *Who Are You, Polly Magoo*
1964–2002 Takes photographs for the book *Paris*
Lives in Paris

FURTHER READING
John Heilpern, *William Klien*, New York, 1981
Alain Sayag, *William Klein*, Paris, 2005

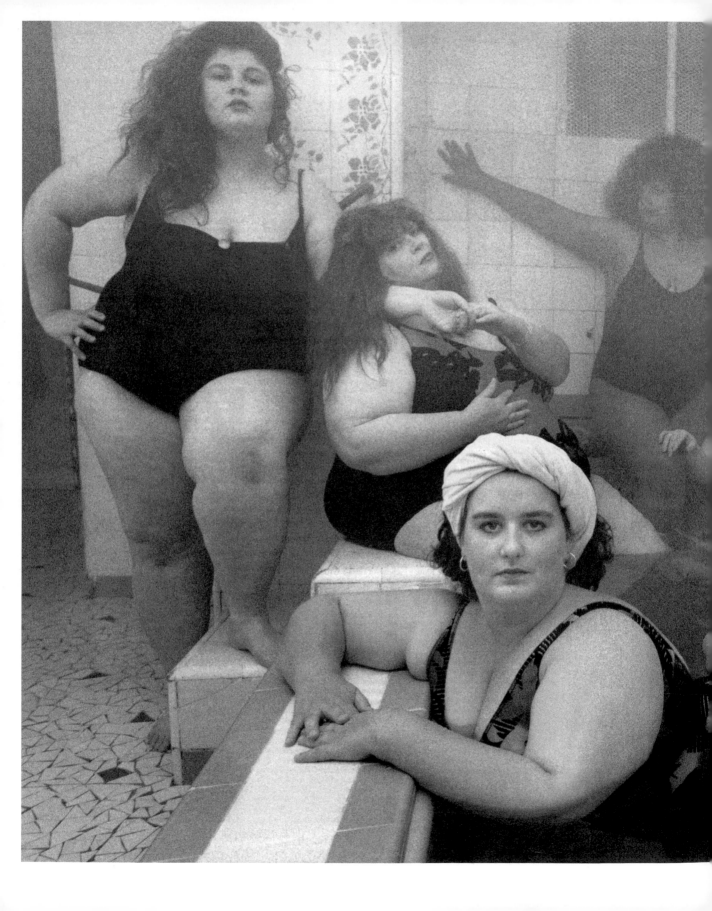

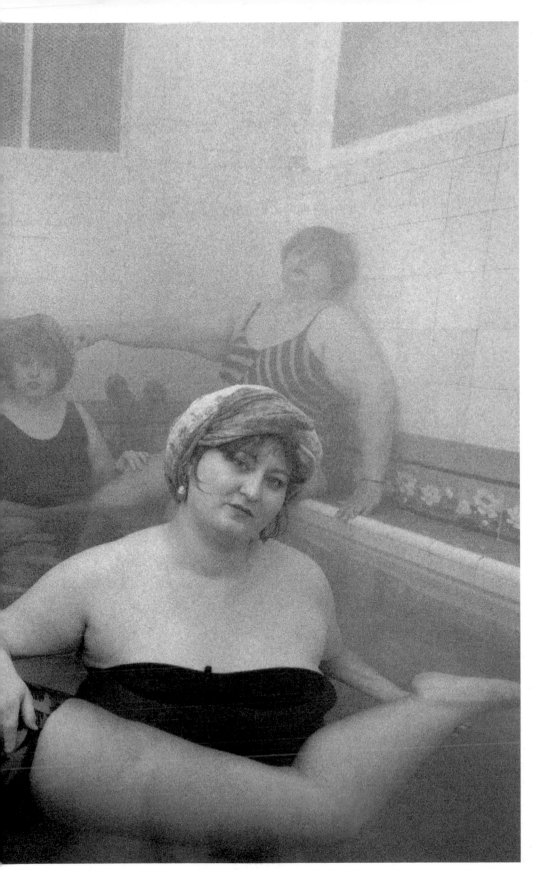

Club "Allegro Fortissimo," Paris 1990

1938 Kemel Atakürks dies

1926 Reception of Swiss
civil right codes in
Turkey

1939–1945 World War II

1875 1880 1885 1890 1895 1900 1905 1910 1915 1920 1925 1930 1935 1940 1945 1950 1955 1960

1979–1989 War in Afghanistan **1990** Reunification of Germany

1983 The Turkish part of Cyprus **2003** Terrorist attacks in Istanbul
declares independence **2003** The War in Iraq begins

961 Construction of the Berlin Wall begins **1984** The PKK launches its armed independence campaign

1965 1970 1975 1980 1985 1990 1995 2000 2005 2010 2015 2020 2025 2030 2035 2040 2045 2050

ARA GÜLER

A native of Armenia, Güler was active as a Near East correspondent for glossy magazines and in the course of his long career traveled most of the world, except for South America. He portrayed a range of celebrities, recorded hundreds of buildings by Sinan, greatest of all Ottoman architects, yet returned again and again to his favorite motif—Istanbul and devoted a unique homage to the city on the Bosphorus.

If New York is associated once and for all time with the photographs of William Klein, Paris with Atget, Kertész, Brassaï, Doisneau, and Ronis, no one will be able to think of Istanbul in future without recalling Ara Güler. He is known as the city's keenest eye, not as a chronicler or archivist but as a man who walked its streets and observed all its goings on. Güler's Istanbul is the city of dockworkers and porters, water and tea vendors, fishermen and artisans; his style a social realism that sees working people not as a class but as inhabitants of a city, and in consequence does without Marx and Engels.

One of his favorite haunts was Galata Bridge and the nearby neighborhoods, and he recorded life in Eminönö before it was razed in 1959. Just as Atget avoided the grand boulevards of Paris, Güler provided a picture of "old Istanbul"—its horse-drawn carts and slow barges, when hammer blows still echoed from the docks and the traffic-tailored, high-rise modern city and nationalism were still a thing of the future. His images spirit us nostalgically back to a time when you could walk past "garden gates covered with the purple flowers of the Judas tree." It is the Istanbul of fish restaurants, old Ottoman wooden houses, flaking façades—and poverty. Güler attempted to capture a "vanishing world," as he himself once admitted.

It may have been Brassaï's views of Paris by night that inspired Güler to wander the nocturnal city, collecting atmospherically charged images in the music bars and nightclubs of the popular Beyoğlu quarter. His pictures of ferries crossing the Bosphorus at daybreak, seeming to echo with the cries of seagulls, evoke the expanse of this metropolis spanning two continents. From 1950 to 1990—before the economic boom in Turkey set in—Güler followed the development of his home city in photographs, collecting the masterpieces from these four decades in the volume *A Photographical Sketch on Lost Istanbul.*

1928 Born in Istanbul, Turkey, son of an Armenian pharmacist
1950 Trains as an actor, then studies economics and photographs for the newspaper *Yeni Istanbul*
UNTIL 1961 Works as chief photographer for the magazine *Hayat;* then Near East correspondent for the new Turkey office of *Time-Life,* later for *Paris-Match* and *Der Stern*
1961 Becomes the only Turkish member of the American Society of Magazine Photographers; from 1951, works as a correspondent of Magnum, Paris
FROM 1975 Makes portraits of Bertrand Russell, Winston Churchill, Arnold Toynbee, Picasso, Dalí, and others; *Ara Güler's Creative Americans* published
1980 *Ara Güler–Photographs* published in Turkey
1989 His portraits from the movie scene appear in *The Movie World of Ara Güler;* visits Indonesia, Malaysia, and Brunei in connection with the publishing project *A Day in the Life of...*
1992 Photographs of buildings by the greatest Ottoman architect Sinan appear in *Sinan, Architect of Soliman the Magnificent;* exhibition of the Sinan photographs at the Expo Seville; photographs for the book *Living in Turkey*
1994 *A Photographical Sketch on Lost Istanbul*
1995 *Vanished Colours* and *All the World in Their Faces*
Ara Güler lives in Istanbul

FURTHER READING
Ara Güler, *All the World in their Faces,* Istanbul, 1995

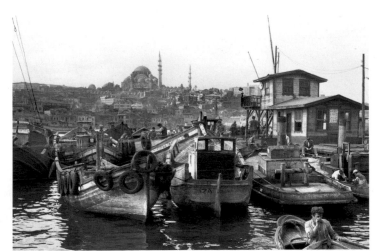

left page
Water Sellers at the Hamidiye Fountain near the Galata Seraglio, 1952

left
Boatmen at the Repair Shipyard, 1956

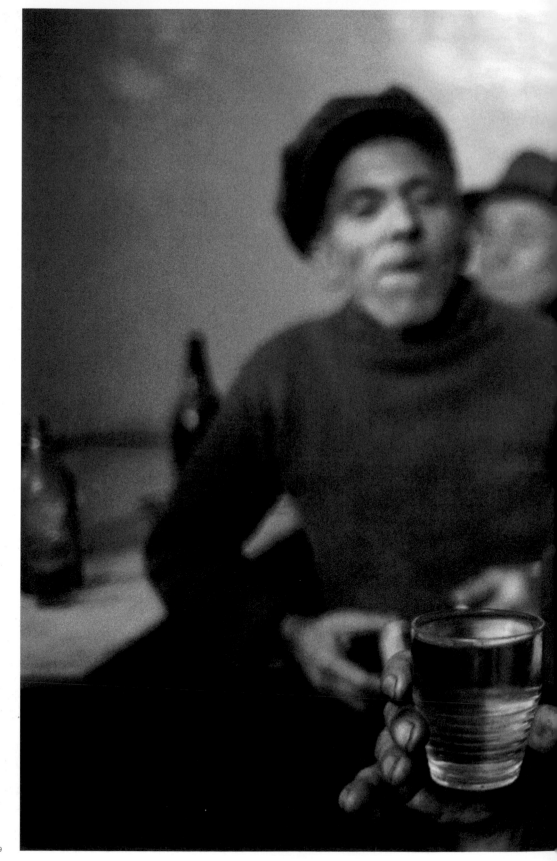

Drunken Man in a Bar in Tophane, 1959

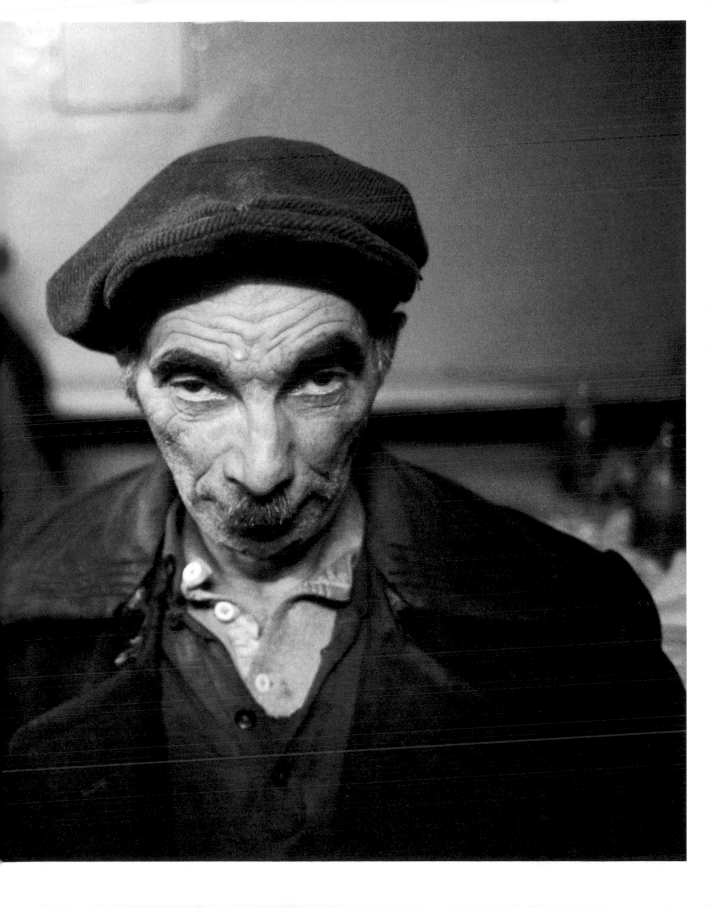

PETER MAGUBANE ▬▬▬▬▬▬▬▬▬▬

JÜRGEN SCHADEBERG ▬▬▬▬▬▬▬▬

GUY TILLIM ▬▬▬

1948 Universal Declaration of Human Rights
before UN General Assembly

1923 b. Nadine Gordimer, **1948** National Party wins elections in South Africa
South African playwright **1939–1945** World **1950** Racial segregation abolished
War II in the USA

| 1880 | 1885 | 1890 | 1895 | 1900 | 1905 | 1910 | 1915 | 1920 | 1925 | 1930 | 1935 | 1940 | 1945 | 1950 | 1955 | 1960 | 1965 |

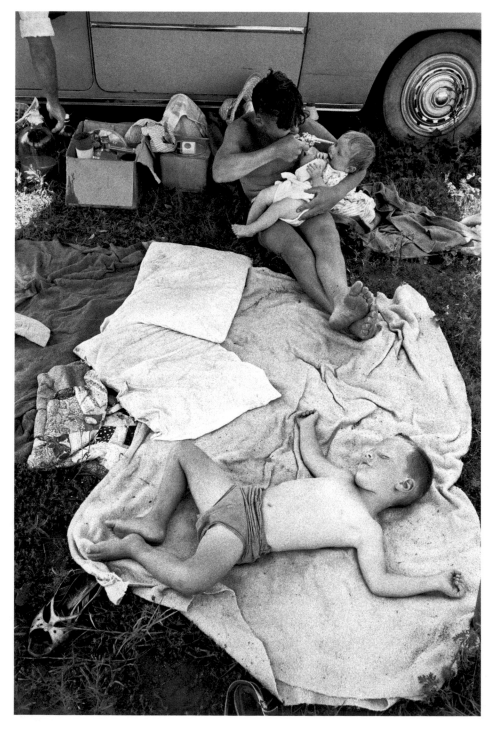

Picnic on New Year's Day, Hartebeespoort,
Transvaal, 1965

962 Nelson Mandela is arrested

1967 Start of Six-Day War

1990 Miriam Makeba returns to
South Africa after her exile
1993 Nelson Mandela/Frederick de Klerk
awarded Nobel Peace Prize
1994 Termination of Apartheid
in South Africa

2001 Terrorist attacks in the USA

2003 The War in Iraq begins

1970 1975 1980 1985 1990 1995 2000 2005 2010 2015 2020 2025 2030 2035 2040 2045 2050 2055

DAVID GOLDBLATT

No other photographer recorded South Africa under apartheid with more psychological penetration than David Goldblatt. From the beginning of the Afrikaner National Party regime in 1948 until its formal end in 1994, he crossed the borderline between the ethnic worlds to show how "in the geology of South African structures are to be read the accretions of our history and the choices we have made."

Goldblatt was not a chronicler in the documentary sense. He photographed neither racial violence nor political events, but supplied—as a white South African—a social diagram of his country by focusing on its people, of whatever color. He attempted neither to confirm clichés nor to propagate social revolt, although he did greet the end of apartheid with great relief. The quality of his images derives from the fact that, quite apart from their historical context, they represent magnificent studies of the human condition.

Goldblatt shows people at home or at work in a way that lends even the most ordinary of details eloquence. In his portrait of Miriam Diale in her bedroom in Soweto (1972), the elegantly dressed woman appears before an unpapered wall with a simple tulip-shaped lamp beside her. There could be no greater contrast than to the many living rooms of whites, which are veritably stuffed with mementos. Occupational portraits of blacks show domestic workers, cleaners, a broom saleswoman, a "boss boy"; those of whites a township superintendent, a chairman and business manager of a mining company. Although August Sander's occupational portraits reverberate here, an even closer parallel is seen with Diane Arbus's psychologically charged portraits from 1960s New York.

Goldblatt's masterworks include a series of photo reportages, especially the one on "shaft sinking" at the President Steyn No. 4 Shaft at Welkom (Orange Free State), images of great atmospheric density that reflect men's stamina under adverse conditions. This series is the South African counterpart to Salgado's much later photographs of a gold mine in Serra Pelada, Brazil (1986).

Even more unsettling are Goldblatt's 1983–1984 pictures of commuters from the homeland of KwaNdebele, who every morning at 3 a.m. boarded a bus for a several hours' ride to their workplaces in Pretoria and returned by the same route every night—permanent residence in white neighborhoods being prohibited by the Group Areas Act. Anyone who infringed on this ruling risked a considerable fine or even prison, as reflected in Goldblatt's portrait series on punished individuals and families (1981). Entire housing developments, city districts and buildings were demolished when they were declared "black spots," and reopened for white settlement. In 1977, Goldblatt created a memorial for one of these areas, Fietas, before the razing of its private residences and commercial buildings began. Another series documented Protestant churches in South Africa, proving that towards the end of apartheid, the churches grew increasingly windowless and fortresslike.

The new South Africa also gave Goldblatt an opportunity to explore the "social landscape" and its faultlines. In large-format images he recorded historical places and landscapes redolent with the absurdity of white urban planning. A further series was devoted to views of streets "in the time of AIDS."

1930 Born in Randfontein, South Africa
1950s Studies economics and obtains Bachelor of Commerce at the University of the Witwaterstrand, Johannesburg
1963 Sells his parents' haberdashery; begins commercial photography work
1973 Publishes *On the Mines*, with an essay by Nadine Gordimer
1975 *Some Afrikaners Photographed*
1982 *In Boksburg*
1985 One-hour television feature on Channel 4 in the UK
1986 *Lifetimes Under Apartheid*
1989 *The Transported of KwaNdebele*; founds the Market Photography Workshop for discriminated adolescents in Johannesburg
1998 *South Africa: The Structure of Things Then*, exhibition at the Museum of Modern Art, New York
2001 Awarded an honorary doctorate from the University of Cape Town
2005 *David Goldblatt—South African Intersections*
2006 Awarded the Hasselblad Prize, Göteborg
Lives and works in Johannesburg

FURTHER READING
J. M. Coetzee et al., *Fifty-one Years: David Goldblatt*, exh. cat. Museu d'Art Contemporani, Barcelona, 2001
Lesley Lawson, *David Goldblatt*, London and New York, 2001

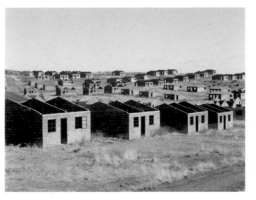

Incomplete houses, part of a stalled municipal development of 1000 houses. The allocation was made in 1998, building started in 2003. Officials and a politician gave various reasons for the stalling of the scheme: shortage of water, theft of materials, problems with sewerage disposal, problems caused by the high clay content of the soil and a shortage of funds. By August 2006 420 houses had been completed. Lady Grey, Eastern Cape, 5 August 2006

above
Lily Goldblatt, Portrait David Goldblatt

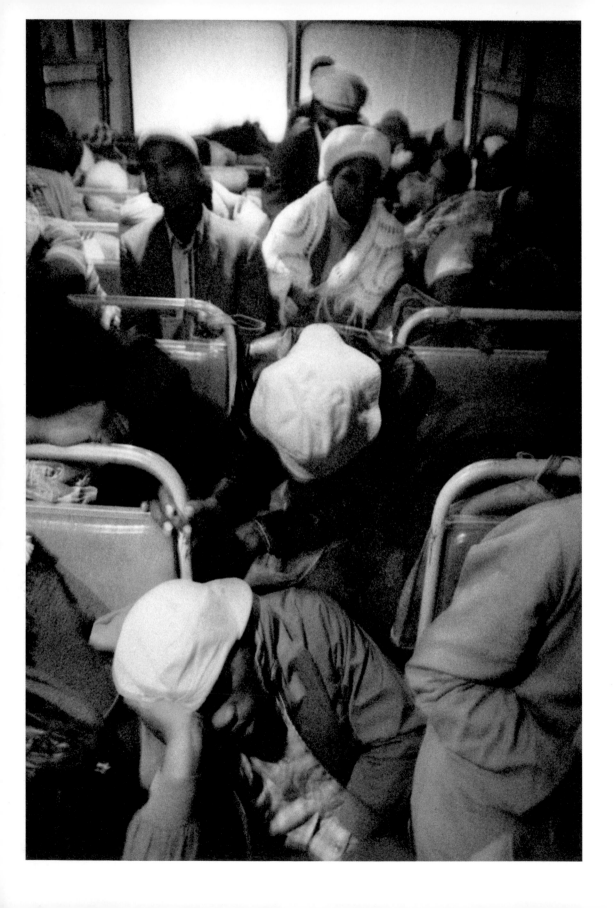

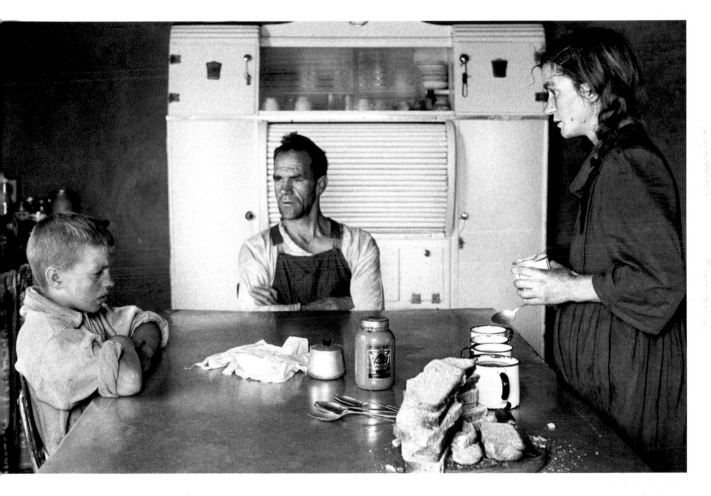

above
A Plot Holder, His Wife and Their Eldest
Son at Lunch, Wheatlands, Randfontein,
Transvaal, September 1962

left
Going to Work: 3:30 am, Wolwekraal-
Marabastad Bus, 1983

1939–1945 World
War II

1950 Racial segregation abolished
in the USA

1955 Eight communist bloc countries
sign a mutual defence treaty
called the Warsaw Pact

| 1880 | 1885 | 1890 | 1895 | 1900 | 1905 | 1910 | 1915 | 1920 | 1925 | 1930 | 1935 | 1940 | 1945 | 1950 | 1955 | 1960 | 1965 |

The Dwarf, 1958

1960 John F. Kennedy becomes President of the USA
1963 "I Have a Dream" speech
(Martin Luther King)
1964 Vietnam War begins
1970 Zabriskie Point (Michelangelo Antonioni)
1981 First flight by the Columbia
space shuttle
2001 Terrorist attacks in the USA
2003 The War in Iraq begins

1970 1975 1980 1985 1990 1995 2000 2005 2010 2015 2020 2025 2030 2035 2040 2045 2050 2055

BRUCE DAVIDSON

Davidson is known foremost as a photographer of the Civil Rights Movement in America. His sympathy for this cause at a time when apartheid-like conditions obtained was highly appreciated by black Americans from New York to the Deep South, and opened doors for him to their private lives.

Davidson's early essay, *Brooklyn Gang* (1959), records the activities of the Jokers, one of the many New York street gangs notorious for their infighting. He went to Coney Island with these youngsters, where they spent the night under the Boardwalk. (His picture of a blonde girl combing her hair in the mirror of a cigarette machine would become famous.) Then they all took the bus back to Manhattan. Davidson was 24 at the time, the gang members 17. Though his photographs were rejected by *Life*, a year later they were published in *Esquire*. In 1962 they promptly earned Davidson a Guggenheim Grant, which enabled him to devote two years to the subject of "Youth in America." "I now had the youth from the Freedom Rides and the South on my mind," Davidson recalled, and he allied himself with those who openly opposed "the status quo of segregation, bigotry and intolerance."

Without adopting an accusatory tone, Davidson depicted the life of New York blacks on the lower rungs of the social ladder, demonstrations, the arrest of activists by the cops, but also moments of joy in the black community. Characteristic of his style was a poetic suspension of moments in the flux of time. At public appearances of political leaders, such as Malcolm X in New York, he focused largely on the spectators. Pictures taken in Chicago in 1962 provided insights into the life of the black upper class. In harsh contrast were his photographs of the Georgia cotton fields, and of shacks in an itinerant laborers' camp in South Carolina with a school barracks for black children. A Ku Klux Klan nocturnal ritual made it graphically clear that the social air in America was ablaze.

In Davidson's photographs of protest marches in Mississippi and Birmingham, it was the scenes taking place on the margins that were especially eloquent. We should remember that these were the years when black activists boarded "white" buses despite segregation and severe risked a beating for it. On 28 August, 1963, Martin Luther King delivered his "I have a dream" speech, and Davidson photographed the hope-filled masses gathered in front of the Washington Monument. Recalling the 54-mile (87-kilometer) protest march from Selma to Montgomery on 21 March, 1965, the photographer said, "I walked with the marchers over the entire route, photographing many of them face-to-face. I wanted to see them as individuals, not just as symbolic silhouettes in a faceless crowd."

For his two-year project *New York: East 100th Street*, Davidson chose a block in Spanish Harlem which, neighbors said, was the worst in one of the city's most notorious slums. He worked with a plate camera and tripod, "to see with greater depth and sharper detail in to the rooms, buildings, vacant lots, streets and rooftops that define the space they called their home." Though these people trusted Davidson and gave him access to their private sphere, he was "afraid to break the painful barrier of their poverty." This project stands in the great social documentary tradition of a Dorothea Lange and Walker Evans, with the focus shifted from fieldworkers' shacks in the Deep South to the tenements of New York.

1933 Born in Oak Park, Illinois, USA
1949 Wins the Kodak National High School Contest
1950 Attends Rochester Institute of Technology, then Josef Albers's class at Yale University
1955–1957 Stationed with the armed forces in Georgia, Arizona, and then near Paris, France; meets Henri Cartier-Bresson; his first photographs published in Life
1958 Becomes an associate member of Magnum, and full member in 1959
1959 Photoessay *Brooklyn Gang* published in *Esquire*
1960 Photoessay *England and Scotland*, for *The Queen* magazine (published in book form in 2006)
1961–1964 Takes fashion photographs for *Vogue*; accompanies Freedom Riders on an illegal bus trip from Montgomery, Alabama, and to Jackson, Mississippi (1961)
1962 Receives a Guggenheim Fellowship for his project on the Civil Rights Movement
1963 Exhibits at the Museum of Modern Art, New York; photographs the construction of the Verrazano Narrows Bridge between Brooklyn and Staten Island
1965 Photoessay *Welsh Miners*
1966 Stipend from the National Endowment of the Arts for *New York: East 100th Street*
1968 Makes his first films with a 16 mm camera; stills during the filming of Michelangelo Antonioni's *Zabriskie Point*
1970 Film *Living off the Land*, on junk metal collectors in the New Jersey Meadows, for CBS; exhibition *New York: East 100th Street*, Museum of Modern Art, New York
1986 Makes his first color photograph series, *Subway*
1999 Publishes *Portraits*
2002 *Time of Change—Bruce Davidson: Civil Rights Photographs 1961–65*
Bruce Davidson lives in New York

FURTHER READING
Bruce Davidson: Photographs, New York, 1978

1925 b. Jean Tinguely, Swiss painter and sculptor

1959 Cuban Revolution victory

1962 *The Physicists* (Friedrich Dürrenmatt)

1939–1945 World War II

| 1880 | 1885 | 1890 | 1895 | 1900 | 1905 | 1910 | 1915 | 1920 | 1925 | 1930 | 1935 | 1940 | 1945 | 1950 | 1955 | 1960 | 1965 |

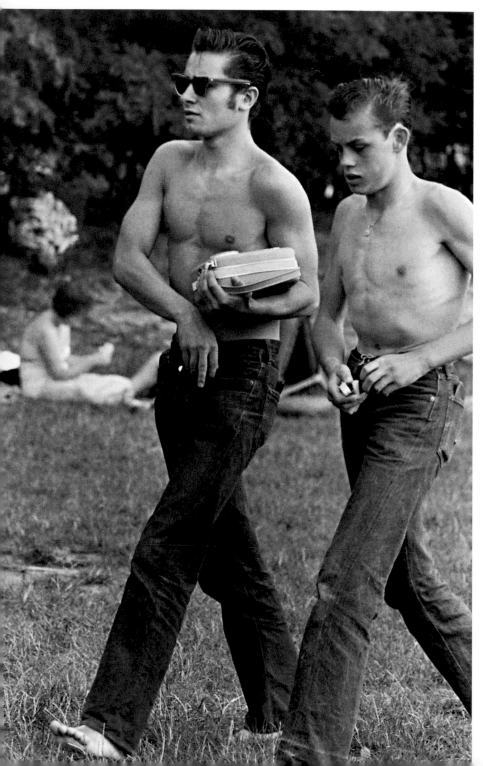

Wannsee, Berlin/West, 1961

right
Cordia Schlegelmilch, René Burri, 16 April 2004

966–1976 Cultural Revolution in China

1989 East Germany opens checkpoints
in the Berlin Wall
1989 Tiananmen Square Massacre

1980 In Poland, the independent trade
union Solidarity is established
1990 Reunification of Germany
1990 End of Lebanese Civil War

| 1970 | 1975 | 1980 | 1985 | 1990 | 1995 | 2000 | 2005 | 2010 | 2015 | 2020 | 2025 | 2030 | 2035 | 2040 | 2045 | 2050 | 2055 |

RENÉ BURRI

Born a quarter of a century after the co-founder of Magnum, Cartier-Bresson, and later president of this famous photographers cooperative, Burri experienced the final flowering of photojournalism before television took over the field. The Swiss-born photographer is perhaps the last representative of this era.

Like Cartier-Bresson, for over 40 years Burri sought out the hot spots of world politics. Airplanes were his living room. He shot wars without becoming a war photographer, and he captured countless street scenes without becoming a representative of "street photography." He rubbed shoulders with Picasso and Le Corbusier, Giacometti and Tinguely, without ever viewing himself as a portraitist. In addition, for many years he focused on major modern buildings, yet in his freelance work architecture always took second place to people. Burri's work is most outstanding for a kaleidoscopic variety in which the transitions between the genres are well-nigh indistinguishable.

Averse to official posturing, he preferred the margins of big events or waited patiently for some unexpected private gesture that showcased the incidental— especially at state occasions, for which he had a season ticket. Burri was gifted at making subtle, humorous points that never descended to the level of gags. His masterwork is the collection *The Germans*, a grand tour through a divided and later reunited country, the diagram of a society composed of highly diverse impressions gained in East and West from 1957 to 1997.

It is tempting to associate Burri's aesthetic rigor with his Protestant Swiss background, and with the expectations of the Swiss journal *DU*, to which he often contributed. Extreme close-ups of faces and other such formal experiments were not his thing. Instead, he infused complex scenes teeming with figures with an intriguing ambiguity. This holds for *John F. Kennedy's Funeral* (1963) as much as for *Café, Tu-do Avenue, Saigon* (1973). Burri's finest shots show situations that are seemingly drifting apart or charged with tension, rapidly clamped into a unity as if by collage.

His most important portrait shows a cigar-smoking Che Guevara in an expansive mood, very relaxed by comparison to Alberto Korda's Christ-like icon. Burri's masterful photograph *São Paulo, Argentina* (1960) is a record of a torn society, taken from a bird's-eye view, overlooking the roofs and cavernous streets of the metropolis. Much as for his exact contemporary Lee Friedlander, for Burri the world could hardly be grasped through the truth of *a single* viewpoint.

1933 Born in Zurich, Switzerland
1955 Makes a "picture report" on a school for the deaf and dumb; takes photographs of Le Corbusier's chapel Notre-Dame du Haut, Ronchamp
1956 Becomes an associate member of Magnum; photographs Egypt during the Suez Crisis
1958 Records the building of the Assuan Dam in Egypt, and the training of underground fighters in Algeria (FLN) and Syria
1959 Becomes a full member of Magnum
1962 Photographs the German writers association Group 47
1963 Photographs Fidel Castro and Che Guevara's Cuba; records John F. Kennedy's funeral in Washington
1964 Photographs Pope Paul VI's visit to Palestine
1966 Documents the Culture Festival in Dakar, Senegal
1968 Documents apartheid in South Africa and the Civil Rights Movement in America
1972 Makes a film on the artists Jean Tinguely
1974 Documents President Richard Nixon's visit to Egypt
1978 *Ruins of the Future*
1979 Documents Palestinian training camps in Lebanon
1982 President of Magnum
1983 Large retrospective, *One World*, at Kunsthaus Zürich
1986 Film *The Nuclear Highway*
1989 Photographs the fall of the Berlin Wall and the massacre around Tiananmen Square, Beijing
1991 Photoessay on war-torn Beirut

FURTHER READING
Hans-Michael Koetzle, *René Burri Photographs*, London, 2004

1933 b. James Brown,
US American musician

1939–1945 World
War II

1948 Universal Declaration of Human
Rights before UN General Assembly

1950 Racial segregation abolished
in the USA

1880	1885	1890	1895	1900	1905	1910	1915	1920	1925	1930	1935	1940	1945	1950	1955	1960	1965

Christmas Eve, 1963

1960 The Mali Federation between
Senegal and Sudanese Republic
gains independence from France

1993 Nelson Mandela/Frederick de Klerk
awarded Nobel Peace Prize

1994 Termination of Apartheid in South Africa

1967 Start of Six-Day War

| | | | | | | | | | | | | | | | | | |
1970 1975 1980 1985 1990 1995 2000 2005 2010 2015 2020 2025 2030 2035 2040 2045 2050 2055

MALICK SIDIBÉ

Sidibé is the party photographer par excellence. He recorded the young people of Mali in West Africa during the euphoria of the post-liberation years. No other photographic archive contains more laughing, dancing, and smiling than that of the international award-winning photographer from Bamako.

When Mali shook off French colonial rule in 1960, Bamako, like other African capitals, went into raptures. But its young men and women had other reasons to celebrate, too. "The city sets you free," as they were likely the country's first younger generation to realize. Sidibé was on the spot, and he untiringly made use of the opportunity. Going to as many as five parties a night, he often developed his films until sunup, so he could show the prints quickly and take orders for enlargements.

Sidibé must have enjoyed his role immensely. When he turned up at one of the countless parties in nocturnal Bamako, he would actuate his flash, and everyone knew, "Malick's here!" In his mid-20 at the time, he was only a little older than his clientele, and completely integrated in this—by now historical—generation.

Fêtes surprises or *fêtes poussières* these events were known as, because the dancing in the unpaved courtyards set the dust flying. Or people congregated at their parents' homes or one of the countless clubs that shot up like mushrooms, and had names that Malick still often uses as picture titles: Happy Boys Club, Lionceaux Club, Beatles Club, and more. This was the era of the twist, cha cha cha, and later rock 'n' roll and beat. A record went on the turntable and the mating game could begin. Cheeky dance steps and poses, fashionable garb and the latest record sleeves set the scene.

Malick captured the spontaneity and charm of these fetes with a fresh eye. He also accompanied his customers down to the banks of the Niger, showing them swimming, rollicking, and just letting off steam. His photographs record the way the sexes were able to meet freely and openly in public for the first time, beyond all traditional West African etiquette. The photographer's informal style corresponded to his subjects' improvisational skill. In addition, Malick ran—and still runs—a classic photographic studio that attracts individuals and couples on a variety of Christian and Islamic holidays, as well as other occasions.

The party days were already over by the 1970s, when increasing socialist regimentation and curfews suffocated Mali's nightlife. For many years Malick had to supplement his income by repairing cameras. It was not until the discovery in the 1990s of his studio and archive that he became known outside Africa.

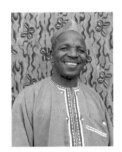

1936 Born in Soloba, French Sudan, now Mali
1952 Graduates from secondary school
TO 1955 Attends the École Nationale des Arts, Bamako, to become a goldsmith, followed by training at the "Photographic Service" studio run by the Frenchman Gérard Guillat (Gégé)
1956 Obtains his first camera
1962 Opens his own studio
1995 Retrospective at Fondation Cartier pour l'art contemporain, Paris, followed by participation in numerous international exhibitions
2003 Hasselblad Prize, Göteborg, Sweden
2007 Awarded a Golden Lion, Venice Biennale

FURTHER READING
André Magnin, *Malick Sidibé*, Zurich, Berlin and New York, 1998

Malick Sidibé (undated)

ALBERT RENGER-PATZSCH

CANDIDA HÖFER

THOMAS STRUTH

1928 b. Andy Warhol,
US American artist

1929 Wall Street Crash crash

1939 b. Richard Serra,
US American sculptor

1939–1945 World War II

1949 Democratic Republic of Germany
(DDR) established officially

1949 The Federal Republic of Germany
is established

1961 Construction of the
Berlin Wall begins

| 1880 | 1885 | 1890 | 1895 | 1900 | 1905 | 1910 | 1915 | 1920 | 1925 | 1930 | 1935 | 1940 | 1945 | 1950 | 1955 | 1960 | 1965 |

Shaft Towers in South
Wales and Manchester
(undated)

1980 In Poland, the independent trade
union Solidarity is established

1991 The Warsaw Pact is officially dissolved
at a meeting in Prague

1990 Reunification of Germany

| 1970 | 1975 | 1980 | 1985 | 1990 | 1995 | 2000 | 2005 | 2010 | 2015 | 2020 | 2025 | 2030 | 2035 | 2040 | 2045 | 2050 | 2055 |

BERND AND HILLA BECHER

The Bechers' encyclopedic oeuvre attests to an obstinate resistance to the ravages of time, to the imminent demolition and decay of abandoned industrial buildings. Their documentation has a hybrid character, providing an exhaustive visual archaeology of 19th-century industrial architecture while representing a photographic agenda which, taking the form of a "typology," reflects an extremely coherent conception.

Pittsburgh, the Ruhrgebiet, Liverpool, Lorraine—world-famous manufacturing cities and regions that simultaneously call the great economic crises to mind. The decades-long decline of the German coal mining and steel industry not only put hundreds of thousands out of work but delivered up the concrete vestiges of a bygone era to the demolition ball. The architectural record of heavy industry on the Rhine and the Ruhr—former pride of the early industrial period—will remain part of the general visual memory thanks to the Bechers' painstaking collecting and recording activity.

For 40 years they roamed the region around Dortmund, Essen, and Siegen, photographing mines, pitheads, water towers, Bessemer converters, gasometers, ventilators and factories. They recorded grain silos and houses, especially the half-timber houses in the Siegen manufacturing area. Pilgrimages with the camera took them to abandoned manufacturing plants in Liège, Pas-de-Calais, Ohio, South Wales, and Pennsylvania. It was a systematic survey of a kind not seen since the days of Eugène Atget. Albert Renger-Patzsch, too, was a predecessor of this type of industrial reportage.

The Bechers' archival activity was sparked by a fascination with the commanding presence of these industrial monuments, their look of "anonymous sculptures," despite the fact that, being engineering structures, they were seldom designed with an eye to aesthetic effect. The photographers' aim was "to prove that the forms of our times are the technical forms," as they announced as early as 1971. This was the period of Pop Art, when many artists, tired of subjective abstraction, turned to the cool gloss of the readymade and sometimes rejected painting entirely.

To achieve maximum precision, the Bechers used large-format cameras whose long exposure times caused passersby to vanish from the picture. Only diffuse, cloudy light supplied the homogeneous illumination they desired. Photographing in spring or fall had the advantage that shrubs and trees were bare and did not obscure the structures. The Bechers climbed ladders and scaffolds, perched on roofs, or photographed from the windows of neighboring houses to find the ideal, half-high vantage point from which images undistorted by perspective could be taken. This unchanging viewpoint from image to image engenders a regular rhythm that lends a compelling aesthetic effect to their photographs when combined into multipartite tableaux.

HILLA BECHER
1934 Born Hilla Wobeser in Potsdam, Germany
1951–1954 Serves an apprenticeship in photography, then works freelance
1958–1961 Helps to establish a photography department at the Düsseldorf Art Academy

BERND BECHER
1931 Born in Siegen, Germany
1947–1950 Serves an apprenticeship in decorative painting
1953–1956 Attends Stuttgart Art Academy
1957–1961 Studies typography at Düsseldorf Art Academy
1959 Beginning of collaboration with Hilla
1961 He and Hilla marry
2007 Dies in Rostock

1972–1973 Both are guest instructors at the College of Visual Arts, Hamburg
1975–1976 Exhibition at the Museum of Modern Art, New York
1976–2000 Professors of photography, Düsseldorf Art Academy
1977 *Fachwerkhäuser des Siegener Industriegebietes*
1985 *Fördertürme*
1988 *Wassertürme*
1991 *Pennsylvania Coal Mine Tipples*
1992 *Häuser und Hallen*
1993 *Gasbehälter*

FURTHER READING
Susanne Lange, *Bernd and Hilla Becher: Life and Work*, Cambridge, MA, 2007

1950 Racial segregation abol-
ished in the USA

1939–1945 World War II **1960** John F. Kennedy become
President of the USA

1880 1885 1890 1895 1900 1905 1910 1915 1920 1925 1930 1935 1940 1945 1950 1955 1960 1965

1970 Kent State massacre: 4 students shot
by the Ohio National Guard Kent **1993** Bill Clinton becomes President of the USA
1975 USA is defeated in the Vietnam War
1981 Ronald Reagan becomes President
1969 Apollo Moon landing of the USA

| 1970 | 1975 | 1980 | 1985 | 1990 | 1995 | 2000 | 2005 | 2010 | 2015 | 2020 | 2025 | 2030 | 2035 | 2040 | 2045 | 2050 | 2055 |

LEE FRIEDLANDER

Friedlander was the master of urban collage, creating a provocative kaleidoscope of glimpses of the everyday aspects of the city. Yet as soon as we have become accustomed to the smell of asphalt he takes us into the great outdoors with its plants, trees, and landscapes. He was never in deadly earnest about any of this, however, and enjoyed playing jokes on his viewers.

While other photographers avoided posts, street-lamps and traffic signs to gain an unhindered view of buildings, streets and passersby, Friedlander purposely let "street furniture" intervene. For him, advertising, billboards and signs were an integral part of the urban texture that made all modern cities look the same. People hurrying by—no longer the idle strollers of a bygone era—appear fragmented, part of the jumble of urban symbols. Mirrors and mirroring, reflections in display windows, maximize the visual complexity, and when a poster appears, our gaze seems to bounce back from it. Friedlander photographed images of images, making obsolete the question of where reality stops and media reproduction begins. He fed his impressions of big cities into revolving glass doors, creating an equivalent to Robert Rauschenberg's "combine paintings." A chapter in his series *Architectural America* reduces Los Angeles, Phoenix, and New York to obscuring fences, and in another place most of what we see of "Nebraska," "Portland" and "Las Vegas" are the door handles and upholstery of his sedan. Friedlander's 1993 book *Letters from the People* is an updating of the random urban visual texts of the kind seen in Brassaï's 1930s graffiti. His early portraits, no longer serving the illusion of great individuality, show people in their personal ambience or outdoors, often evidently tired and sometimes purposely unphotogenic. Usually in the worst mood of all is Friedlander himself—in unassuming, private self-portraits he grimaces because the camera is too close, or because taking his own picture perhaps wasn't such a good idea after all. A tendency to sabotage pathos was already evident in Friedlander's 1970s series *The American Monument*. It showed American heroes in self-aggrandizing poses, mounted, imperially enthroned, fulfilling the country's Manifest Destiny in bronze and marble. In every case, vantage point and composition were used to unmask pretense. Mount Rushmore was bearable as a reflection in a window at best. Anyone who still doubted that Friedlander's oeuvre was laced with humor and cynicism learned differently here. Nor was he able to face the gravestones at Stagliano cemetery in Genoa, Italy, with anything but irony, using careful cropping to spoof the sentimental poses of mourning on the marble reliefs. Again and again, Friedlander sought out gardens, parks, and open countryside, though admittedly "great American landscapes" à la Ansel Adams could hardly be expected of him. His favorite motifs were dead or leafless trees, and he was especially fascinated by the graphic textures of dense branches and undergrowth. In the 1990s, the Sonora Desert in Arizona became his ideal landscape. Friedlander also photographed flowerbeds, gardens, and flowers— the last blossomless, reduced to stems in water-filled glass vases.

1934 Born in Aberdeen, Washington, USA
1952 Studies at the Art Center School of Design, Los Angeles
1955 Moves to New York
1964 Visits Europe
1960, 1962, 1977 Receives John Simon Guggenheim Foundation Fellowships
1977, 1977, 1978, 1979, 1980 Receives National Endowment for the Arts fellowships
1973 *Self-Portrait*
1981 *Flowers and Trees*
1990 Receives the John D. and Catherine T. MacArthur Foundation Fellowship
1992 *The Jazz People of New Orleans*
1996 *The Desert Seen*
2002 *At Work*
2003 *Stems*

FURTHER READING
Peter Galassi, *Friedlander*, with an essay by Richard Benson, The Museum of Modern Art, New York, 2005

left page
New City, New York, 1997

left
New York City 1966

JOSEF SUDEK GILLES PERESS

ANDRÉ KERTÉSZ

1945 United Nations founded

1929 b. Milan Kundera, Czech author **1961** Constructic
of the Berli
1939–1945 World War II Wall begins

| 1880 | 1885 | 1890 | 1895 | 1900 | 1905 | 1910 | 1915 | 1920 | 1925 | 1930 | 1935 | 1940 | 1945 | 1950 | 1955 | 1960 | 1965 |

Untitled (undated)

1970 1975 1980 1985 1990 1995 2000 2005 2010 2015 2020 2025 2030 2035 2040 2045 2050 2055

JOSEF KOUDELKA

Koudelka's eye was sharpened by the experience of being an outsider, first among the Romany in eastern Slovakia, then as an émigré who, after the "Prague Spring" was crushed, went into a 20-year exile in 1970. For 15 years he lived a nomad's life, with no permanent residence, "on the minimum," as he later said, and photographed only what interested him.

In his 1988 classic, *Exiles*, Koudelka summed up his vagabond life as a stranger in strange lands. Even randomly observed scenes on streets, in fields, in parks, or on the coast draw meaning from the general context of "exile." In the over 60 images, animals repeatedly appear like leitmotifs—stray dogs, a monkey on a chain, a turtle turned on its back, a dead crow hung on a string. We are continually faced by situations of estrangement, visual and psychological disquiet—parables of human homelessness. Beyond exile in the narrower, political sense, Koudelka brings other associations to the theme. Even tarpaulins dangling from a scaffold, an upturned boat, or sunbathers on the steps of the Metropolitan Museum reverberate with a sense of exile.

Back in 1975, Koudelka published the book that made him famous in the West: *Gypsies*. Avoiding all romantic clichés, he showed Romany families with their children, their living rooms, humble houses, poor settlements. Europe's largest border-crossing ethnic group became visible as a basically closed society with its own heritage and intrinsic quotidian beauty.

From 1986 onwards, Koudelka produced numerous series, especially landscapes, using a panoramic camera: the devastation caused by open-pit mining in northern Bohemia (1990–1994), war-ravaged Beirut (1991), the changing countryside around the Lhoist limestone quarries in the Limelette region of Belgium (2001), the Camargue (2002), and archaeological sites in Greece (2003). His panoramic formats were displayed both horizontally and vertically. It was not "beautiful" landscapes that interested him but "landscapes altered by contemporary man." Despite the destructiveness of open-pit mining, Koudelka did not see himself in the role of environmentalist but discovered in such scarred landscapes an "untamed beauty, strength."

1938 Born in Boskovice, Moravia, Czechoslovakia
1956–1961 Studies engineering at the Technical University of Prague
1981–1967 Works as an aeronautical engineer; photographs for the theater magazine *Divadlo*
1967 Begins full-time photography
1965–1967 Records religious festivals in Slovakia
1962–1968 Photographs the Romany in eastern Slovakia and, in 1968, in Romania
1965–1970 Official photographer for the Theater za Branou in Prague; becomes a member of the Association of Czechoslovakian Artists
1968 Documents the occupation of Czechoslovakia by Warsaw Pact forces (winning an anonymous award in 1969)
1970 Emigrates to London
1971 Becomes associate member of Magnum, then, in 1974, full member
1975 Solo show at the Museum of Modern Art; publishes *Gypsies*
1976 Fellowship from the Arts Council of Britain, for a project on the British Isles
1988 Publishes *Exiles*
1987 Takes French citizenship
1990 Returns to Czechoslovakia for the first time in two decades
1991 Photographs war-torn Beirut
1994 *The Black Triangle: The Region at the Foot of the Ore Mountains* published in Prague

FURTHER READING
Koudelka, with an introduction by Robert Delpire, Heidelberg, 2006

ABE FRAJNDLICH

1914 b. William S. Burroughs,
US American author

1943 b. Janis Joplin, US American singer

1939–1945 World War II

1946 b. Patti Smith,
US American musician

1942 b. Mohammad Ali
(Cassius Clay until 1964)

| 1880 | 1885 | 1890 | 1895 | 1900 | 1905 | 1910 | 1915 | 1920 | 1925 | 1930 | 1935 | 1940 | 1945 | 1950 | 1955 | 1960 | 1965 |

Ken Moody, 1983

1972 USA uses napalm as a tool of war in Vietnam **2001** Terrorist attacks in the USA

1968 Hunger crisis in Biafra **1985** Mikhail Gorbachev becomes
1969 Apollo Moon landing General Secretary of Communist
1969 Woodstock Festival Party of the Soviet Union

1970 1975 1980 1985 1990 1995 2000 2005 2010 2015 2020 2025 2030 2035 2040 2045 2050 2055

ROBERT MAPPLETHORPE

Mapplethorpe subjected hard-core sex scenes and the sheer beauty of flowers to the same rigorous aesthetic. Parts of his work amount to a stylized showroom of gay subculture, and at the same time a visual requiem for the most important photographer to have died of AIDS.

In the wake of Wilhelm von Gloeden and Wilhelm Plüschow, photographs of male nudes no longer caused much of a stir, yet Mapplethorpe broke the last remaining taboos. The more classical of his compositions still relied on early modern photographers, especially Imogen Cunningham. Legs, backs, feet became sculptural forms in their own right, and throats, navels and nipples took on monumental effect. But the truly shocking aspect of Mapplethorpe's work came with his perfect stagings of practices including S & M and bondage. Drawing on the iconography of porn, he celebrated it with extreme photographic sophistication—a biting synthesis. Mapplethorpe's models and the sexual practices he pictured evidently reflected his personal preferences. In his photographs of African American men, published in book form in 1980, he took the penis cult to an apex, occasionally stylizing their members into still lifes.

Mapplethorpe's images of flowers are virginal by comparison to the rituals of the sexual underground. As early as 1977, he photographed lilies, tulips, orchids and chrysanthemums, a series expanded in the 1980s by highly refined imagery in color. He marshaled all of his stylistic ambition to lend the blossoms the sublime, fragile look of alabaster. Mapplethorpe was also in great demand as a portraitist of high society. The archbishop of Canterbury sat for him, as did Arnold Schwarzenegger—in bathing trunks (1976). Especially his portraits of women with complexions like china and eyes like glass reflected a style to the taste of *Harper's Bazaar*. The sculptors Louise Nevelson and Louise Bourgeois stand out from this series as true character heads, as does Mapplethorpe's artistic partner and one-time girlfriend, Patti Smith. There are also many portraits of the world champion in bodybuilding, Lisa Lyon, to whom he devoted a book. Of his male portraits, those of his lover, friend and patron, Sam Wagstaff, of Philip Glass & Robert Wilson (1976), David Hockney & Henry Geldzahler (1976),

and William Burroughs (1980–1981) are particularly memorable.

Most compelling of all, though, are his self-portraits, some unabashedly narcissistic, others theatrical, and finally those in which we look into the eyes of an artist who has already succumbed to a sense of imminent death. Mapplethorpe presented himself in leather garb with a switchblade (1983), styled himself a devil or a terrorist with machine gun (1983), or made up like a diva with fur stole (1980). Towards the end, his photographs sometimes included skulls, and in the self-portrait made a few months before his death, he leans on a cane with a carved death's head grip.

1946 Born in Queens, New York, USA
1963–1965 Studies advertising design, graphic art, drawing, painting and sculpture at the Pratt Institute, Brooklyn
1967 Meets the rock musician Patti Smith, with whom he will move into the Chelsea Hotel in 1969; works as a show-window decorator
1968 Material collages: boxes, triptychs and "altars," which will later include photographs from porn magazines
1971 Begins using a Polaroid camera
1977 Represented at the Documenta, Kassel
1980 Publishes *Black Males*
1983 *Lady Lisa Lyon*
1985 *Certain People: A Book of People*; photographs Jan Fabre's performance *The Power of Theatrical Madness* in Antwerp
1986 *A Season in Hell: Rimbaud, Mapplethorpe*; numerous portraits for Richard Marshall's book 50 New York Artists; diagnosed with AIDS
1989 Dies in Boston, Mass.

FURTHER READING
Mapplethorpe, with an essay by Arthur C. Danto, Munich, Paris and London, 1992

Calla Lily, 1986

1939–1945 World War II

1880 1885 1890 1895 1900 1905 1910 1915 1920 1925 1930 1935 1940 1945 1950 1955 1960 1965

Refugees in the Democratic Republic of
the Congo, 28 March 1997

CA. 1975 Hunger crisis in the Sahel
1975 Angola gains independence
1985 Schengen Agreement
1992 Siege of Sarajevo
1990 End of Lebanese Civil War
1983 Civil war in Sudan begins
1994 Termination of Apartheid in South Africa
1994 Genocide in Rwanda
2003 The War in Iraq begins
2001 Terrorist attacks in the USA

1970 1975 1980 1985 1990 1995 2000 2005 2010 2015 2020 2025 2030 2035 2040 2045 2050 2055

SEBASTIÃO SALGADO

Rather than individual photographs or small reportages for magazines, from the start of his career in photo-journalism Brazilian-born Salgado has focused on world-spanning documentations on burning issues of our day. Studying economics gave him insight into the causes of global crises such as famine, migration, urbanization and the spread of slums—subjects that have left the engaged photographer no peace for the last 35 years.

Salgado is the best-known representative of a new brand of photojournalism. Instead of doing one job after another for a magazine or picture agency, he conceives comprehensive photographic projects, complete with sponsoring and logistics, that extend over several years. Exhibitions and publications, including partial publication in magazines, are components of the planning. Initially a member of the photographic agencies Sygma and Gamma, then under contract to Magnum, Salgado later shed all corporate ties to work independently for his own firm, Amazonas Images, headed by his wife, Lélia Wanick Salgado.

During his activity for the Investment Department of the International Coffee Organization (ICO), Salgado already became interested in issues of development policy. He had found the subject of his lifetime; but at 30, he decided to address it from a different angle, through photography. As early as 1973, he took up two of his main themes: famine in the Sahel zone of Africa, and guest workers in Europe. The following years were spent primarily in Latin America—on a search for images of "other Americas." Salgado's travels took him through the Andean countries of Ecuador, Bolivia and Peru, back to his native country, Brazil, and to Guatemala and Mexico, where he spent prolonged periods among the Tarahumara and Mixtecs of Oaxaca. Salgado photographed rural people at their everyday occupations and their festivals. Uninterested in formal experiments, he approached them with empathy and respect.

The years' long drought that hit the African Sahel in the mid 1980s brought an end to rural idylls for Salgado, confronting him with a disaster of immense scope. The images he made for Magnum in Ethiopia, Mali, Chad, and Sudan, later collected in the volume *Sahel: L'Homme en détresse* (Sahel: Man in Distress), are among the most shocking in his oeuvre.

Though known for his earlier books, it was *Workers: An Archaeology of the Industrial Age* (1993) that brought Salgado international fame. It was a homage to working people, "a farewell to a world of manual labor that is slowly disappearing and a tribute to those men and women who still work as they have for centuries," as he wrote in his dedication. The book recorded traditional manual tasks from sugar cane harvesting and cigar manufacturing in Cuba, through tuna fishing in Sicily, to sulfur collecting on Kawah Idjen in Indonesia, and also documented mechanical lead smelting in Kasachstan and oil drilling in Baku, Azerbaijan. The 1986 images of the enormous maw of a gold mine in Serra Pelada, Brazil, with thousands of miners crawling antlike up and down steep ladders, are among the most compelling and disturbing in the entire series.

With the volume *Exodus* (1998), Salgado was one of the first to visually address a key contemporary theme: the worldwide migrations and displacements resulting from wars, economic crises, and political terror. He spent seven years photographing in 39 countries. Whether Mexicans crossing the American border wall, Africans who envisage Spain as an El Dorado, the Boat People of Southeast Asia, or Ruandans who fled to the Congo—in 25 crisis regions Salgado recorded the extent of the migrations that have become the rule on our planet. No one who discusses this issue in future will be able to do so without remembering Salgado's moving images.

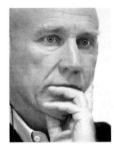

1944 Born in Aimorés, Minas Gerais, Brazil
1963–1967 Studies economics; works for the Brazilian Ministry of Finance
1969 Studies at the École Nationale de Statistique et Economie Administrative, Paris
1971–1973 Active for the International Coffee Organization (ICO) in London; visits Africa for the European Development Fund (EEF) and World Bank; takes his first photographs
1973 Returns to Paris; begins to work as a photojournalist; documents the famine in the Sahel
1974 Active for the Sygma Agency
1975–1979 Active for the Gamma Agency
1977–1984 Makes numerous journeys to South America; publication of *Autres Amériques* in 1986
1979 Joins Magnum; photographs immigrants in France
1981 March 31: photographs the assassination attempt on President Ronald Reagan
1984–1985 Documents the drought in Ethiopia, Mali, Chad and Sudan; the book *Sahel: L'Homme en détresse*, published 1986
1986–1992 Creates his *Workers*
1994 Leaves Magnum, and founds Amazonas Images, Paris
1997 *Terra* published
1998 *Exodus*, an exhibition at the Lisbon World Fair
2007 *Africa*

FURTHER READING
Sebastião Salgado: Workers—An Archaeology of the Industrial Age, New York, 1993

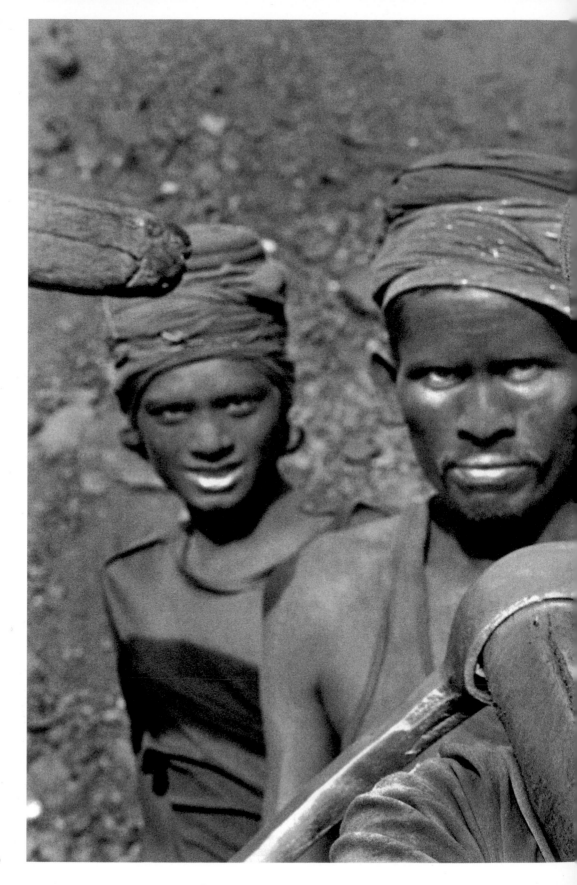

Workers (Women and Men),
Dhanbad, Bihar State, India, 1989

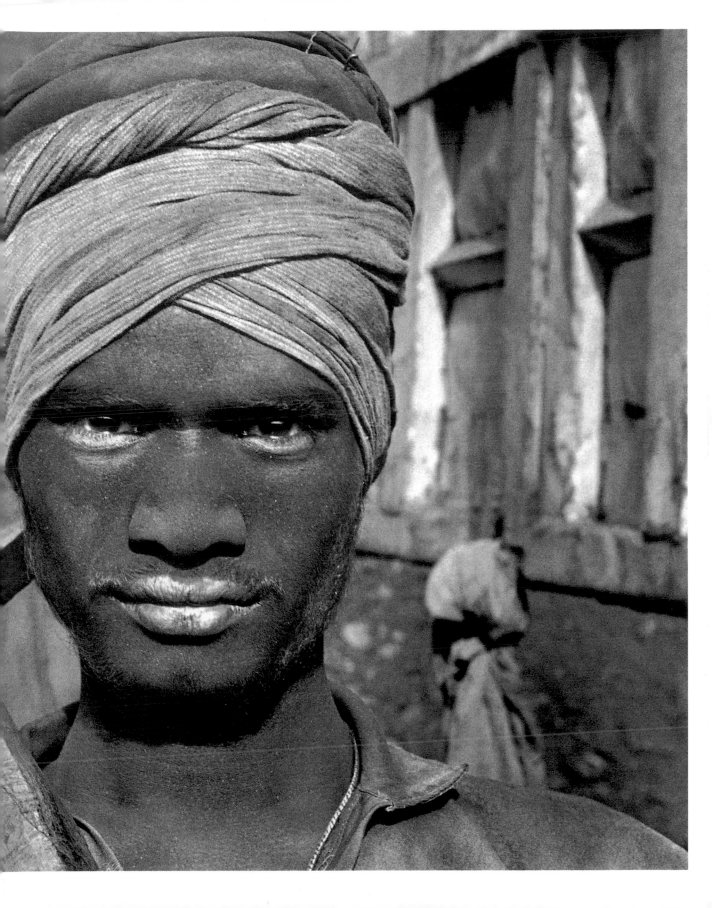

1939–1945 World War II

1952 The Treaty of San Francisco
ends the occupation of Japan

1910 b. Akira Kurosawa, Japanese director

1945 Atom bombs dropped on
Hiroshima and Nagasaki
1945 United Nations founded

1880 1885 1890 1895 1900 1905 1910 1915 1920 1925 1930 1935 1940 1945 1950 1955 1960 1965

1991 The Warsaw Pact is officially dissolved at a meeting in Prague
1989 Emperor Hirohito dies
964 Vietnam War begins
1985 Mikhail Gorbachev becomes General Secretary of Communist Party of the Soviet Union
2003 The War in Iraq begins
2001 Terrorist attacks in the USA

1970 1975 1980 1985 1990 1995 2000 2005 2010 2015 2020 2025 2030 2035 2040 2045 2050 2055

HIROSHI SUGIMOTO

The Zen master of photography, Sugimoto has taken pictures of empty movie screens, calm seas, Buddha figures with attributes of equanimity, colored shadows. He once let the light from burning candles fall through his lens for so long that "the life of a candle" was recorded on film. This is someone who obstinately resists reality as conventionally defined.

What is truly real was revealed to him in the American Museum of Natural History in New York, in face of dioramas with crouching Neanderthals and stuffed polar bears on artificial ice floes. Once photographed, Sugimoto remarked, any object is as good as real. Nor is water just water. Anyone who thinks a single photograph of the sea says it all is mistaken. Sugimoto set out to photograph every sea and ocean on the planet. In the first year of his *Seascapes* series (1980–2003), it was the Caribbean, seen from Jamaica. Then came the Aegean and the Black Sea, Lake Constance and the Baltic, the North Atlantic, the Sea of Japan, and further bodies of water. Only seasoned sailors have seen as many oceans as Sugimoto. He invariably photographs them from a raised vantage point, with the horizon—now razor sharp, now diffuse—exactly in the middle, and the gently agitated water surface occupying the lower half of the image. Crucial is the large format of 120 x 150 centimeters, which invites contemplation like a window on a world in balance and serenity. He wanted to go back in time to the ancient seas of the world, Sugimoto explained, as a primeval man may have seen them.

A panoply of similar Bodhisattva figures in a 12th-century Kyoto shrine are likewise associated with the sea: *Sea of Buddha* (1995). The faces with closed eyes, contemplating inner boundlessness, exude pure harmony. The associations with Zen are so obvious as to need no explanation. Yet that Sugimoto actually succeeded in projecting the notion of the sheer void into film theaters of the 1920s and 1930s and American drive-in movies is astonishing. The temples of Hollywood illusion were transformed into Zen shrines by leaving the shutter open so long that the crime movies and Westerns on the screen vanished into nothingness. There remained only bright white screens, framed by arabesque decor or the black of the night sky.

In his photographs of mathematical objects, called *Conceptual Forms* (2004), too, Sugimoto strived for pure, absolute form. *Helicoid* or *Hypersphere* are the titles of such depictions of trigonometrical functions, calculated by mathematicians and cast in plaster by master mold-makers. He has also photographed architecture, but with the lens purposely adjusted out of focus. Only really good architecture, the photographer says, can stand up to such "blurring attacks."

As little as Japan would be Japan without the tradition of Samurai violence, no review of Sugimoto's work would be complete without his *Chambers of Horrors*. He spent five years recording the terrors in Madame Tussaud's, from the various methods of execution—guillotine, garrote, hanging, electric chair—to notorious murderers seen in the act. To Sugimoto, these staged scenes seemed more real than the real.

It goes almost without saying that when it came to portraits, contemporaries held little interest for him. He preferred the wax faces of Shakespeare or Emperor Hirohito. An occasion to foreground sumptuous textiles was provided by his series on Henry VIII and his unfortunate wives. Thinking you could go to Sugimoto to have your portrait taken would be to misunderstand the master. You can imagine him politely requesting you to die first and come back in the form of a wax effigy. For Sugimoto, photography contains "great magic," but it is not revealed through a hunt for motifs. It is coaxed out of long exposures that embody "visions in my mind."

1948 Born in Tokyo
1970 Graduated from Saint Paul's University, Tokyo
1972 Graduated from Art Center College of Design, Los Angeles
1974 Moved to New York; as a young man, teaches himself photography, and takes on commercial jobs
1975–1999 *Dioramas*
1975–2001 *Theaters*
1977 *Waterfalls*
1980–2003 *Seascapes*
1994–1999 *Chamber of Horrors*
1995 *Sea of Buddha*
1997–2002 *Architecture*
1998 *In Praise of Shadows*
1999 *Portraits*
2001 *Pine Trees*
2002 *Appropriate Proportion*
2004 *Conceptual Forms*
2004–2006 *Colors of Shadow*
2006–2007 *Lightning Fields*
Hiroshi Sugimoto lives in New York

FURTHER READING
Kerry Brougher and Pia Müller-Tamm, *Hiroshi Sugimoto*, exh. cat. Kunstsammlung Nordrhein-Westfalen, Düsseldorf et al., 2007

Katherine of Aragon, 1999

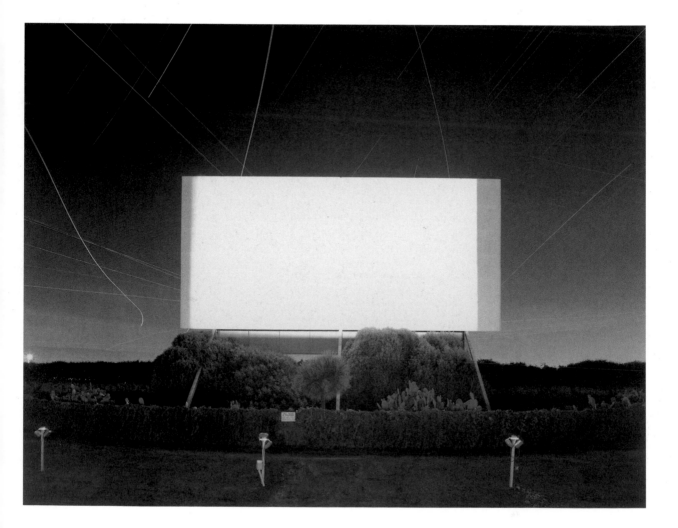

LARRY CLARK

CINDY SHERMAN

ANNIE LEIBOVITZ

1950 Racial segregation abolished
in the USA

1946 UNESCO is established

1962 Cuban Mis-
sile Crisis

1939–1945 World War II

| 1880 | 1885 | 1890 | 1895 | 1900 | 1905 | 1910 | 1915 | 1920 | 1925 | 1930 | 1935 | 1940 | 1945 | 1950 | 1955 | 1960 | 1965 |

1970 1975 1980 1985 1990 1995 2000 2005 2010 2015 2020 2025 2030 2035 2040 2045 2050 2055

NAN GOLDIN

There are no barriers between private life and work in this photographer's case. Even the most intimate things appear in public, on high gloss Cibachrome. These are "snapshots out of love," out of a desire to remember people, places, times, as Goldin herself says.

Having grown up in the gay scene, the subculture of drag queens, junkies and their milieu is home to Goldin. New York, late 1970s—the scene establishes itself on the Lower East Side, where the rents have plummeted. Nightlife burgeons in the lofts and clubs, they dance until they drop at the Mudd Club, TR 3, Tsaiah's, awash in alcohol. Existentialism with an American twist. Warhol's films inspire Goldin to take private life seriously, aesthetically. Though she would love to make films herself, she just keeps on making personal photographs like she had as a teenager. Her flash sheds garish light on scenes in bars, lofts and clubs, in her own living room and bedroom—rumpled beds, people embracing, having sex, in front of the mirror, in the bathtub, on a train. She portrays her countless friends, on a search for themselves somewhere between masculine and feminine or both at once. Nan's eye, as Luc Sante noted, could search out the dirtiest corners of a dingy apartment and discover colors and textures no one else had ever seen—sunset oranges, oceanic blues, hellish, seductive reds. We experience the people close to Goldin laughing and crying, in their loneliness as in their comforting togetherness. Or as they contract AIDS, go through phases of recovery, then mostly, inevitably, succumb. *Gotscho Kissing Gilles, Paris* (1993) is probably one of the most moving records of this theme, because it reflects profound

emotional involvement. Many of Goldin's photographs form parts of a requiem, many of her friends having died young.

Then there are her self-portraits, many of them—alone, in an embrace with someone she loves, with black eyes after being beaten by her lover, clean after having broken her drug habit in 1988, or in the hospital after an accident.

At some point Goldin began to project her slides on the walls of clubs: a "family album" in which everybody recognized everybody else. Later she underscored the show, which ran for several years, with music, and called it *The Ballad of Sexual Dependency*. The selection of pictures continually changed. Goldin's imagery revealed souls, as Luc Sante wrote, as if she looked through the eyes of the people she photographed in both directions. She showed her life, in which her friends and partners played the starring role.

FURTHER READING
Elisabeth Sussman and David Armstrong, *Nan Goldin: I'll Be Your Mirror*, exh. cat. Whitney Museum of American Art, New York, Zurich, Berlin and New York, 1996

left
Joana's back in the doorway, Chateauneuf de Gadagne, Avignon 2000

right
Misty and Jimmy Paulette in a Taxi, NYC, 1991

1941–1976 Mohammad Reza Pahlavi, Shah of Iran

1945 United Nations founded

1939–1945 World War II

1880 1885 1890 1895 1900 1905 1910 1915 1920 1925 1930 1935 1940 1945 1950 1955 1960 1965

Dance of Kurdish Qaderi Dervishes,
Zagros Mountains, Iran

right page
below
Reading the Koran, Iran-Iraq war,
Ahvaz, Iran, September 1982

1973 Oil crisis

1990–1991 Gulf War

2007 Ban Ki-moon becomes General Secretary
of the United Nations

1989–1997 Ayatollah Akbar Hashemi Rafsanjani

1980–1988 Iran-Iraq War

2001 Terrorist attacks on the
London Underground

1979 Islamic Revolution in Iran begins

1979–1989 Ayatollah Ruhollah Khomeini

2003 The War in Iraq begins

1970 1975 1980 1985 1990 1995 2000 2005 2010 2015 2020 2025 2030 2035 2040 2045 2050 2055

KAVEH GOLESTAN

Golestan photographed under two Iranian regimes—that of the Shah, then that of Khomeini—and documented the Islamic Revolution, the Iran-Iraq War, and the Kurdish Revolt. In Time, The Observer *and* Newsweek, *in* Stern *and* Der Spiegel, *he showed the West how it looked behind the facade of the Pahlavi monarchy and the Islamic Republic, and made himself unpopular with the authorities both times.*

When Queen Farah Diba visited Golestan's show *Roospi, Kargaar va Majnoun* in Tehran in 1978, she found his view of life "very gloomy." His photo series on workers, prostitutes in Tehran's Sharh-e No quarter, and children in psychiatric clinics hardly corresponded to the Shah's image of Iran, for which he prescribed modernization and a Western life style.

When Khomeini came to power and some Iranians returned from exile while a million others fled abroad again, when the Shah's feared secret service was replaced by another, religiously orthodox one, reality continued to be selectively defined. The Ayatollahs torched the red light district complete with inhabitants, and fleeing women were strung up on lampposts. Golestan held on for five years before he, too, emigrated with his family to London.

In the meantime, the 1979 winner of the Robert Capa Gold Medal had become internationally known for his pictures of the Iranian Revolution. His famous photograph of the Stars and Stripes, torn from the flagpole of the US Embassy and used by two Shah opponents to tote away their booty, symbolized the end of Iran's orientation to the West, and was published in the *Time Book of the Year*.

Hardly had the gunfire of the revolution died away when the internecine war with Iraq broke out. "I was amazed by how youngsters were willing to die for their beliefs. I felt I had to show this through my photos," Golestan would later write. During the eight years he spent looking "through the camera at death," he captured men dying on stretchers, wounded men swaddled in bandages, and maimed and immolated bodies. Perhaps for one last time a photographer was able to record such unvarnished realities before the embedded journalism of another Iraq war censored them away.

The year the war ended, 1988, saw Iranian Kurdistan rise against the repressive rule of Tehran. At the same time across the border, Saddam Hussein was bombing the Kurdish town of Halabja with poison gas—only the latest, gruesome sign of the social and political oppression under which the Kurds in Iran, Iraq, and Turkey had suffered for centuries. Though himself not a Kurd, Golestan allied himself with these people and their cause. When the West continued to support Saddam, he recorded their desperate resistance. "The subject of my work was death and humanity," Golestan would later sum up his life's work.

In pictures of dances of the Qaderi dervishes in the Zagross Mountains of western Iran he shed light on quite a different side of Kurdish culture. Singing, praying and dancing to the beat of great tambourines, the Sufis whirled themselves into a trance, an ecstatic confrontation with God—scenes no tourist but only a true friend was permitted to witness.

1950 Born in Abadan, Iran

1963–1969 Studies at a boarding school in England

1972 Wins his first commission, for the daily *Kayhan*, on the Northern Ireland conflict

1976 Exhibition on factory workers and farmers, University of Tehran

1977 Works for the daily *Ayandegan*

1978 Exhibition *Roospi, Kargaar va Majnoun*, Aobid Gallery, University of Tehran, with photo series on workers, prostitutes, and children in psychiatric clinics

1979 Documents the Iranian Revolution for *Time*, *Tehran-e Mosavar*, and others; awarded the Robert Capa Gold Medal

1980 *Shooresh* (Rebellion), a book on the Iranian Revolution, co-authored by Mohammad Sayad

1980–1988 Documents the Iran-Iraq War

1983 *Goncheha Dar Tufan* (Buds in the Storm), a book on children and adolescents during the revolution, co-authored by his wife, Hengameh Golestan

1984 Moves to London; works for the Reflex photographic agency

1991 *Recording the Truth*, a film about censorship in Iran, for Channel 4; two years of house arrest and work ban; begins using video

1994 Works as cameraman for Associated Press Television Network

1999 Begins working as cameraman for the BBC

2003 April 2: Killed by a land mine in Kifri, Iraqi Kurdistan

FURTHER READING
Malu Halasa and Hengameh Golestan (eds.), *Kaveh Golestan: Recording the Truth in Iran*, Ostfildern, 2007

Children in Mahabad, Iranian
Kurdistan, 1 May 1981

1945 United Nations founded **1962** Cuban
 Missile
 Crisis
1939–1945 World War II

| 1880 | 1885 | 1890 | 1895 | 1900 | 1905 | 1910 | 1915 | 1920 | 1925 | 1930 | 1935 | 1940 | 1945 | 1950 | 1955 | 1960 | 1965 |

Tupperware Party, Salford,
Greater Manchester, 1985

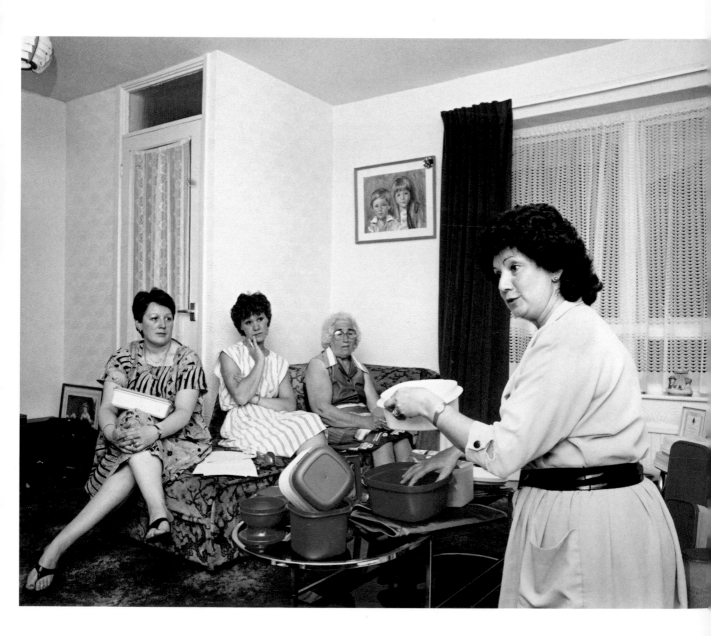

2007 Benazir Bhutto is assassinated
964 Vietnam War begins 1980 John Lennon is murdered 2003 The War in Iraq begins
1979–1990 Margaret Thatcher, British Prime Minister 2005 Terrorist attacks on the London Underground
1982 The Falk- 1990 Reunification of Germany 2005 Harold Pinter wins the Nobel Prize in Literature
lands War 1993 The Treaty on European Union
1969 Apollo Moon landing 1997–2007 Tony Blair, British Prime Minister

1970 1975 1980 1985 1990 1995 2000 2005 2010 2015 2020 2025 2030 2035 2040 2045 2050 2055

MARTIN PARR

Parr's presence on the contemporary photography scene looms even larger now that the sarcastic British photographer has begun collecting, editing outstanding photo books, and curating exhibitions. His wit and inventiveness enliven a field that tends to commercial sterility. Yet Parr is not afraid of boredom—paradoxical as it may sound, it is the source of his art's true strength.

He put on a bored face every time he let himself be snapped in colleagues' studios, or with a stuffed baby lion in the MGM Grand Hotel in Las Vegas, or vanishing into the maw of a shark in Benidorm, Spain. He couldn't have found it easy to suppress a smile. Boredom seems to have had a magical attraction for Parr ever since 1977–1978, when he recorded scenes from small Methodist communities in Yorkshire, and 1981, when he photographed the series *Bad Weather*. Then he commenced collecting "boring postcards" from the 1930s and 1940s. Subsequently he invested considerable effort in making 468 pictures of all the streets, houses and stores in the town of Boring, Oregon, USA (2000). Another series was devoted solely to bored couples.

His early photographs, distantly reminiscent of Robert Doisneau, occasionally have an ironic undertone, as when the guests at *The Mayor of Todmorden's Inaugural Banquet* in Yorkshire threaten to stab each other with their forks (1977). The comfy tastelessness of British sitting-rooms and bedrooms has intrigued him from the start.

At 30, Parr turned to color photography, a hurdle he took with ease. In *Tupperware Party, Salford, Greater Manchester* (1985), the red of the plastic contributed greatly to the tragicomic mood of the scene. From here on, the garish colors of commercial merchandise never let him go. For the series *One Day Trip* (1983–1986), Parr accompanied fellow Britons on their buying sprees to the supermarkets of Boulogne, France. The mountains of goods piled in teetering shopping carts are a festival of acrid color. A contrast is provided by his shots of families in the age of Margaret Thatcher, on Sunday outings to dingy bathing resorts near Liverpool, where the waste heaps abound.

When in 1995 Parr switched from medium format to 35 mm and used a ring flash in daylight to illuminate every pore of his sitters' faces, his sarcasm and the color temperature of his images reached boiling point. The shrill colors made the banality of the close-ups well-nigh unbearable. In the series *Think of England*, begun in the late 1990s, he showed his countrymen sunbathing, their bellies either already filled or just being topped off with a greasy bacon sandwich. From aristocratic receptions to snack bars, Parr wended his way through the most diverse of milieus. Benidorm, a tourist grill on the hotel-lined Costa Blanca firmly in the hands of British tourists, provided Parr with a sunburn red that formed a surreal contrast to the hues of towels and sea. Cheap consumption was paralleled by the cheap laser prints used to reproduce the pictures of *Common Sense* and other series, which were sent— "ugly, colorful and bright"—touring around the world in dozens of exhibitions.

1952 Born in Epsom, Surrey, England
1970–1973 Studies photography at Manchester Polytechnic
1972 Photo series *Butlin's by the Sea*
1974 Installation *Home Sweet Home*, Impressions Gallery, York
1976–1977 *Beauty Spots* series
1980–1983 *A Fair Day*
1982 *Bad Weather*
1986 *The Last Resort: Photographs of New Brighton*
1987–1994 *Small World* series
1989 *The Cost of Living*
1992 *Signs of Times: A Portrait of the Nation's Tastes*
1993 *Bored Couples* and *Home and Abroad*
1994 Becomes a full member of Magnum; photo book *From A to B: Tales of modern motoring*
1995 *Common Sense* series; photo book *British Food*
1996 *Prefabs* series
1998 *Japonais Endormis* series
1999 *Common Sense, Benidorm,* and *Boring Postcards*
2000 *Think of England*
2002 Retrospective at the Barbican Art Gallery, London, and the National Museum, Bradford
2003 *Bliss: Postcards of Couples and Families*
2004 Commissioner of Rencontres Internationales de la Photographie, Arles; *The Photobook: A History Volume* (with Gerry Badger)

FURTHER READING
Val Williams, *Martin Parr*, London, 2002

Oktoberfest, Munich, 1997

AXEL HÜTTE ━━━━━━━━

THOMAS RUFF ━━━━━━━━

THOMAS STRUTH ━━━━━━━━

1949 Democratic Republic of Germany
(DDR) established officially

1949 The Federal Republic of Germany
is established

1961 Construction of the
Berlin Wall begins

1939–1945 World War II

1880　1885　1890　1895　1900　1905　1910　1915　1920　1925　1930　1935　1940　1945　1950　1955　1960　1965

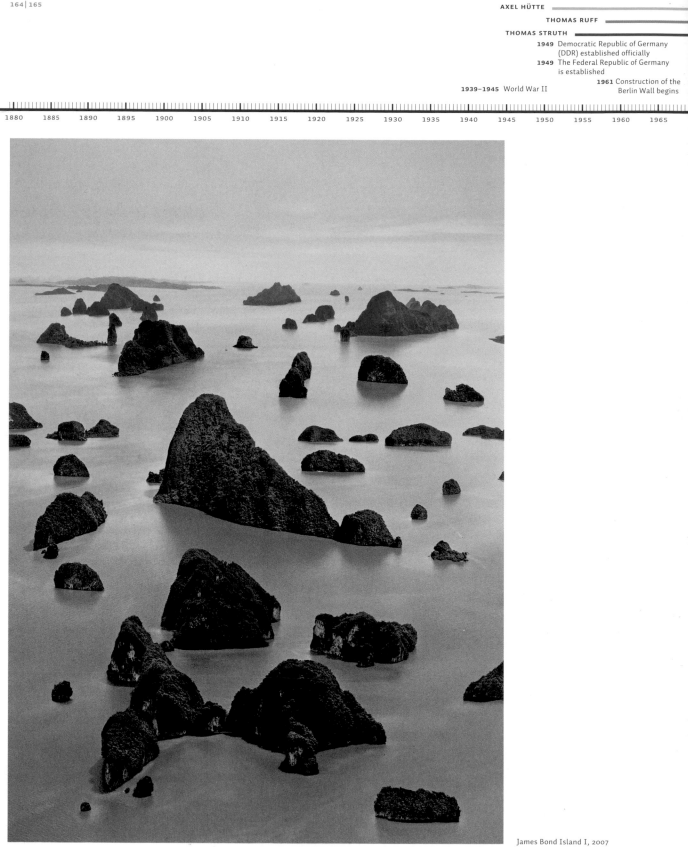

James Bond Island I, 2007

1980	In Poland, the independent trade union Solidarity is established	1991	Michael Schumacher wins his first Grand Prix
1982–1998	Helmut Kohl, Chancellor of Germany	1991	The World Wide Web became publicly available
1989–2006	Love parade in Berlin	2008	Kosovo formally declares independence from Serbia
1990	Reunification of Germany		
1990	Final year of the Cold War era		

1970 1975 1980 1985 1990 1995 2000 2005 2010 2015 2020 2025 2030 2035 2040 2045 2050 2055

ANDREAS GURSKY

The aesthetic of Google Earth and mass scenes à la Hollywood inform the work of this shooting star on the photography scene, who draws record prices on the international art photo market. Rather than presenting photographic impressions, Gursky employs digital processing to rework his images into highly refined panoramas.

Whether the current triumphs of young photographers are more the result of the demise of painting, a hunger for realistic imagery, or a variant of the proliferating "overdesign" of life and art, is something only time will tell. What we can say is that photographers no longer lack self-confidence, and that their gigantic glossy formats are stealing the show from contemporary painting. In retrospect, images by Albert Renger Patzsch or Henri Cartier-Bresson look like miniatures. These masters refused to be called artists. Gursky, in contrast, would feel insulted if one referred to him as a photographer, in the craft sense. Like the German photographers Axel Hütte, Jörg Sasse, Thomas Struth, Candida Höfer, and Thomas Ruff, Gursky was a student of the Bechers.

Gursky's works are visual symphonies, obsessively packed with detail of a *trompe l'œil* precision. Like Albrecht Altdorfer's monumental painting *Alexander's Victory*, each of his subjects is expanded into a spatially all-encompassing universal landscape. His *Tour de France I* (2007) shows an Alpine stage that effortlessly covers two vertical kilometers in altitude. An asparagus field in *Beelitz* (2007), seen in a bird's-eye view, rises into a linear pattern that recalls the slats of a ventilation duct. The archipelago of Gursky's *James Bond Island* seems to consist of all the islands in Micronesia.

Gursky's images tempt us to search for the joints between the separate pictures of which they are composed and the hinges between their changes of perspective. His reproduction of modules of a motif present intriguing rebuses to the eye. The photographic illusions and cinematic effects are fascinating: mass scenes reminiscent of the movie *Ben Hur* (*Pyongyang I*, 2007), or human figures swarming like insects over megastructures à la *Blade Runner* (*Klitschko*, 1999; *Madonna I*, 2001). The stadiums, arenas, factories overflow with people. And then, in sharp contrast, are those images that veritably celebrate aseptic emptiness: *Prada II* (1997), *Schiphol* (1994), or *Supernova* (1999), evoking outer space as the last exit for mankind. This division between puristic places of contemplation—*Rhine II* (1999)—and orgies of global hypertension and mass entertainment—the Chicago stock exchange, the Berlin Love Parade, traffic chaos in Cairo—seems almost schizophrenic. Seen from a great distance, Gursky's crowds appear tame and manageable. Images of mass animal raising in the United States and Japan provide an ironic commentary.

1955 Born in Leipzig, Germany
1978–1981 Studies at the Folkwang School, Essen
1981–1987 Studies at the Düsseldorf Art Academy, with Bernd Becher, whose master student he becomes in 1985
1987 Exhibition at the Dusseldorf Airport
1989 Exhibition at the Centre Genevois de Gravure Contemporaine, Geneva; 303 Gallery, New York; Museum Haus Lange, Krefeld
1992 Exhibition at Kunsthalle Zurich; Victoria Miro Gallery, London; Galleria Lia Rumma, Naples
1994 *Andreas Gursky, Photographs 1984–1993*, exhibition at Deichtorhallen, Hamburg, and De Appel Stichting, Amsterdam
1997 *Andreas Gursky: Fotografien 1984–1998*, Kunstmuseum Wolfsburg and Fotomuseum Winterthur
Andreas Gursky: Fotografien 1984 bis heute, Kunsthalle Dusseldorf
2001 Exhibition at the Museum of Modern Art, New York, which travels to Madrid, Paris, Chicago and San Francisco
2007 Exhibition at the Haus der Kunst, Munich
2008 Exhibitions at Istanbul Museum of Modern Art, Istanbul; Sharjah Contemporary Arab Art Museum, Sharjah; Ekaterina Foundation, Moscow; Museum für Moderne Kunst, Frankfurt; Kaiserring, Goslar
Andreas Gursky lives in Dusseldorf

FURTHER READING
Peter Galassi, *Andreas Gursky*, New York, 2001

1928 b. Andy Warhol,
US American artist

1937 b. David Hockney,
British artist

1939–1945 World War II

1947 b. Elton John, British musician

1949 Democratic Republic of Germany
(DDR) established officially

1949 The Federal Republic of Germany
is established

| 1880 | 1885 | 1890 | 1895 | 1900 | 1905 | 1910 | 1915 | 1920 | 1925 | 1930 | 1935 | 1940 | 1945 | 1950 | 1955 | 1960 | 1965 |

Adam, 1991

1990 Reunification of Germany 2003 The Iraq War begins
1980 In Poland, the independent trade 1997 Princess 2008 Kosovo formally declares
 union Solidarity is established Diana dies independence from Serbia
1981 Prince Charles and Lady Diana marry 2007 Gordon Brown becomes Prime
1981 The HIV virus is identified Minister of the United Kingdom

1970 1975 1980 1985 1990 1995 2000 2005 2010 2015 2020 2025 2030 2035 2040 2045 2050 2055

WOLFGANG TILLMANS

Tillmans focuses as much on socks draped on a radiator, apple blossoms by night, underarm hair, and naked lovers as he does on abstract color fields and starry skies. He is both hedonistic and committed, loves both tangibility and immateriality. His sensuously colored work is personal, imaginative, and always ready to surprise.

A breakfast tray on the folding table on an American Airlines seat is provocatively garnished by the exposed penis of Tillmans's traveling companion. This is one of his many still lifes that consist of flowers, vegetables, underpants, undershirts, or other equally banal things, arranged to bring out their color contrasts. A party-devastated interior complete with scattered leftovers and waste, skillfully illuminated, becomes a feast for the eye. Not even slush dotted with the footprints of passersby escapes Tillmans's lens. In his *Paper Drops* (2004), he approaches a formal purism that recalls the New Vision of the 1920s.

Again and again Tillmans has turned his attention to people, beginning with pictures of nightlife in London clubs. The approaches of Andy Warhol, Nan Goldin, or Larry Clark may have encouraged him to focus on his friends and private milieu. A series of portraits resulted, and even the commissioned ones retained a personal, intimate character.

Then there is the Tillmans who records cloud formations, manipulates their colors, or draws veils over them (*Intervention Pieces*), the creator of ethereal images of hair-fine lines on a light ground (*String Pieces; Freischwimmer*) or of dust particles on toned backgrounds (*Blushes*). In other series he conceptually celebrates the intensity of various monochrome C-prints, made without a camera. An enthusiastic amateur astronomer from boyhood, Tillmans recorded the Venus transit of 8 June, 2004, in sublime photographs.

This is someone who retains freedom of choice of motifs, and continually rediscovers people, things, and situations with an unbiased eye. A cup of tea with a film of grease on it, mice creeping out of the sewer at night... Tilmanns effortlessly overcomes the conventional borderlines between genres, including that between "art" and photography. His exhibitions generally take the form of large-area arrangements of glass-framed C-prints and freely suspended inkjet prints of various format, with

purposely disparate motifs and subjects, distributed along the walls according to a momentary whim. In addition, he presents exhibitions as "polyphonal processes," comprising newspaper cuttings, photocopies, and photographs on wooden tables under glass. These reflect the politically conscious and engaged side of Tilmanns's nature. Religious terror (*For the Victims of Organized Religions*, 2006), an inhuman economy dictated by shareholder value, homophobia and AIDS are themes that especially concern him.

1968 Born in Remscheid, Germany
1987–1990 Lives in Hamburg
1990–1992 Attends Bournemouth and Poole College of Art and Design, England
1992–1994 Lives in London
1994–1995 Lives in New York
1996 Settles in London
1996 *Wer die Liebe wagt lebt morgen* (He Who Dares to Love Lives Tomorrow), Kunstmuseum Wolfsburg
1998–1999 Guest professor at the College of Visual Arts, Hamburg
2001 *Aufsicht* (Supervision), exhibition at Deichtorhallen, Hamburg
2000 Turner Prize, Tate, London
2003 *If One Thing Matters, Everything Matters*, Tate Britain, London
2003–2006 Professor of Interdisciplinary Art, Städelschule, Frankfurt am Main
2004 *Freischwimmer*, Tokyo Opera City Art Gallery
2005 *Truth Study Center*, Maureen Paley, London
2006 *Freedom from the Known*, P.S. 1 Contemporary Art Center, New York

Freischwimmer 26, 2004

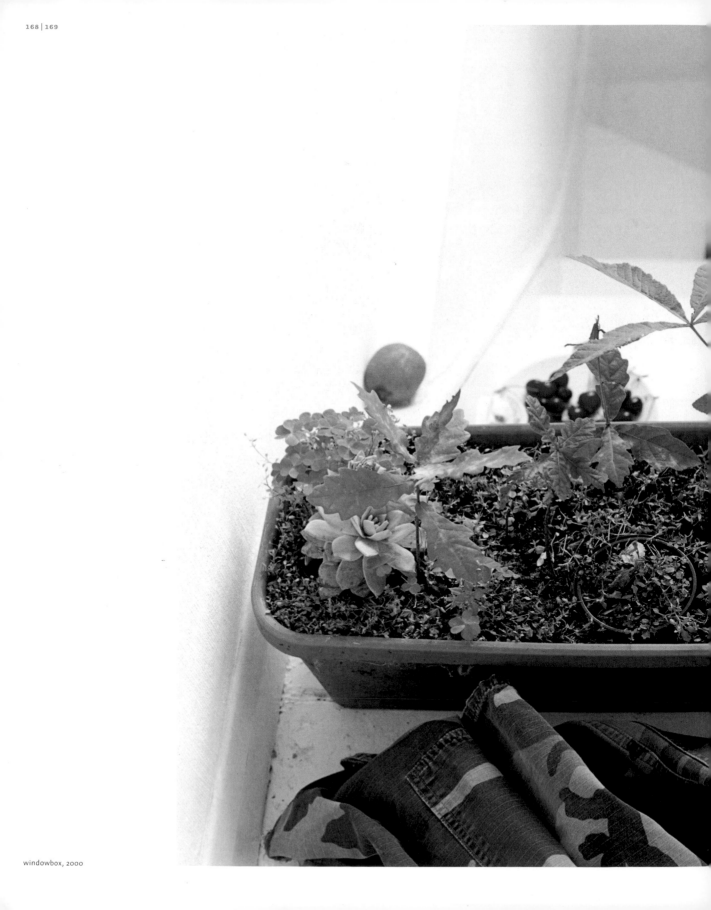

windowbox, 2000

INDEX

PHOTO CREDITS

The illustrations in this publication have been kindly provided by the museums, institutions and archives mentioned in the captions, or taken from the Publisher's archives, with the exception of the following:

Diane Arbus: Courtesy The Estate of Diane Arbus, LLP; Richard Avedon: Courtesy The Richard Avedon Foundation, New York; Bernd and Hilla Becher (Portrait): ullstein bild – Massine; Brassaï (Portrait): Dorka; René Burri (Portrait): akg-images/Cordia Schlegelmilch; Henri Cartier-Bresson (Portrait): ullstein bild; Robert Doisneau (Portrait): akg-images/Marion Kalter; Lee Friedlander: Courtesy Fraenkel Gallery, New York; David Goldblatt (Portrait): Lily Goldblatt; Kaveh Golestan: Courtesy Kaveh Golestan Estate, Teheran/London; Andreas Gursky (Portrait): ullstein bild – ddp Nachrichtenagentur; Lewis Hine: Courtesy National Archives Still Picture Branch, College Park, Maryland; Lewis Hine (Cover): ullstein bild; Dorothea Lange: Courtesy Dorothea Lange Collection, The Oakland Museum of California; Dorothea Lange (Portrait): Paul S. Taylor; Robert Mapplethorpe: Courtesy Robert Mapplethorpe Foundation, Inc.; Eadweard Muybridge (Portrait): akg-images; Helmut Newton: Courtesy The Helmut Newton Estate, TDR; Helmut Newton (Portrait): akg-images/Niklaus Stauss; Albert Renger-Patzsch (Portrait): Hugo Erfurt; Willy Ronis (Portrait): akg-images/Marion Kalter; Sebastião Salgado (Portrait): ullstein bild – ddp Nachrichtenagentur; August Sander: Courtesy Die Fotografische Sammlung/August-Sander-Archiv, Köln; Edward Steichen (Portrait): Carl Björncrantz; Alfred Stieglitz: George Eastman House; Alfred Stieglitz (Portrait): Robert Brown; Paul Strand: Courtesy Aperture Foundation, New York; Josef Sudek (Portrait): J. Sauer; Wolfgang Tillmans: Courtesy Galerie Buchholz, Köln; Edward Weston: Courtesy Center for Creative Photography, Tucson; Edward Weston (Portrait): Tina Modotti; Garry Winogrand: Courtesy Fraenkel Gallery, New York

South East Essex College
of Arts & Technology
Luker Road, Southend-on-Sea Essex SS1 1ND
Tel:(01702) 220400 Fax:(01702) 432320 Minicom: (01702) 22064∠